INTUITIVE
LIGHT

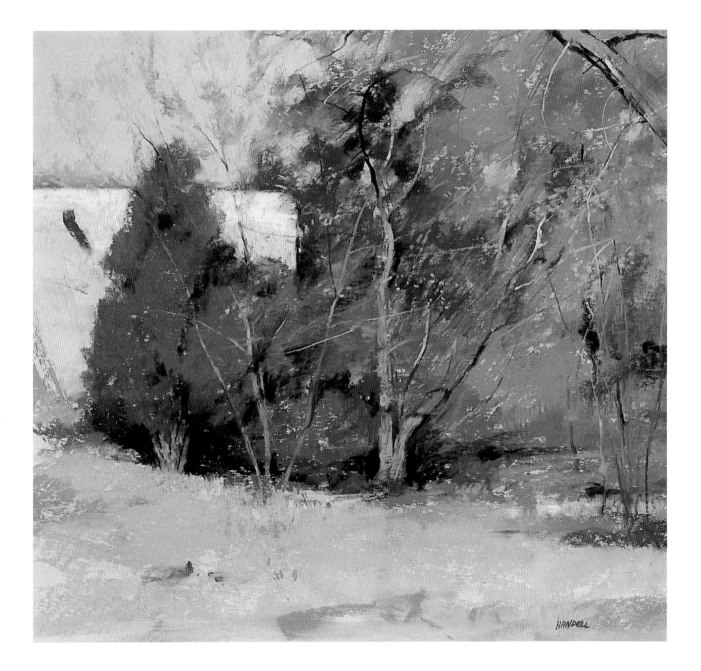

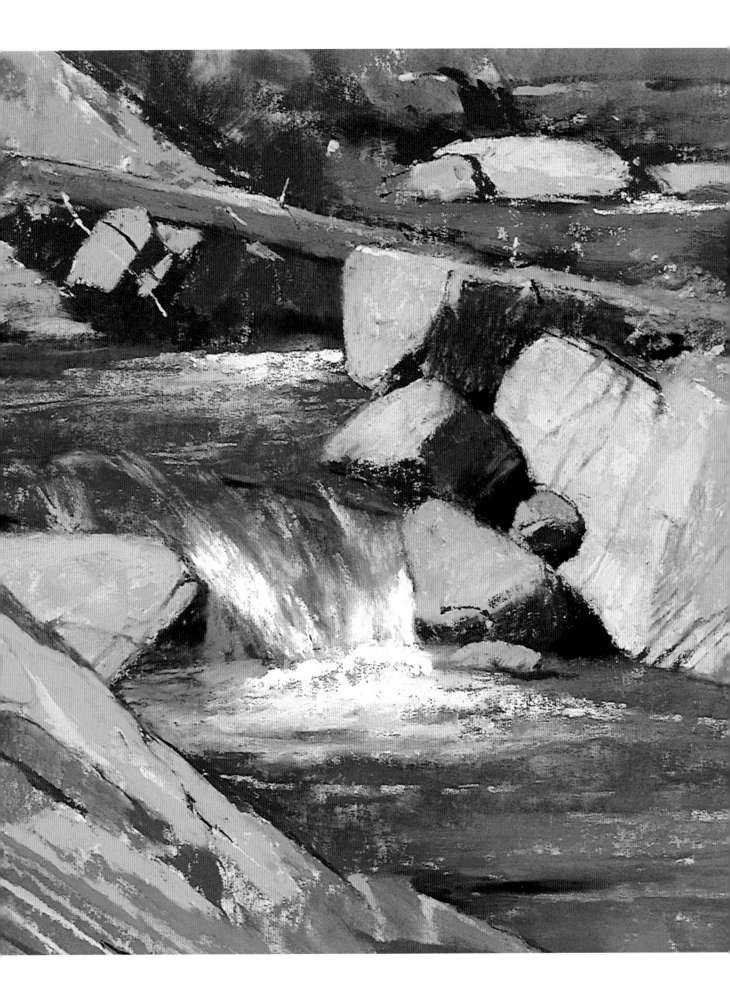

INTUITIVE LIGHT

*An Emotional Approach to Capturing the
Illusion of Value, Form, Color, and Space*

ALBERT HANDELL AND LESLIE TRAINOR HANDELL

WATSON-GUPTILL PUBLICATIONS/NEW YORK

Page 1: *Late September*. Pastel on sanded board. 14 x 15 inches (36 x 38cm). Courtesy of the Shriver Gallery, Taos, New Mexico.

Pages 2-3: *Nature's Bridge*. Pastel on sanded board. 9$\frac{1}{2}$ x 11 inches (24 x 28cm). Collection of John Koontz.

Page 5: *Is Anybody Home?* Pastel on sanded board. 16 x 22 inches (41 x 56cm). Collection of Leonard and Stephanie Armstrong.

Page 6: *Summer Sky*. Pastel on sanded board. 8$\frac{3}{4}$ x 10$\frac{3}{4}$ inches (22 x 27cm). Courtesy of the Ventana Gallery, Santa Fe, New Mexico.

Page 8: *Hint of Jade*. Oil on Masonite panel. 23$\frac{1}{2}$ x 29$\frac{1}{2}$ inches (60 x 75cm). Private Collection.

Pages 10-11: *Juniper Alley*. Pastel on sanded board. 16 x 15 inches (41 x 38cm). Courtesy of the Ventana Gallery, Santa Fe, New Mexico.

Pages 26-27: *Early Spring*. Pastel on sanded board. 11 x 12 inches (28 x 30cm). Courtesy of the Ventana Gallery, Santa Fe, New Mexico.

Pages 58-59: *Johnson Pond Road*. Pastel on sanded board. 10$\frac{1}{2}$ x 10$\frac{1}{2}$ inches (27 x 27cm). Collection of Dr. and Mrs. Edward J. Urig.

Pages 94-95: *5 P.M. Santa Fe*. Pastel on sanded board. 13 x 14 inches (33 x 36cm). Private Collection.

Senior Editor: Candace Raney
Photography of artwork: Hawthorne Studio, Santa Fe, New Mexico
Designer: Bob Fillie, Graphiti Graphics
Production Manager: Ellen Greene

First published in 1995 in the United States by Watson-Guptill Publications, a division of BPI Communications, Inc., 1515 Broadway, New York, NY 10036

Library of Congress Cataloging-in-Publication Data
Handell, Albert, 1937-
 Intuitive light: an emotional approach to capturing the illusion of value, form, color, and space / Albert Handell, Leslie Trainor Handell.
 p. cm.
 Includes index.
 ISBN 0-8230-2521-7
 1. Painting—Technique. 2. Light in art. 3. Visual perception.
I. Handell, Leslie Trainor, 1949— . II. Title.
ND1484.H35 1995 94-43005
751.4—dc20 CIP

Manufactured in Hong Kong

1 2 3 4 5 6 7 8 9 / 03 02 01 00 99 98 97 96 95

To my teachers and students

ACKNOWLEDGMENTS

I want to thank the teachers I studied with at the Art Students League of New York: the late Louis Priscilla and the late John Ward Johnson, a sculptor who taught drawing and anatomy. Both men had studied with famed anatomist George Bridgman. I feel privileged to have studied with these men. I still use the information they imparted. At 19, I began painting with Frank Mason. He gave me important painting concepts and ideas on light that I also continue to use. I would like to thank a friend, Richard Schmid, whose works have inspired me all these years, and whose books were very helpful to me.

I enjoy teaching. I want to thank all of my students for their desire to study with me, their enthusiasm, their hard work, and the "dumb" questions they've asked me. They made me pause and reflect many times. And because I needed to articulate, explain, and explore what I was showing my students these past 20 years, I've come to fully understand my craft.

I want to give a special thank you to Leslie, for all her work over the years. *Intuitive Light* was her idea. This is our fourth book together. I am thankful for her patience, understanding, and love.

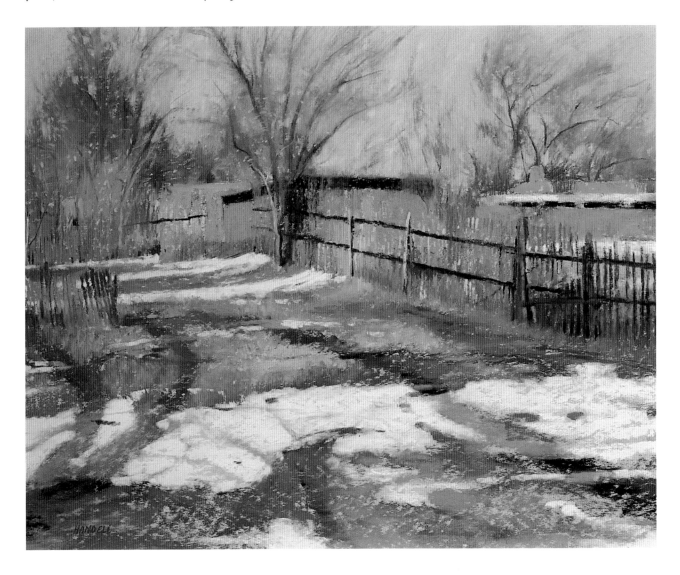

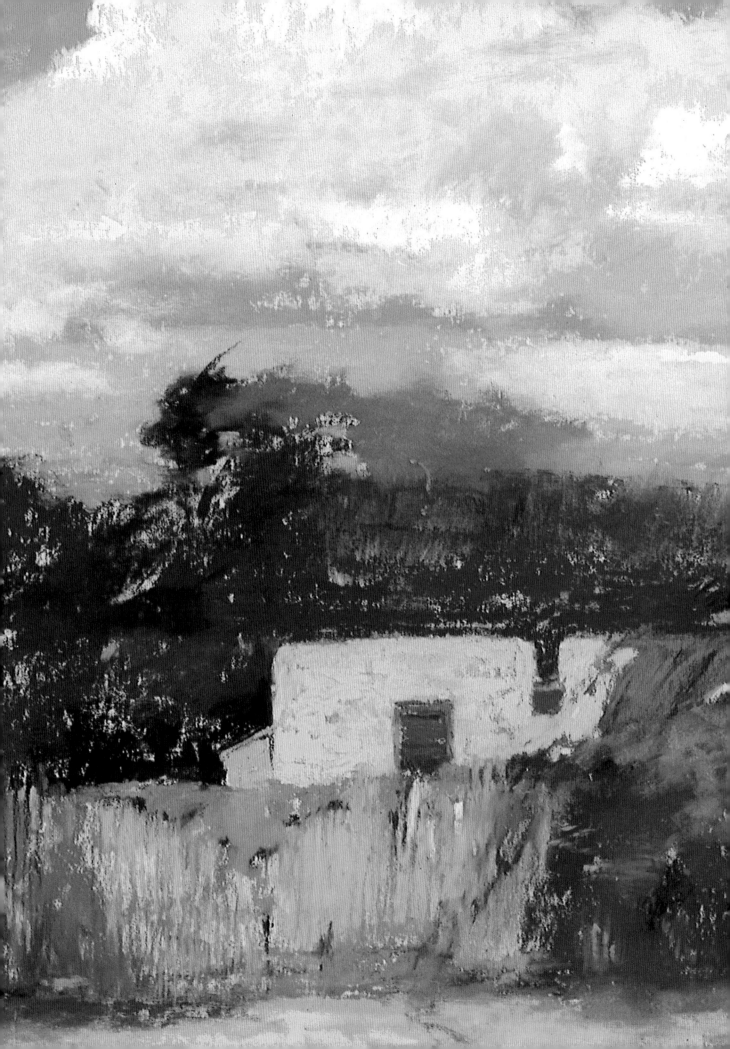

Contents

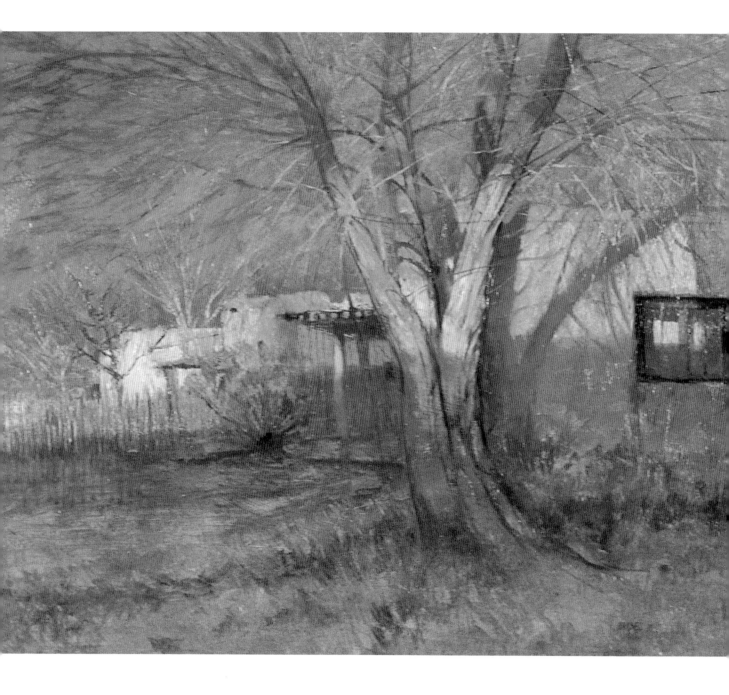

Introduction

As I review the introduction to our third book, *Intuitive Composition,* written six years ago, I realize that I've been painting for 38 years. I've had an interesting and varied career. Subject matter has changed, but more important, my color and the sense of light that I achieve in my paintings have changed.

As a student I learned to paint with oils. After nine years of study and working on my own exclusively with oils, I decided to experiment with pastels. That experiment changed my life. Switching to pastels was like a fish going to water.

As a child growing up in Brooklyn, New York, I used to draw in the streets with two-cent and five-cent boxes of chalks. How would I know that I would expand on this later in life? I'd been impressed by *Saturday Evening Post* illustrators, such as Norman Rockwell, Dean Cornwell, and John Pike. I wanted to be an artist like them. My painting instructor at the Art Student's League of New York was Frank Mason, who still teaches at the League. From Frank I learned to paint in the tradition of classical realism. But I remember having a discussion one day in the cafeteria at the League, by serendipity, that has stayed with me all of these years. "A truly good painting has an inner glow to it," he said. Whoever "he" was, my endeavors at the time didn't possess this quality. Needless to say, I made up my mind then and there that one day they would.

When I started working with pastels in the fall of 1965, I felt an immediate response to the medium. In contrast to oils, which is a glossy medium, pastel is a matte medium. As a result, I couldn't get the rich, glossy darks that I could with oils. I was used to this quality so, of course, I naively tried to manipulate the pastels to achieve it. But no matter what I did, the pastels didn't get as rich and dark as the oils. It finally dawned on me to go after what the medium of pastel is special for. Pastels have an incredible range of colors that are high in key. Making good use of these colors immediately added more light to my works, and I was excited.

For the next 29 years, I continued to paint with both mediums, switching from one to the other as my feelings spoke to me. All during this time, the light in my paintings became brighter and more luminous. I moved to Santa Fe, New Mexico, 11 years ago. The light here is truly special. The colors are vibrant, and the skies are wide open with extremely varied weather conditions. When I shoot slides here in Santa Fe, my light meter tells me that I'm shooting at double the amount of light that I was photographing my subject matter in back east, in Woodstock, New York.

Throughout my career, I've worked in different color keys, from dark, somber colors to much lighter, happier colors. At all times I realize I was clearly dealing with the light, with light and atmosphere. All paintings are, in a sense, paintings of light. Light reveals the beauty of the world to us. The illusion of value, color, form, and space is determined by the effects of light.

As with any study, it is always important to begin with an understanding of the basic rules. Here, this is the behavior of light that is predictable and consistent. But as with any rules, I recommend that once you know them, once they've become a part of you, forget them and follow your feelings and reactions. Sense and intuit the light that captures your imagination. More and more I find that my focus in my painting is my reaction to the light I experience.

Like *Intuitive Composition,* this volume is designed so that you can either read it from beginning to end, or thumb through it, stopping at any section, reading only that section, and still come away with a feeling of completeness. It is our hope that the pictures, thoughts, and ideas within this book inspire and inform you, as well as help clarify the ideas and feelings you can have for light and color. If the information, insights, and realizations found in this volume help you discover and fine-tune your own reactions to light, your own personal vision and creative process, then this book will also be a successful endeavor.

ALBERT HANDELL
LESLIE TRAINOR HANDELL
Santa Fe, New Mexico
September 20, 1994

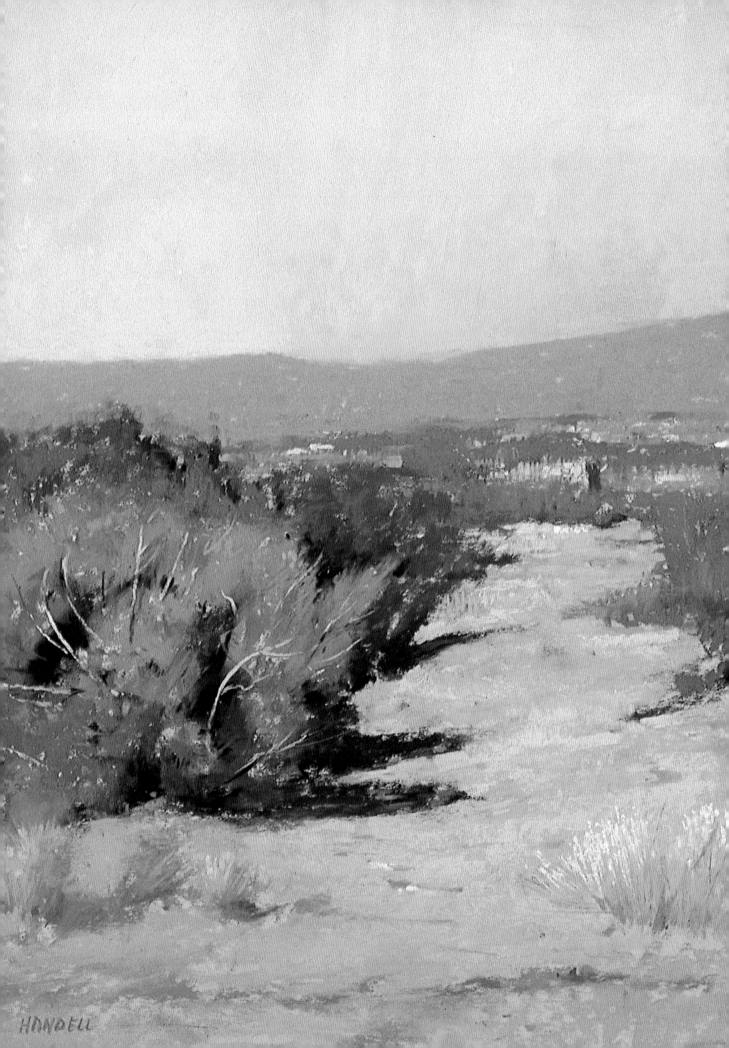

Part One

SEEING
LIGHT

Everyone sees the effects of light. Without it, there is no visible world. Through the actions of light, we perceive and interpret the physical world. Often we are in touch with the way light affects our moods and feelings, finding ourselves cheerful or happy on bright, sunny days and perhaps more contemplative or even a bit sad on a succession of gray, overcast days. Translating these emotions into artistic terms and learning to see how an artist sees involve more than simply recognizing objects or estimating the time of day. Together, they are a deeper visual experience that encompasses feeling, sensing, intuiting, and understanding the actions and the play of light inside an all-prevailing luminosity that, from moment to moment, continually transforms the everyday world into a visually magical and wondrous place. ❧ You can learn to see more than just the objects of the world. It is important to first understand in practical terms how the behavior of light defines the nuances of form, color, space, and atmosphere. But once this becomes second nature, live inside this visual experience, enabling your deep personal reactions to surface as you "see" the outside world from within.

The Magic of Light

We live in a world of light. Light is all around us. Sunlight gives us light and colors, as well as defines the forms of the physical world we perceive. The extraordinary power of light creates all the subtleties that transform our world into a world of rich and beautiful colors and nuances. It is also filled with elusive and transitory experiences.

Light from the sun travels 93 million miles and reaches the earth in eight minutes. This light doesn't originate on its own. The sun emits an electromagnetic force that travels through space. The rays of this force must strike an object before the light can be seen or felt.

Sunshine consists of many different rays or waves, each of which acts independently as it reaches the earth. Each of the waves the sun emits possesses its own distinct quality of length and frequency. Some of the waves allow us to visibly experience luminosity, or light. We experience others as heat. Still others produce chemical actions that break down molecules of organic matter. From this we come to realize that all of existence is energy from the sun in some form or another. We ourselves are in essence frozen light.

Although we perceive sunlight as white, it is actually a mixture of seven different colors. When we let light pass through a prism, which is a triangular piece of glass that refracts, or bends, light, we can separate white light into these seven different colors of the spectrum. The original meaning of the word spectrum was "an appearance or apparition." Today, we use "spectrum" to describe the colors of the rainbow we see when we break up white light. In the natural world, raindrops can break up white light just the way a prism does into the phenomenon we experience as the rainbow. We perceive the rainbow as red, orange, yellow, green, blue, indigo, and violet.

We can endlessly describe and explain nature, but our primary purpose here is to inspire all artists to fully appreciate, in their own personal vision, the effects of its mystery and wonder, especially those of light. Once we consciously begin to experience our lives in terms of light, the ordinary becomes extraordinary. We notice and feel the physical world that light gives form to, and through the elusive play of light and shadow, we sense and respond to the magic light creates.

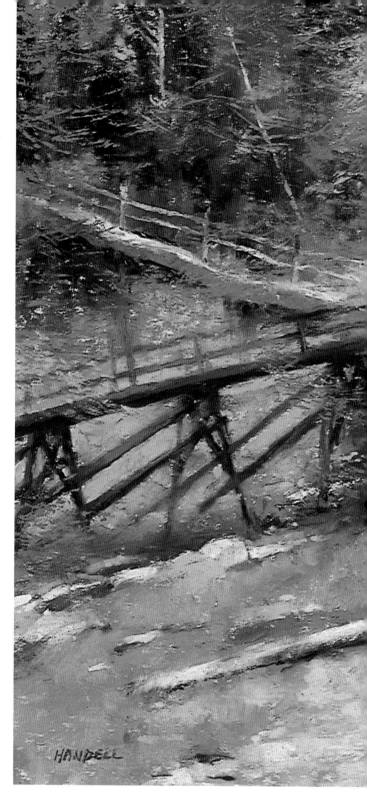

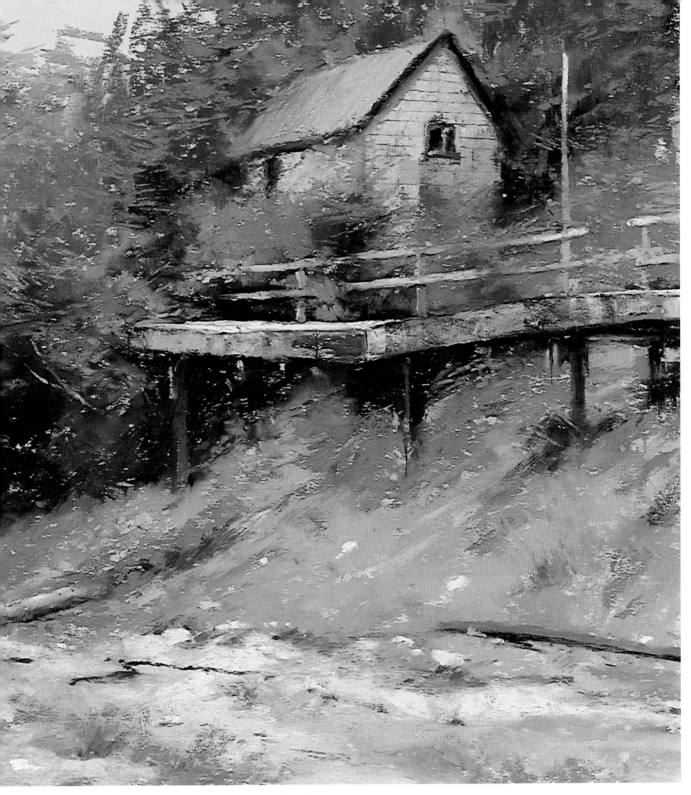

Baranof Island

Pastel on sanded board. 12 x 17 inches (30 x 43cm). Private Collection.

The sky was gray all day long, creating wonderful conditions to work in. The old, weathered boardwalk and boathouse stood majestically as time slowly took its toll. The sky clouded up for a while, but later in the day the clouds broke, releasing an incredible yellow that permeated down into the foreground greens. This yellow-toned prevailing light tied together the sky and ground in a way that made every element of the painting seem to belong there. As this completely unexpected light interwove in and out, it gave the scene a momentary sense of magic that only certain types of illumination can.

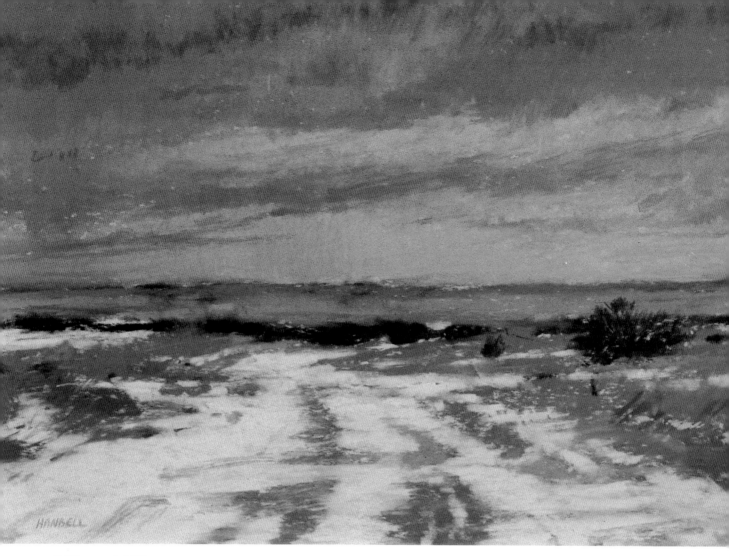

Miles and Miles

Pastel on sanded board. 11 x 16 inches (28 x 41cm).
Collection of Bill Standerwick and Karen Bond.

Sunsets are always magical. As I watch some, I often think that it would be difficult for the light to be any better. Here, the light had subsided a bit, and this painting shows the last quiver of a marvelous sunset. The warm orange of the sky complemented the cool colors of the rest of the scene. The strong lines of the horizon and the top of the mountain add a sense of weight to the earth as the colors interact.

Time Gone By

Pastel on sanded board. 17 x 12 inches (43 x 30cm).
Collection of James Roybal.

"Time Gone By" is a winter landscape of Nambé, New Mexico. The colors of the adobe and the surrounding earth and trees are warm and muted. The entire array of colors, from the rich red adobe to the warm yellows, to the winter grass, and to the white snow patches, provides variety and explains the lay of the land. There is a heaviness to the illumination in this pastel. The gray-purple color of the sky suggests this; it also complements the other warm, muted colors that weave through the painting and harmonizes them. The colors this magical light produces make this pastel sing.

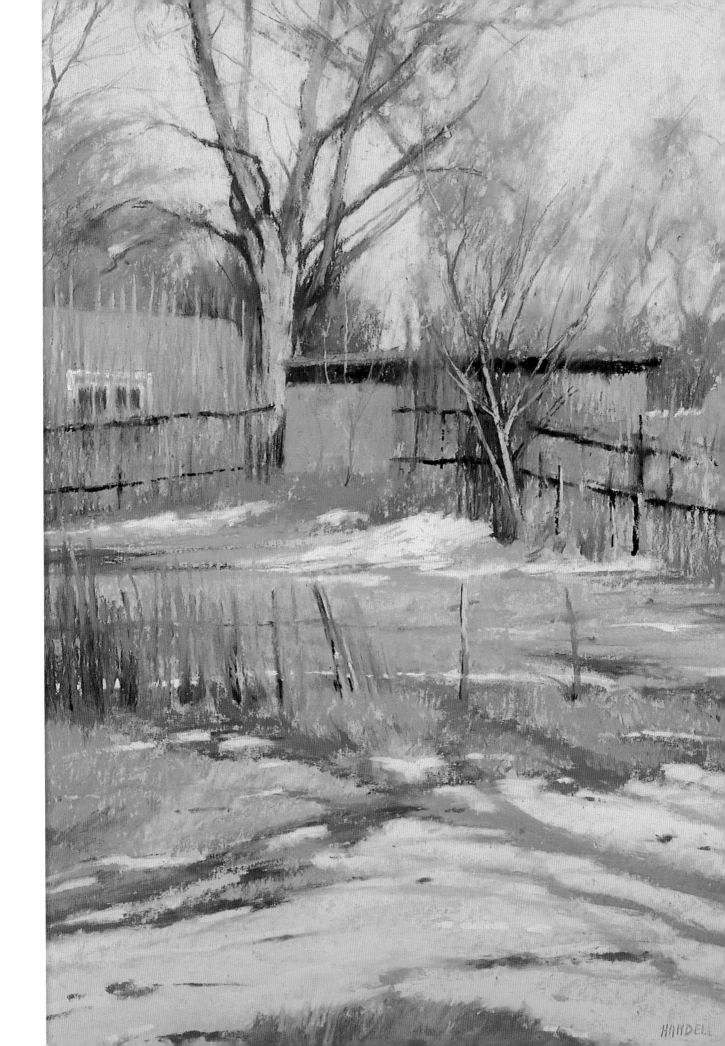

Perceiving and Interpreting the Physical World

The sun is luminous and gives off its own light. Nevertheless, its rays are invisible. What we see and perceive are the effects of light, which just eight minutes earlier was energy from the sun. The rays from this energy travel through space in straight lines. When they strike a surface, any surface, they turn back, like a ball bouncing off a wall. This bouncing or reflection is what makes the objects of the world visible. In order for us to be able to see light, it must be reflected off something. At times the earth's atmosphere distorts these rays; this occurs when dust and moisture particles are present. Air molecules in the atmosphere interact with the rays of light to produce the blue color of the sky.

Rays of light are, in fact, responsible for all the colors of the world. All objects are black in the absence of light, but each possesses certain chemical properties that reflect color in the presence of light. As a result of these qualities, light rays hitting an object are either absorbed or reflected. When we perceive the colors of objects, we aren't seeing what is absorbed but what is reflected. For example, a geranium is red because it has absorbed all the rays except the red ones, which are reflected back. When all the light rays are absorbed, no color exists and we perceive black. Conversely, when all the light rays are reflect-

ed, we perceive white. The myriad of colors that make up our visible world are created by the rays being reflected back into our eyes.

Keep in mind that light can't bend around corners. The direction of light can, however, be changed when it passes through transparent substances, such as water or glass. This is called refraction. When light illuminates objects, it bathes them in an overall glow. But when light strikes opaque objects through which it can't pass, the planes that aren't illuminated become shadows. The areas in light and the areas in shadow can be grouped together as patterns that, in turn, define the objects we perceive.

Sight is perhaps the most important of our senses. Nine tenths of the information we experience in the world is transmitted to our brains via light. From our earliest experiences, we learn to interpret the images sent to our eyes in relation to our sphere of experience. Visual images affect us deeply. They become a part of our memory and imagination. We recognize and understand them when we see them again. All of this is conceivable because of the existence of light. Going deep into the experience of light will strengthen, enhance, and support the reality of your perceptions, as well as your interpretations of the physical world.

Side Street

Pastel on sanded board.
7½ x 10½ inches (19 x 27cm).
Courtesy of the Ventana Gallery,
Santa Fe, New Mexico.

I enjoy painting complicated subjects that challenge my perception. "Side Street" is a good example of this with its white picket fence, warm adobe colors in light and shade, and the tree in the front yard that seemed to be taking over. The dark shapes of a side window and the front door, along with the suggestion of white pillars, add more color and complexity. Through the play of light, I discerned different greens surrounding the scene. I started with brown chalk and established all the elements of the composition immediately. Next, I put in the light-and-shadow patterns. Notice that nothing is brighter than the white fence. The unpretentious nature of this exciting subject initially drew my attention.

Tall Pines

Pastel on sanded board.
9 x 11 inches (23 x 28cm).
Collection of Harry and
Renata Berry.

This small pastel is part of a group of miniatures I painted one year. This pastel has a strong impact because I was able to capture a sense of tall pines swaying gently in a light breeze and bathed in afternoon light. The background for these tall pines is a cloudy sky that contains a great deal of gray and purple. This contrasts elegantly with the bright, soft yellows of the foreground field. The trees are located in the middle distance, growing out of what seems to be a broken stripe of greens. Abstractly, this division of space creates an arresting setting.

The Pink Adobe

Pastel on sanded board.
14 x 15 inches (36 x 38cm).
Courtesy of the Ventana Gallery,
Santa Fe, New Mexico.

This pink adobe is an old building with lots of lovely architectural detail. The strong contrasting colors of the scene compelled me to paint this pastel. I chose a closeup in order to achieve a dramatic composition and to bring out the rich, contrasting colors the most. The impact of the rich turquoise and cobalt-blue sky next to the vibrating pink adobe was stunning. The dark windows added weight to the building. The pink color of the adobe appears even more vibrant against the dark, blue-green shrubbery of midsummer. I designed and interpreted the local colors into rich, flat patterns that powerfully express the excitement I felt when I came upon this scene.

Reality and Illusion

When we look at the objects light illuminates, we perceive their color, size, and shape. We also sense their weight and perceive their position in space as their forms are modeled and defined through the everchanging play of light and shadow. And we recognize and understand these forms as the reality of our visual and tangible world.

When we look at an object, we see only a small part of it at one time. If we continue to look at it with fixed vision, the rest of our field of vision becomes blurred. Ordinarily, however, our eyes don't remain fixed on one point but move quickly over an entire area. As a result, the whole object seems to be in focus.

I paint realistically in a style of focus and suggestion. The moment of fixed vision, which reveals the center of focus or center of interest, can be seen clearly. The remaining field of vision is suggested. The sense of light and reality I can capture in this way has a believability that relates to human visual experience. I can achieve a softness to the sense of reality we perceive in direct experience through the effective use of the aesthetics of lost and found edges. Lost edges occur when weakly contrasting colors—colors that have similar values—are next to and touch each other. Here, the places where one color stops and another starts are softer, more difficult to discern, and harder to find. With found edges, contrasting colors that touch have distinct edges because they vary so radically in value. This differs photorealism in which everything in the final image is seen in detail, and viewers are led to believe that everything is in focus at the same time. A painting is then understood as an illusion of depth and space on a flat surface. As a result, by sensing how light defines forms, giving them shape and solidity, we can use our understanding and our feelings to create the illusion of the reality we see.

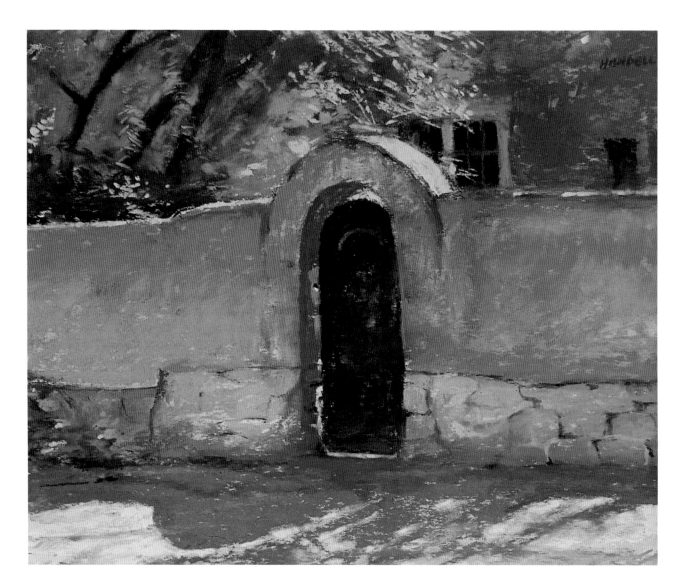

The Archway

Pastel on sanded board. 9 x 11 inches
(23 x 28cm). Private Collection.

The warm orange-pink colors of this adobe wall have a
special quality to them. The rich, dark browns of the
arched doorway, snuggled into the larger arch of the
wall, complement the wall's lighter, airier colors. The
midmorning light reflected in the adobe wall had such
a special glow that it had an almost illusory quality. A
short time later, the light changed, and the vibrant,
reflected colors in the adobe wall disappeared. The
sense of light that initially caught my eye was no longer
there. In this pastel showing architecture in overhead
light, the top planes—the archway and the sidewalk—
are the brightest planes. Here, I laid out the initial
drawing with a #346-P Nu-Pastel burgundy, which is a
warm reddish-brown color.

The Garden Wall

Pastel on sanded board. 9 x 11 inches (23 x 28cm).
Collection of Fred and Susan Harburg.

Here, the blue-greens make a striking contrast in front
of the pink adobe. I played down the darker shadows
on the adobe wall so that the greens would appear even
richer. The background remains just a suggestion, with
a glimmer of a yellow adobe wall behind the pink
adobe wall. At times, the sun struck the yellow wall and
increased the intensity of color I found in this scene. I
tied up the patterns of the bright yellow wall and the
bright yellow-greens of the ground at the bottom of
the pastel. By panning the subject as the light changed
and the colors shifted, I was able to focus on the illu-
sion in the scene. The physical appearance of the sub-
ject was altered, but the wall, the ground, and the
bushes themselves didn't move.

Light, Mood, and Feeling

Light is luminous and transitory, magical and elusive. It is difficult to separate it from mood and feeling. As light illuminates our experience of the world, it is an expression of who we are at any given moment. The amount and quality of light that we experience and that we let into our consciousness and expression reflect who we are.

Light is the essence we radiate from within. How we see and how consciously we use our eyes and feelings to interpret the visual world in artistic terms directly influence the mood and feelings we express in our paintings. The extent to which the outward light and the mood of a specific environment combines with the inner awareness of each individual artist is determined by a subtle interaction and dance. Consider the following examples. You would expect bright sunlight in a scene to inspire a cheerful mood; an overcast day, perhaps a somber or contemplative mood; and diffuse light, perhaps a mystical, ethereal mood.

Keep in mind that all paintings are essentially paintings of light. Whatever the subject, it is the light that determines the impact that a painting has. The type of illumination captured in a painting strongly influences its mood, feeling, and emotional quality, as well as gives life and meaning to the subject depicted.

Artists are always able to consciously choose the expression of the light in a painting. Nevertheless, although it may sound ironic, the choice may not always be a conscious one. There is much inside individual artists that determines how they paint light, whether in a high key or in a low key. Following your intuition brings this out. For example, I was moodier when I was younger. The low-key light I was working in had plenty of atmosphere to it and at times produced an unsettling mood. My colors were darker and thus heavier, which in turn made my subjects seem ponderous. This overall look reflected who I was during that period. Much time and many works have passed since then. Today, the light I achieve in my paintings is different. My works have more luminosity to them. Over the past 10 years that I've spent chasing after the elusive afternoon light of the southwest, draped in the atmosphere and moods that I encounter here, I've used a wider range of lighter colors. As such, my paintings are lighter emotionally.

The aspects of painting, light, mood, and feeling are always subtly interacting within each individual artist. They enhance each other and bring out each other's best qualities. Because of their interrelatedness, I don't see how they can be separated from the intuitive sensing of light.

Moody Afternoon
Pastel on sanded board.
15½ x 14½ (39 x 37cm).
Collection of Lee Wheless.

At times, overcast illumination can be dark and brooding. Here, it brings out the earth colors in front of the strong blue of a distant mountain. The cool light blues of the foreground snow complement these earth colors beautifully. The mood is quiet, and a slight midwinter chill hangs in the air.

June Afternoon

Pastel and watercolor on sanded board. 11 x 11 inches (28 x 28cm). Private Collection.

The light on this June afternoon was exciting. The sky was luminous and brilliant. I began with watercolor, letting the transparent washes act as a color base. I underpainted the sky completely using loosely applied blue and gray watercolors. When they dried, I worked into and over them with mauve and purple pastels to tie them up. I continued until I achieved the radiance I desired from the combination of the two mediums. I kept the ground simple and separate from the sky, and I used the trees as a border. For a sense of space and proportion, I included the adobes in the background.

Light and Artistic Vision

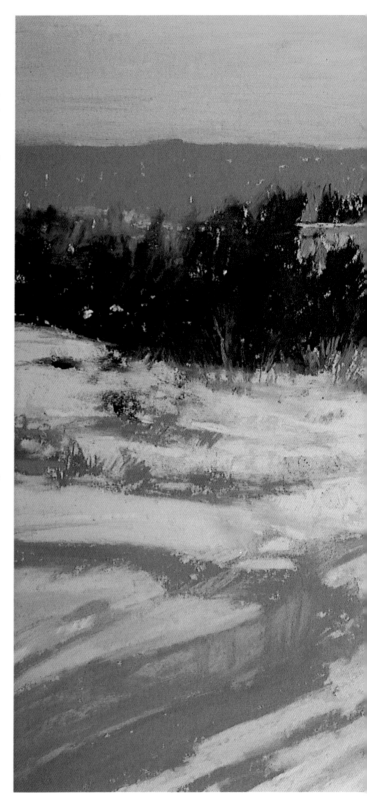

The world is an incredible place filled with limitless beauty and variety. Its rich subtleties are an endless source of inspiration to artists. Painters strive to capture a sense of the light of this visible world, internalize it, digest it, and express it in a personal way. Paintings that capture this magic and radiance are always special and have a life of their own.

Too often we take for granted the most wondrous things in our lives simply because they are there. Light illuminates our daily world, and so we function in it. But we can make the space in our lives to see more light, as well as to sense and feel more light and our deeper connection to it and the essence of existence. Light is an alive, everpresent, vibrating energy. When we allow ourselves daily quiet moments to stop, to look, and to feel, we begin to see more. And we begin to see more light. This can only serve to enhance your personal artistic vision as a painter.

Spend time experiencing light. Be reflective and really learn to see. Observe, sense, and feel the presence and effects of light. Return to favorite subjects in order to understand how they're illuminated at different moments. Experiencing light in this way will put you in touch with something deeper within yourself that will, in turn, begin to radiate in your works as your own vision, your own sense of light. Don't be afraid to let the experience itself guide you. Let each moment be a new discovery. The results may be a magic you never imagined possible.

Winter Blanket

Pastel on sanded board. 11 x 16 inches (28 x 41cm).
Collection of Patrick and Barbara McKee.

My reaction to the play of light in scenes like this is quite strong. I go on long walks in winter just to take in the feel of the light. Many of these walks inspire paintings. This is how "Winter Blanket" came about. Here, the warm oranges of the late-afternoon sky offset the rich blue hues of the distant mountain. The sky and mountains are framed at the base with the dark blue-green pinon trees and the light adobes, which create an appealing contrast themselves. I left the bottom half of the painting comparatively open. The large area of snow required details to provide contrast to the mountains.

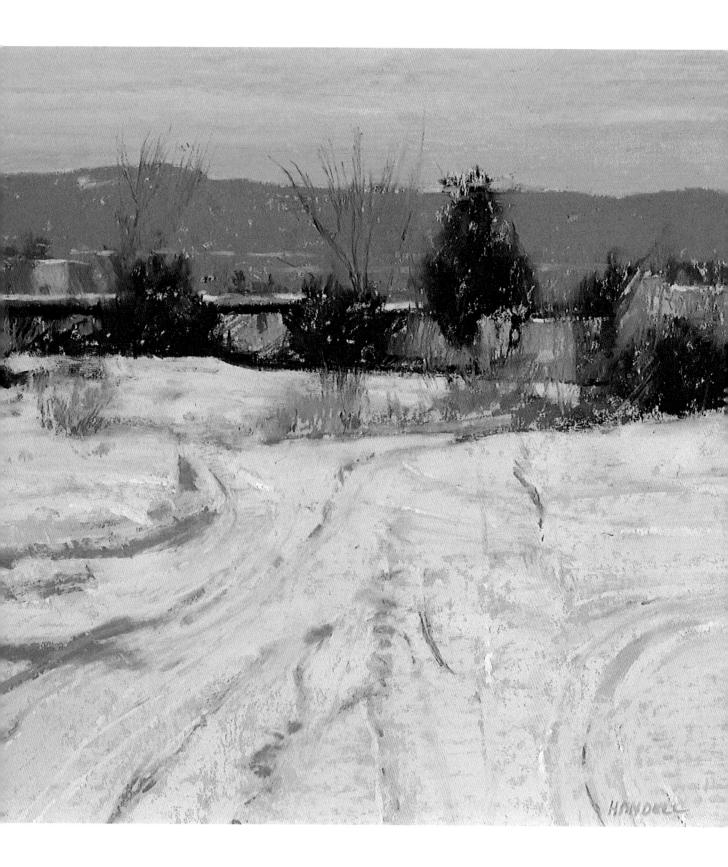

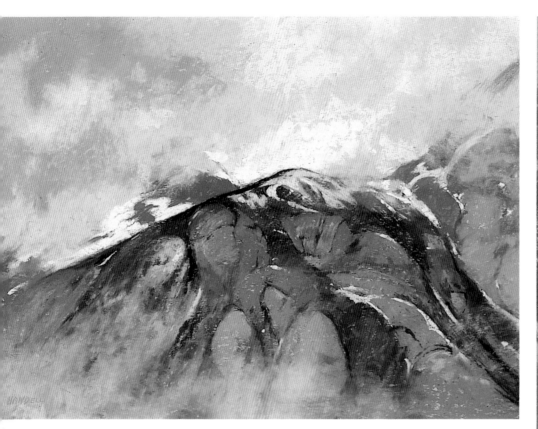

Foot Peak, Swan Lake

Pastel on sanded board. 12 x 17 inches (30 x 43cm).
Collection of Dr. and Mrs. Edward J. Urig.

In addition to the light in this Alaskan
scene, the dramatic combinations of the
clouds, mountains, snow, trees, and
exposed rock captured my attention. The
cloud patterns were constantly changing,
and at times the clouds covered a consider-
able portion of the mountains. At this
moment, however, they'd moved on, so
most of the mountains were visible again.
At times, the sun kept trying to break
through the clouds. When it did, the scene
became a breathtaking collage of light,
moving clouds, majestic mountains, and
lost and found edges. Each aspect was dif-
ferent and complementary in color and
texture. During the three hours I spent on
location painting this pastel, I saw hun-
dreds of possible paintings. Which moment
to choose is always a question. Remember,
your first impression is usually your
strongest.

Chamisa

Pastel on sanded board. 16 x 22 inches
(41 x 56cm). Private Collection.

On this brilliant, sunny morning of late
winter, the air was clear and cold, and the
chamisa was still dormant. The rich blues
of the sky complement the warm adobe
earth tones and the colors of the trees. The
lighter earth tones and the darker mauve
tones enhance the play of light on the sub-
ject. After suggesting the general tones and
colors of the subject, I moved from one
color to the next, and from one finished
area to the next. In this way, I was able to
compare and relate them to each other as I
completed the painting.

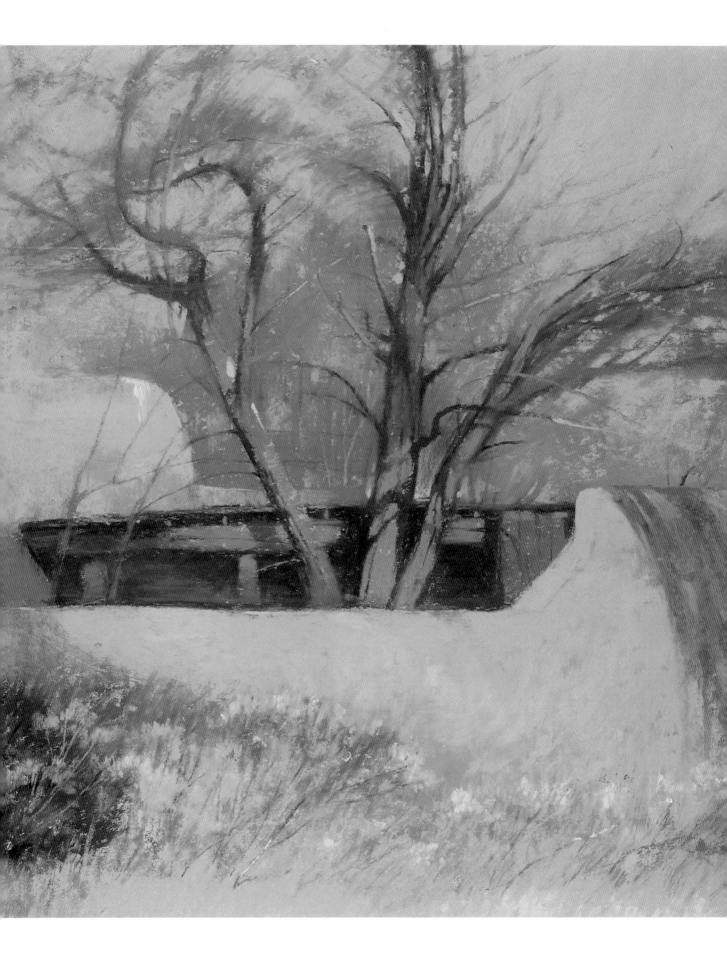

HANDELL

Part Two

THE NATURE OF LIGHT

Light is energy. It is alive, and it vibrates as it travels. Its omnipresence envelops and saturates the physical world. Light is radiant, elusive, and transitory. It is directional in nature and through its continual reflecting movement illuminates and explains our world. The position of a subject in relation to a light source, whether from the front, the back, the side, or overhead, adds a different dimension to each study of light and the objects illuminated. ❧ The essence of light is one, but its actions in the world are diverse. When we speak of light in artistic terms, we are aware of how the painter observes and feels how light creates the color, form, space, and atmosphere of the visible world. An artist may choose to spend a lifetime studying the beauty of outdoor light, from the lovely nuances of different times of day to seasonal changes of light and weather conditions. Indoor light provides another scenario and an entire world of study that can occupy a lifetime, too. ❧ In general, indoor illumination is often darker and more subdued than outdoor light, but the dominating sense of light's energy is still present. Understanding how patterns of light and shade are created and how their accurate massing solidifies the quality of light in a painting is also essential. Most important, however—no matter what the light condition you're drawn to paint—is to always be aware of the nature of light as vital energy. At times it can be soft, subtle, and echoing, and at other times blaring and obtrusive, but it is always ever-present, moving, ever-changing, and powerful in its statement.

Natural Light Outdoors

The most important aspect of painting in natural light outdoors is to remember that it is directional and continually changing. Patterns of light and shade can change dramatically, particularly on sunny days. Shapes discerned one minute can become hard to find the next. But on gray days outdoor illumination is relatively stable.

As the angle of the sun changes throughout the day, the color of the sunlight varies and, in turn, affects whatever it strikes accordingly. Early-morning light has a cool purplish quality; midday light, a bluish-white hue; and late-afternoon to evening light, a warm yellow-orange hue. The different angles of outdoor sunlight greatly alter the condition and colors of the sky and whatever clouds are present. The sky then influences colors below in a very direct way.

Seasonal changes of the angle of the sun also affects the quality of natural outdoor light. In winter, the angle is low, and the nuances of tertiary colors prevail; no strong primary or secondary color is predominant during winter. In contrast, the sun is directly overhead during the summer months, and the presence of green, a strong secondary color, dominates the landscape. By making the observation and study of light a way of life, you'll be able to expand the sense of light you capture.

MORNING LIGHT

Morning light, which has a clean quality, naturally begins at dawn. Early-morning light is present from about 5 A.M. until no later than 8 A.M. During this window of time, the sun is comparatively low, and the earth is still wet with dew and mist. As the sunlight is filtered through the vapors of this cool air, oranges, pinks, and purples are produced. There is also more reflection of light, and cast shadows are quite long. Then from about 8 A.M. to 11 A.M., the angles of light and shade change, and the morning sun moves on.

Atmospheric color is also influenced by the amount of moisture in the air. This is called aerial perspective. Suppose you're looking at a landscape. The closest red is the brightest, but its value changes as it recedes into the distance, going from red to gray to a greenish gray, its complement. Yellow drops off even faster than red, quickly turning from yellow to gray to a purplish gray, its complement. Dark blue holds up best; in the distance, this color looks gray with just a smattering of orange, its complement.

When you paint morning light, keep in mind that as the sun rises, its light is directed toward the earth from different angles, such as 20 degrees, 30 degrees, and 45 degrees. The sun reaches a 90-degree angle at the height of midday. Local colors are affected by the angle of the light. For example, green trees can appear to have a pinkish glow in the early morning. When the sun is higher in the sky than 60 to 70 degrees, which occurs at about 11 A.M., morning light has come to an end.

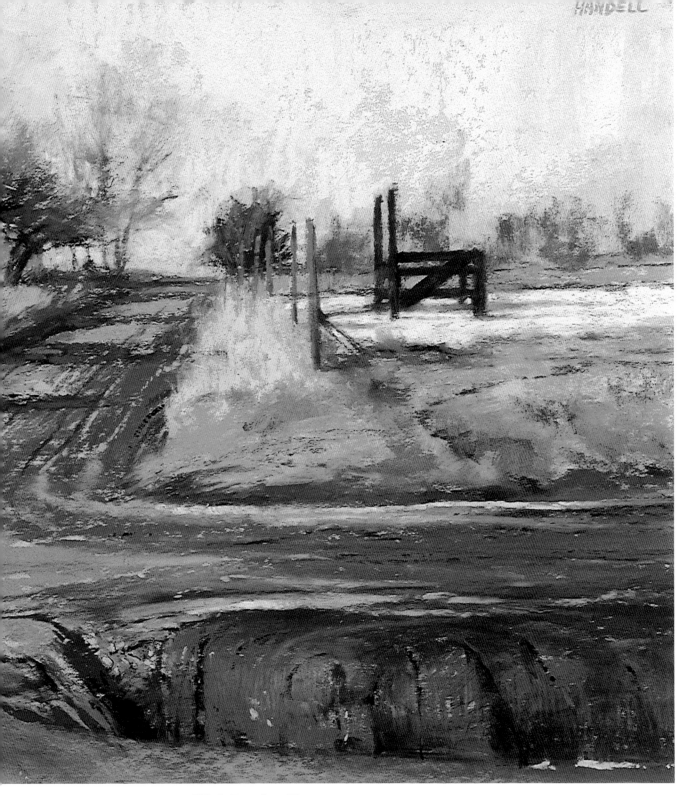

High Road to Taos

Pastel on sanded board. 12 x 17 inches (30 x 43cm). Collection of David and Gini Duval.

Here, the quality of the light suggests midmorning: the lights are bright, the night ice is melting, and the earth is wet and deep in color. Each and every area in this pastel can be seen clearly and exactly. The white overhead light from the sun renders pure colors. The melting ice has a bluish cast because light reflects into it from the warm, bluish-gray sky. At 11 A.M., the cast shadows were still long, but they weren't as long as they were when the sun was very low in the sky during the early-morning hours. The colors are rich and varied. When painting a large sky area as flatly as I did here, I turn to my Schmincke soft pastels. They are the most buttery pastels available today, and they cover surfaces best. For this sky, I used #65-O, which is the lightest blue-green color Schmincke makes, and #64-O, which is the company's lightest cobalt blue.

MIDDAY LIGHT

On a sunny day, midday light is basically an intense, direct overhead light. The upright planes are dark, but light reflections bounce off the ground and back up into the forms. As a result, the underlying planes are warmer and can be slightly lighter than the top planes. In addition, the cast shadows are short at this time of day, unlike the long shadows of late-afternoon light.

Midday light is beautiful and should be painted. The air isn't as cool as it was earlier in the day, so you don't have to contend with the color-altering properties of vapors. Although colors are truer at this time of day, midday light may not be the first type of illumination to work with if you're just beginning to paint. The pinkish-orange glow of early morning has disappeared, and the sun looks white. Other lighting conditions might be clearer to analyze and thus easier to paint. And in some instances midday light may be even more difficult to paint than early-morning or late-afternoon light. Midday illumination may not show a subject to its best advantage because the light itself makes such a strong statement. Furthermore, this light breaks up shadows, so you lose sight of subject shapes in the scene.

During the summer months, I love going into the woods at midday. From 11 A.M. to 3 P.M. in June, July, and August, the light is directly overhead and quite intense. It filters through the forest, showing us the yellow-greens of translucent light as it filters through the leaves and illuminating its top planes. The light then reflects off the forest floor and warms the bottom of the tree branches. The upright planes of the trees and foliage create dark, mysterious contrasts to these striking lights. I try to take advantage of the endless play of strong light-and-dark patterns as the midday light moves on.

I've also successfully painted midday light in urban areas. I remember the upright planes of doorways in various cities as being very dark and, once again, mysterious, with the steps and the top planes catching the light. Marketplaces at midday also prove to be interesting when bathed in strong overhead light.

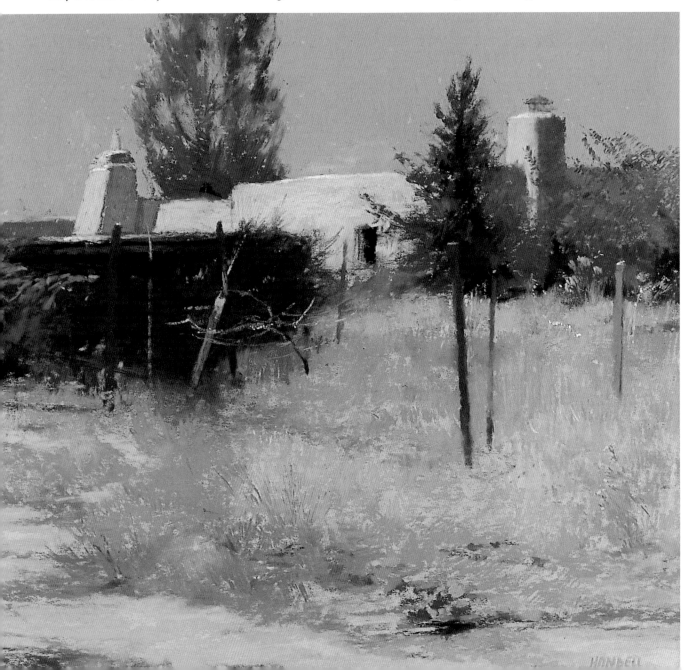

The View from Don Gaspar

Pastel on sanded board.
14 x 15 inches (36 x 38cm).
Collection of John Koontz.

This view is practically across the street from my studio in Santa Fe. I began this pastel late in the morning, about 10:30 A.M. or so, and continued working until 2:30 P.M. I usually prefer not to paint during these midday hours—and especially not during the intense heat of mid-June. However, this scene grabbed hold of my attention, and I was surprised to find myself painting in the midday sun. The light was so intense that I worked under a black umbrella. Overhead midday light produces very few cast shadows, so it has a distinct quality. The upright planes in shadow are actually the darkest planes in the painting. Because the ground planes received the most illumination, they are, therefore, the brightest, lightest colors in the painting. The sky is a deep, rich blue.

The Yellow Skirt

Pastel on sanded board.
14 x 22 inches (36 x 56cm).
Courtesy of the Ventana Gallery, Santa Fe, New Mexico.

Right outside my northlit studio in New Mexico is a lovely, secluded garden where I am able to work outdoors with models. In this standing pose, the sun hit the top of the model's head and her left shoulder. Her left hip also receives the light; the rest of the figure is in shadow. As the light bounces back up in midday light, strong reflections are thrown into the upright shadows. This raises the value of the colors, making them more luminous. The local colors are light. The flesh tones of the model's back contrast nicely with the dark tree and the adobe.

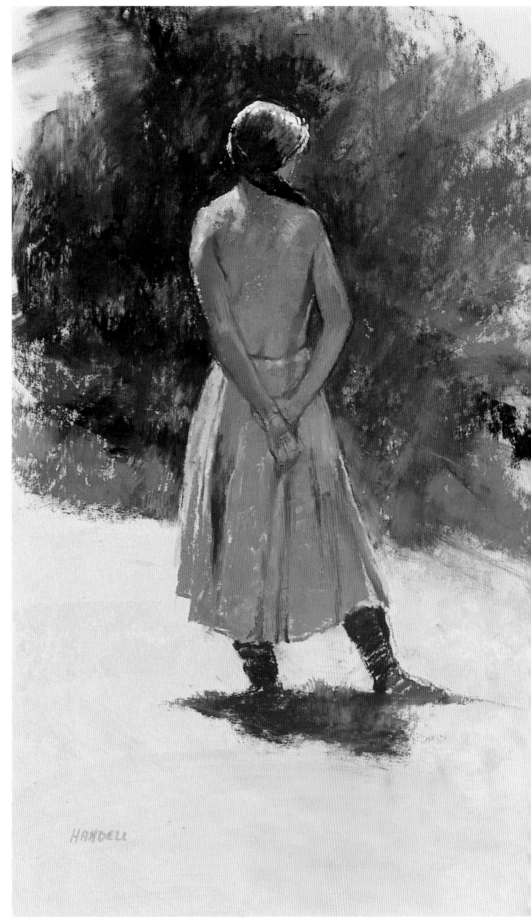

LATE-AFTERNOON LIGHT

Late-afternoon light is one of my favorite lights to paint, especially in wintertime. The earth bakes as the sun moves from east to west and vapors rise. Then as sunlight passes through these vapors, the orange light begins to glow warmly. You'll encounter late-afternoon light from about 3 P.M. to 5 P.M. during the winter, and from about 6 P.M. to 8 P.M. during the summer. Because the light is lower in the sky, long, cool shadows are cast. The upright planes facing the sun get more light and as such are brighter. Complementary colors come into play quite a bit as the sun gets more and more orange. There is also a blue quality to the shadows because of the blue sky. And there is a natural tendency for a subject's complementary color to slip into the shadow. For example, if you observed a yellow forsythia, you would notice purple in its shadow.

This quality of late-afternoon light is beautiful, especially here in the Southwest where there are adobe buildings made of the earth. I think of them as the earth standing up. There is a natural flow from earth to buildings. When the afternoon light comes streaking across the landscape and hits the adobe buildings, the upright planes stand out prominently, yet they are in color harmony with the earth planes. The pinks and oranges of the adobe are warmed up even more in this low-angled light. You can see the planes clearly, and no foreign local color to throw off your perceptions is present.

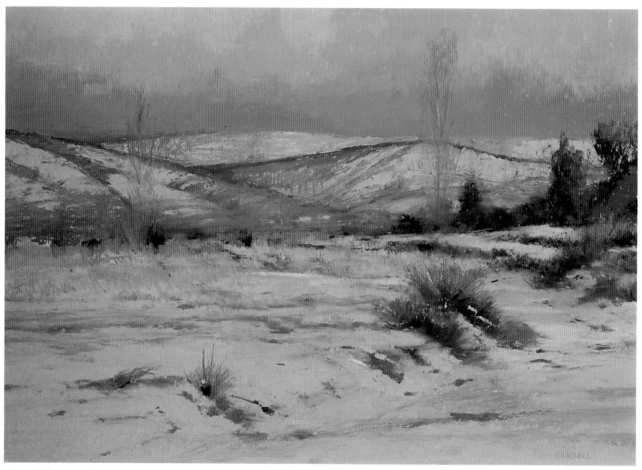

Sun Mountain
Pastel on sanded board. 16 x 22 inches (41 x 56cm). Private Collection.

As the sun sets during the late afternoon, the light is quite warm. Here, I used pastel tones to bring out the late-afternoon glow in the sky and on the distant mountain. Whatever isn't in sunlight at this time of day becomes relatively cool in color unless the local color is extremely light. This is why the winter grass in the middle foreground looks the way it does. The cool foreground colors provide an effective contrast to the warm, dark background colors.

OVERCAST DAYS

On overcast days, the sun is hidden behind cloud formations that cover the gray sky. What occurs when the sun filters through these clouds is similar to what happens when light hits semi-opaque frosted glass. The light becomes trapped, and the entire glass becomes a source of illumination. Local colors are truest when sunlight is trapped in white clouds. Furthermore, there may actually be more light, and more brilliant light, on certain overcast days than on sunny days. The clouds are illuminated all over. At other times, however, the cloud formations can be so heavy that an overcast day is quite dark.

Keep in mind that on overcast days when the sky is bright and luminous, it is usually the lightest element in the landscape. This is the steadiest kind of illumination an outdoor painter can work from. Also, because overcast light comes from above, the top planes in a scene are lighter than the upright planes. In addition, a full range of values and colors can be observed, and the local colors of objects can be seen at their truest. You should also remember that in overcast lighting conditions, colors get grayer as they recede in the distance. Dark colors get a touch lighter in the distance, while light colors get a bit darker as they recede.

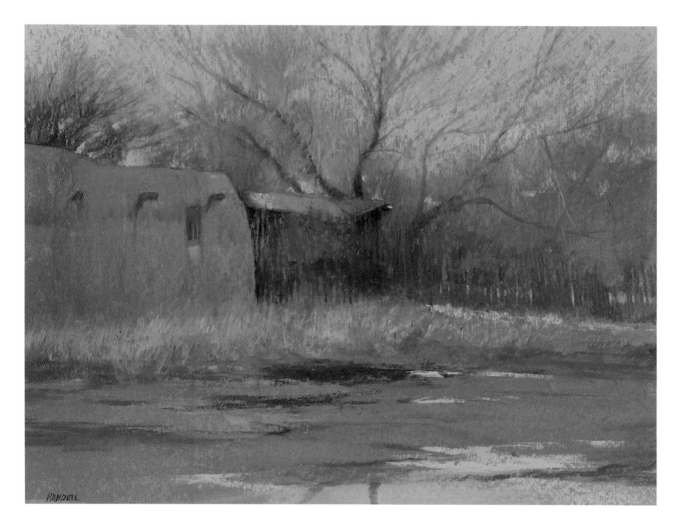

Gray Day in Santa Fe

Pastel on sanded board. 16 x 21½ inches (41 x 55cm). Private Collection.

I made this pastel from a photograph that was taken on an unusually dark, dreamy type of day for Santa Fe. The soft contrasts throughout the painting create this unusual mood. I kept the colors muted and low in key. The background trees are faintly suggested. The entire painting in general is dark and low in key, thereby providing a sense of the moisture in the air that accompanies this type of lighting. To capture this and to offset the warm colors of the rest of the pastel, I added some purple to the sky.

The Sky as a Source of Light

During the day, we're bathed in sunlight. The sky, the space in our atmosphere we tend to think of as empty, is actually filled with minute air molecules. New scientific discoveries tell us that waves of light traveling through space are scattered by these air molecules. As this action is repeated over and over again, it creates the effect of light we perceive as the blue sky. This color is altered at times as a result of several factors. These are: the interaction of the air particles and the light waves; the distance the light waves travel through the atmosphere in relation to the angle of the sun; and the quantities of other particles present in the atmosphere, such as fine volcanic dust or drops of water and mist.

On sunny days, the luminous blue sky becomes a secondary light source to the sun. You can observe its effect in cast shadows that lie on the ground, facing the blue sky. These shadows always have a bit of blue in them, which is a reflection of the blue sky.

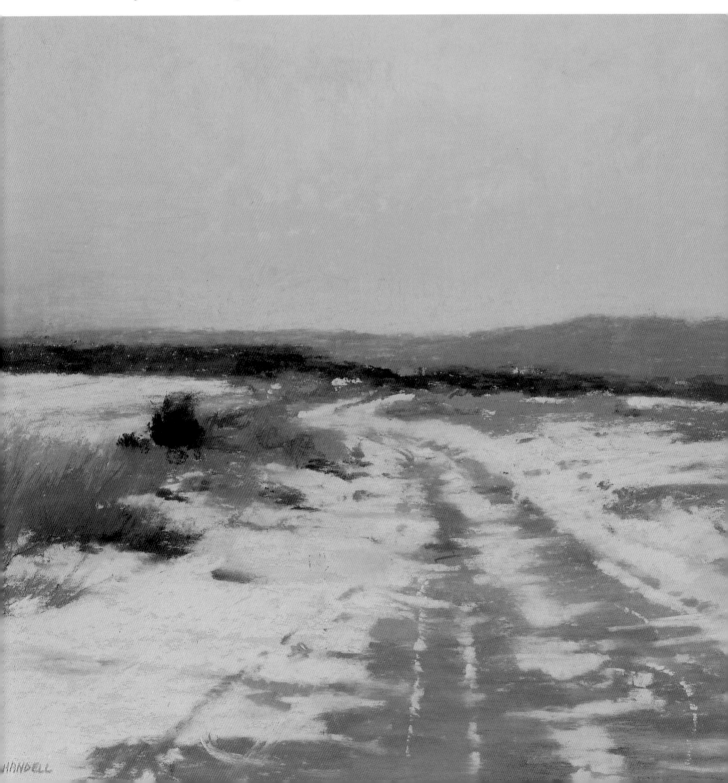

Seasonal Changes of Light

The angle of the sun produces the different types of light we experience as the seasons change. In the temperate climates north and south of the equator, these changes are quite pronounced and create a variety of lighting conditions throughout the year that provide artists with an endless source of inspiration. In the Northern Hemisphere, the longest day of the year is June 21, and the shortest day is December 21. Halfway between these two dates are the spring and fall equinoxes, which fall on March 21 and September 21, respectively.

Surprisingly, the sun is actually closer to the earth in winter, at a distance of 91 million miles than it is in the summer, at a distance of 93 million miles. The reason why the weather is hotter during the summer than the winter involves the direct angle of the sun to the earth. In the summer, the sunlight is more overhead throughout the entire day. But the low angle of winter sunlight makes it so cold and yet so beautiful to paint. During the winter months, you can paint at practically anytime during the day. I don't find the same to be true during the summer. I prefer resting from 11 A.M. to 5 P.M. during the height of the summer months and painting earlier or later in the day, when the cast shadows are longer.

SPRING

Spring and fall are the transitions between winter and summer. During the early spring, I'm inspired by the way the winter colors are heightened by the light yellow-greens of the new growth. Then, when you add to this the delicate colors of blossoms and the changing angle of the light as it begins to get more intense, a whole new visually exciting world lifts the long mantle of winter light.

SUMMER

During the summer, the illumination from the sun is an intense overhead light. Fortunately, the summer is also characterized by an abundance of green foliage that absorbs this harsh light and infuses the landscape with a beautiful density. Be aware, however, that because of all

Magic Moment
Pastel on sanded board. 14 x 14 inches (36 x 36cm).
Collection of Leslie Trainor Handell.

Here, the sky is full of color that harmonizes the entire painting. The purple below the sky is a contrasting color, but it harmonizes with the bit of light purple at the base of the rich greens in the sky. All of the elements in the bottom half of the pastel, which include the snow and the road leading into the distance, contain colors that reflect the colors of the sky. This is because the sky itself is a source of light. As the color of the sky changes, the colors reflected in the foreground also change.

the prevailing greens the colors of summer are darker than those of winter. At times, the dominance of this green cast can be overpowering and can prevent you from seeing many of the subtleties of the landscape. Although some painters feel that this strong color cast can overwhelm a scene, I love painting the intense variations of these rich yellow-green and blue-green colors.

FALL

Early autumn is the culmination of the year's greenery. Depending upon where you live, by early September, the lush blue-greens of midsummer may not be as vibrant as they were in July. The trees and bushes aren't as dense because of wind and erosion. Then suddenly a few weeks later, there is frost at night and the greens are no longer even there. A riot of color takes their place. In the Northeast, the leaves are bold reds, yellows, and oranges, while in the Southwest, brilliant yellows predominate.

On September 21st, the first official day of autumn, the sun is lower in the sky than it is during the summer as it approaches the shortest day of the year. The sun has moved to a more visually pleasant angle. Then as autumn progresses and after its most intense and colorful days have passed, the light gets even lower in the sky and softer. By November, you once again see your first glimpses of the winter landscape. It is quiet and cold, and the beginnings of pearly gray days are discernible as the light weakens and the cycle of seasonal light changes continues.

WINTER

The low angle of the sun in winter creates a light I find conducive to good painting practically anytime throughout the entire day. The rich greens of summer are gone, leaving the delicate mauves, grays, browns, and muted reds and greens of winter. There is a comparative softness to winter light, although this can be deceptive on a bright sunny day. The light seems brilliant, and the color of the blue sky is rich. Snow always adds an exciting element to the winter landscape, whether it takes the form of a blanket of snow revealing the shapes of objects more forcefully, or the beautiful patterns created by patches of melting snow.

I love trees in winter. Their growth and rhythmic movement visible in skeletal form can be easily studied during this season. The colors of the trunks change throughout the length of the trees, making for a beautiful variety within a limited range, all harmonized within a contained area. At the bottom of a tree trunk that is all in light, you see a dark brown tinged with purple, while the upper portion of the trunk is light tan. I enjoy observing trees at this time of year so much that I'm convinced that you can't fully appreciate or understand trees unless you first study them during the light of winter.

Around the Corner

Pastel on sanded board. 9 x 11 inches (23 x 28cm).
Courtesy of the Ventana Gallery, Santa Fe, New Mexico.

This pastel captures the promise of spring, which is visually an
exciting time of year. The season's new growth is visible in
the reddish tips and branches of the trees. Soon, light-yellow
and green buds start opening up on the branches and twigs
of the trees, covering their skeletons with a new mantle of
green. For a few weeks during early spring, however, trees are
still as separate and distinguishable as they are in winter. And
the light that illuminates them is still soft because the sun is
only beginning to approach the overhead angle present dur-
ing the summer.

Lush Green

Pastel and watercolor on sanded board. 12 x 17 inches (30 x 43cm).
Collection of Donald and Peggy Krasner.

During the summer months, the sun is directly overhead, and
at midday its light is intense. At this time of day, I like going
into the woods to paint. The forest canopy provides relief
from the overhead illumination, and I can take advantage
of the many beautiful subtleties of green as the light filters
through the trees. When I came across this old, rural, white
house at around 3 P.M. one summer day, I noticed that it off-
set the surrounding greens. I did a great deal of preliminary
painting with transparent watercolors to establish the under-
painting for this pastel. After the watercolors dried, I worked
on top with pastel. Lots of transparent watercolor shows
through in the finished painting, giving a lushness to the
greens and a strong luminosity to the light. This combination
truly brings out the feeling of summer.

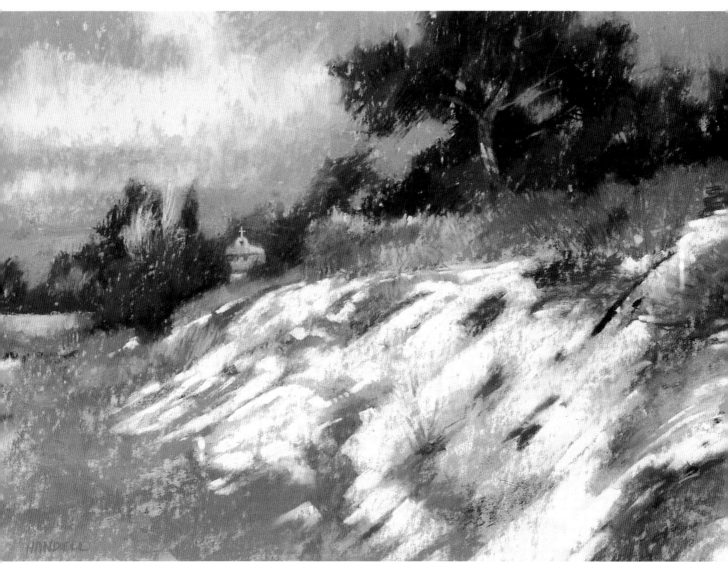

October's First Snow

Pastel on sanded board. 12 x 17 inches (30 x 43cm). Private Collection.

Autumn in the Southwest is interesting. Some of the green
leaves turn yellow. The aspen trees change, and in September
the chamisa flowers brighten the desert fields with mustard-
colored blossoms. Although the brilliant reds and oranges of
maples and oaks that blanket the East Coast don't exist here,
the angle of light on this desert landscape has its own special
beauty. And as the yellows and greens fall off and the land-
scape becomes more tonal in late October and early Novem-
ber, there is always a good chance of snow. This first snow
doesn't blanket everything; it is more of a patchwork-type of
snow, as this pastel suggests. The light is getting a bit weaker
as the silvery days of November approach. A gentle softness
illuminates the landscape with the distinct light of autumn.

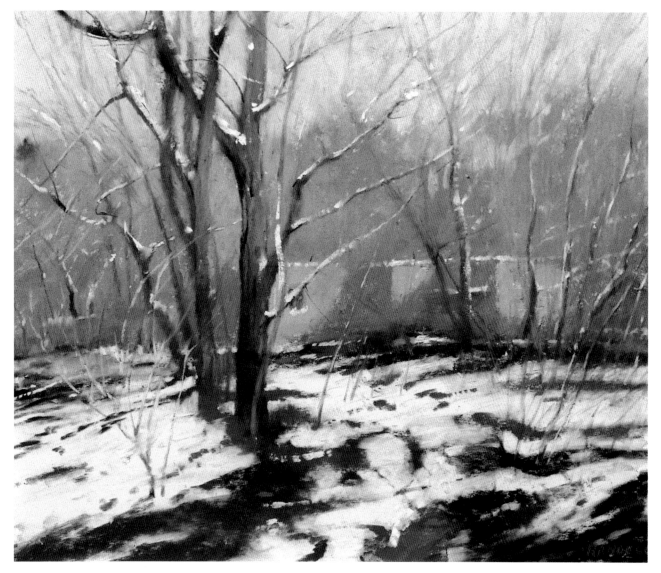

Approaching Storm

Pastel on sanded board. 9 x 11 inches (23 x 28cm). Private Collection.

Winter is perhaps my favorite season. The winters aren't
terribly cold in Santa Fe, so I am able to work on location
quite a bit. Snow enhances the grays, the mauves, and the
other tones of the winter landscape. The sun is low on the
horizon and gives off a gentle light, which is discernible even
on a gray day. Here, the moisture in the air is suggested. The
planes of the trees in the foreground of the painting are dark-
er than those of the background trees. The adobe colors
brighten the winter colors, thereby increasing the beautiful
quality of the illumination in the scene.

Natural Light Indoors

For me, natural light indoors in a studio usually refers to the light that enters from high windows that face north or from north skylights. This illumination is a cool, constant light that reflects from the sky and quietly drifts into the studio. Its resulting warm shadows don't change direction during the day; they just get less intense. To take advantage of this light, you need a northlit studio if you live north of the equator and a southlit studio if you live south of it.

What makes studio north light special is that it is steady and unchanging. It simply gets weaker, darker, and bluer as the day progresses. Of course, north light in the studio may at times get a little brighter or a little duller depending on the intensity of the sunlight or in the presence of a cloud cover. On a cloudy day, however, light is often brighter.

If light enters my studio in New Mexico from any other direction than north, the sunlight entering the room will produce different patterns of strong illumination as the sun moves throughout the day. At times, its brilliance will be overpowering. So, although a studio with light entering from the south, east, or west can work, painting under such conditions requires special considerations. The bright light doesn't work for viewing objects quietly and objectively, but it can be effective in other ways. Your approach to this type of painting should be similar to working outdoors since the light and shadows will move and interesting cast shadows will result.

In such cases, you can't move the source of light. You can, however, modify it. For example, you can place a lace curtain over a window to filter the light. And covering all or part of the window with white fabric or paper or a black drape will each have a different effect. White cotton traps the sunlight and allows a soft light to filter through, while black cotton completely prevents the sunlight from coming through. Here, you also need to think about the positioning of the subject, as well as whether it is being illuminated from the front, back, side, or above.

Geraniums

Pastel on sanded board. 16 x 22 inches (41 x 56cm).
Collection of Mike and Andraya Simpson.

Natural light coming indoors from a single source, such as a high north window, is directional and soft. It brings out the richness of colors, as well as the nuances of colors and values. This type of illumination also enables you to see objects clearly. Here, the light shows the planes and colors of the large geranium leaves beautifully. The finished painting has a fullness to it. The relationship of the leaves to the background is successful because the harmonious tones and colors make an ideal environment for the red colors of the flowers.

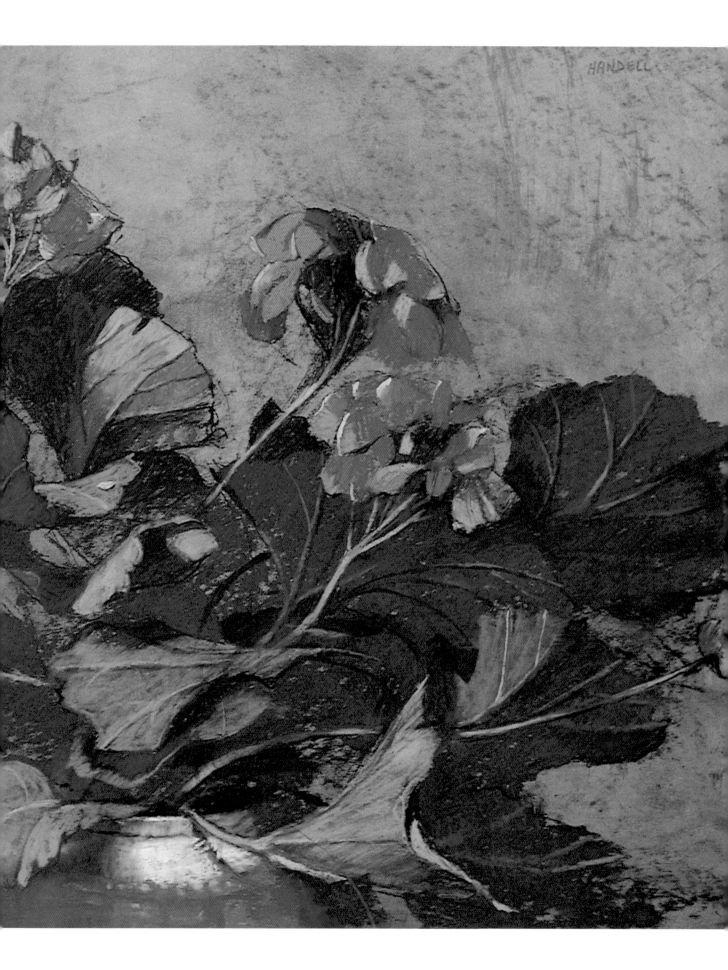

Artificial Light

In today's world, we may not always have the ideal studio we wish for, so we may need to—or choose to—paint in artificial light. While this kind of illumination can distort colors, it has the advantage of being a steady light source that you can control. I sometimes use 4-foot-long, 5600K daylight fluorescent bulbs because they have the full spectrum of natural north light. Keep in mind, though, that your subject and palette should be illuminated by the same type of light. If they are in different kinds of light, you might be thrown off and confused.

Furthermore, you can use artificial light to observe objects under different lighting conditions that you choose. For example, you can use a spotlight to analyze a still life under sidelighting, backlighting, frontlighting, or overhead light. In addition, by changing backgrounds you can study how the light is absorbed or reflected, as well as how the objects are seen in the image. Feel free to experiment and explore your options.

Another option is to add a table lamp to an indoor arrangement. The diffused illumination that reflects through the shade can enhance the light of a painting. Make sure that your light source is hidden by a shade or a cloth, and that you aren't looking into the light source itself. An incandescent yellow light will warm up your colors, while an ordinary fluorescent bulb will produce cool white or bluish-white light. Again, experimentation, observation, and following your feelings can lead to new and exciting possibilities.

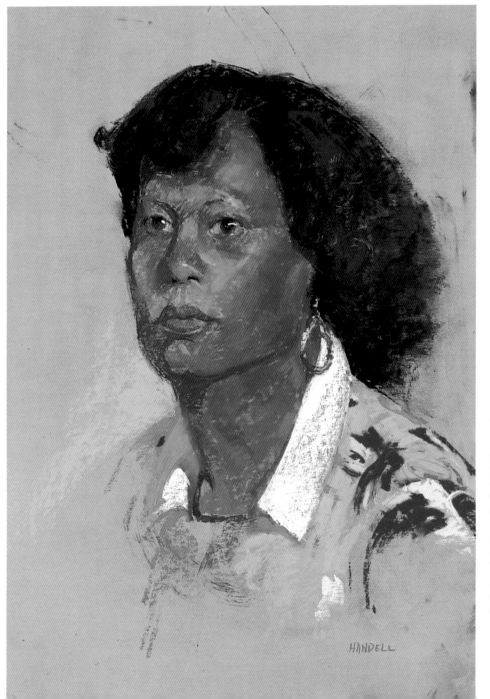

HANDELL

Portrait of Sylvia

Pastel on sanded board.
17 x 12 inches (43 x 30cm).
Courtesy of the Ventana Gallery,
Santa Fe, New Mexico.

In this portrait, the artificial light from an ordinary kitchen light bulb adds warm colors and an appealing glow to the model's richly colored complexion. The illumination also intensifies the colors here. The shadows, on the other hand, are not only darker, but also grayer and cooler because they pick up the coolness of the fluorescent light. As such, they provide a striking contrast to the warm flesh tones.

Winter Silence

Pastel on sanded board.
9 x 11 inches (23 x 28cm).
Private Collection.

Here, the late-afternoon light streaming in from the left illuminates the right side of the adobe quite strongly. As a result, the color of the adobe is reflected as pink in the bluish-gray cast shadows of the foreground snow. Notice that these warm, pink reflections in the cast shadow are near only the wall that the light is bouncing off.

Reflections and Reflected Light

Light is energy. It keeps moving, striking and illuminating whatever is in its path. Light reflects from all surfaces upon which it falls just as a ball bounces off a wall or a floor. It is this action of light that enables us to see objects and sense the space they occupy.

Reflected light is caused by light bouncing back into shadows from nearby objects. Areas of reflected light in shadow are higher in value than the shadow areas in which they fall, but they aren't as high in value as areas of color that the light source hits directly. Suppose that you have a ball suspended in the air, and light is hitting it from one direction. This arrangement leads to soft light, and a bright side and a dark side—a shadow. If you then moved the ball closer to a white wall, the light would pass the ball, hit the wall, and then bounce back into the shadow of the ball. This reflected light isn't as strong as the light hitting the ball directly.

Reflected light in shadows can be best seen outdoors in intense illumination, such as on bright, sunny days. Although all surfaces reflect light, smooth, shiny surfaces reflect more light and clearer images than matte surfaces. Under certain conditions, they'll even reflect or bounce back mirror images of nearby objects. Consider, for example, the smooth surface of water. When this surface is disturbed, the light is scattered and reflected in many different directions, thereby creating a distorted image. Keep in mind, too, that the colors in such a reflection aren't as intense as the source of the reflection itself. This is because the colors and value contrasts are stronger in the object itself.

The amount and intensity of the light reflected is influenced by the color of the object, too. White objects reflect a great deal of light and absorb very little. Conversely, black objects absorb more light than they reflect.

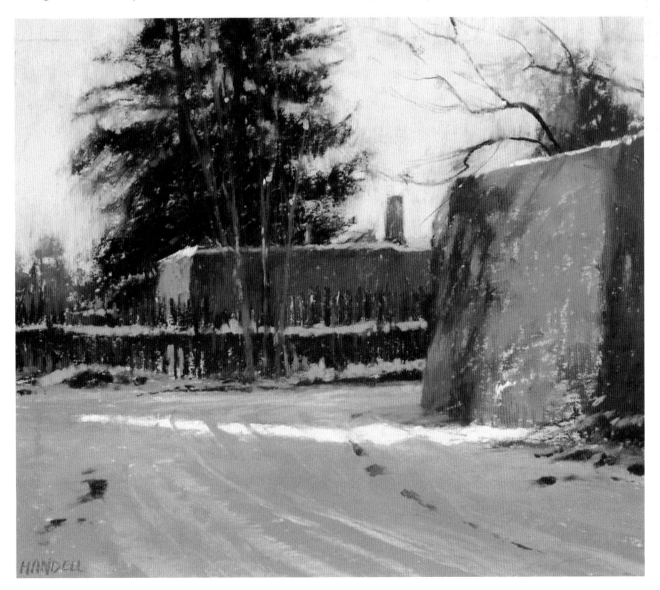

Pink Rocks

Pastel on sanded board.
12 x 17 inches (30 x 43cm).
Courtesy of the Ventana Gallery,
Santa Fe, New Mexico.

It is important for artists to
realize that as they work on
location, the type of reflec-
tion present can change dur-
ing the painting session. A
reflection can look like a mir-
ror image of a subject one
moment and a mere hint of
the subject the next. I paint-
ed this pastel from life at the
old millstream in Woodstock,
New York. Here, I kept the
suggestion of the reflection
to a minimum by using a
dark reddish-brown; I
believed that this approach
would work best for the
overall feel and sense of
light. This painting of rocks
and water borders on the
abstract. Its details are in the
rocks themselves. Their
reflection is suggested in the
water, which is basically a
shape of rich, dark colors.

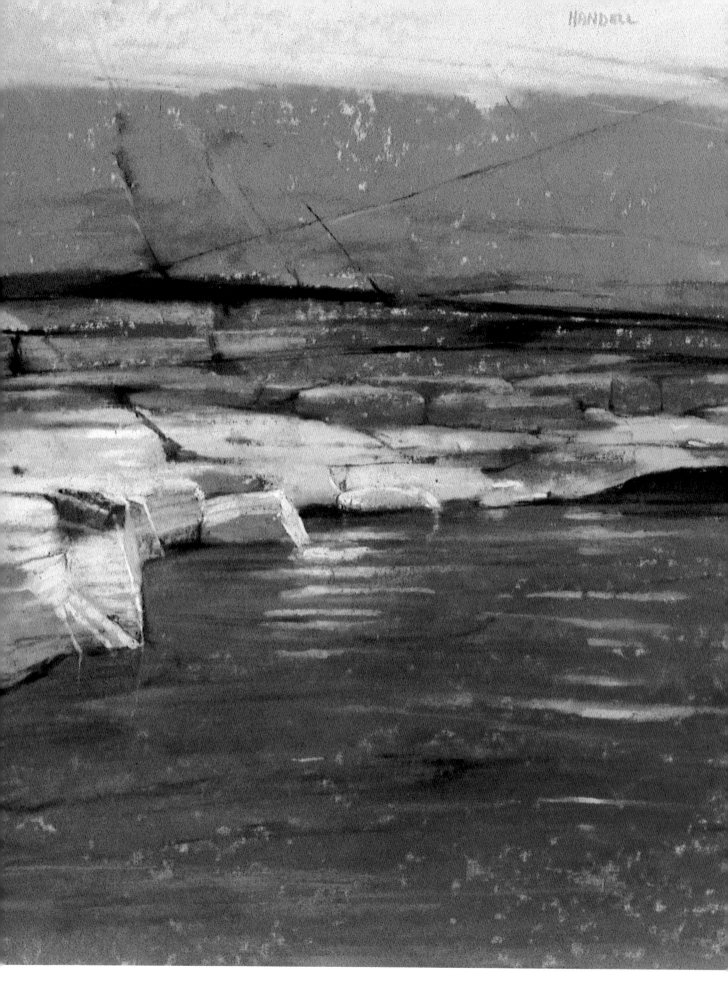

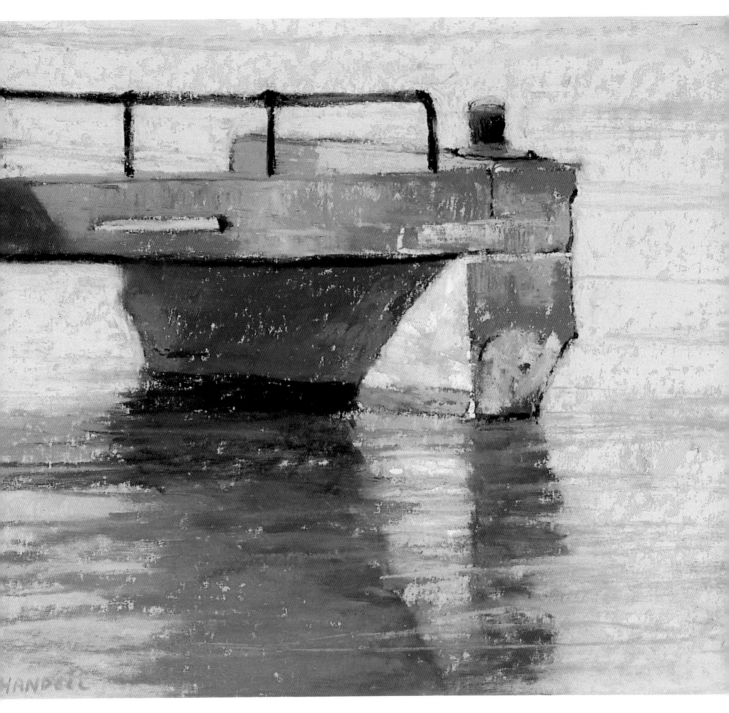

Micah's Pier

Pastel on sanded board. 9 x 11 inches (23 x 28cm). Collection of the artist.

I seemed to be having one of those days when, even with the best of intentions, nothing gets painted. I was with Micah, my 9-year-old son who is an ardent fisherman, at his favorite fishing pier in the Adirondack Mountains of New York. Suddenly late in the afternoon, I saw my painting as the sunlight hit a section of the old weatherbeaten pier with its reflections in the water. With only the last hour of sunlight remaining, I quickly got out my materials and started to work. I was intrigued by the light, colors, and details of the old pier and how they all meshed into muted colors as they reflected into the moving water. I began this painting by designing a shape on my surface that included the pier and its reflections. I considered them as one, despite the more contrasting colors in the pier itself. I made my initial drawing with #279-P Nu-Pastel cold medium gray because I wanted this image to be somewhat neutral, not too warm or too cold. I then interwove the subtle colors of the pier's reflections with the light and dark greens of the currents. These mirror-like reflections are elongated because of the low angle of the late-day light. Since I didn't want the darks to compete with the reddish band at the base of the pier, I subdued them a bit.

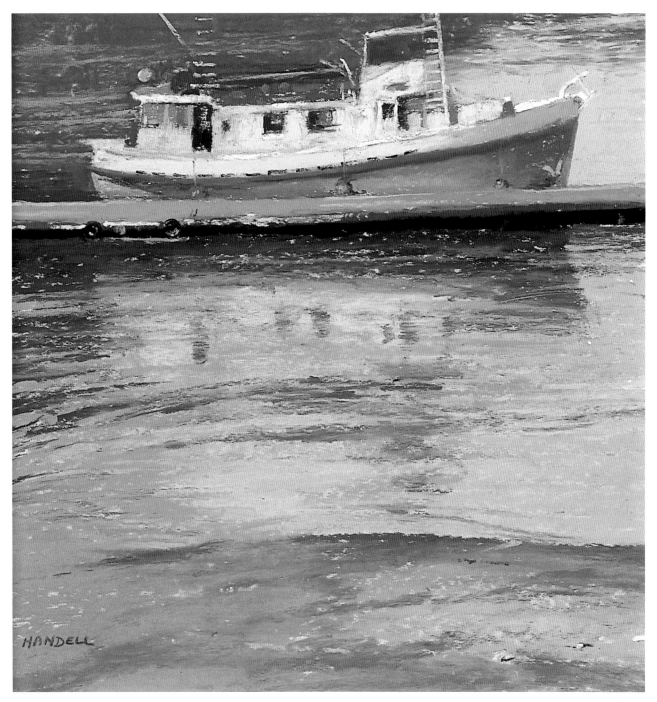

The Sea Comber

Pastel on sanded board. 10½ x 10½ inches (27 x 27cm).
Collection of Bob and Diane White.

While sailing on the Sea Comber on a painting trip in Alaska,
I found myself drawn to the ship and its reflections. I've dis-
covered that reflections in water vary from exact replicas to
mere suggestions of their source. This depends at times on
the stillness of the water. When the water starts to ripple, it
disturbs and fragments the reflection. This pastel conveys a
sense of both the reflection of the Sea Comber and the cur-
rent of the water. I had to delicately interweave these two ele-
ments in order to achieve the desired effect. I took soft char-
coal and lightly feathered the entire water area.

Understanding Shadows

Wherever there is light, there are shadows. Naturally, certain lighting conditions produce more shadows than others. The effective use of shadows can be as much a part of a painting as the successful depiction of the objects on which the light falls. Through these dark contrasting passages of shadow and light, a painting suggests the patterns of light.

The source of the illumination determines whether the resulting shadows are soft or hard. Shadows cast by objects struck by strong sunlight, which is a bright light source, have hard edges and rich colors, and are strong and clear. Shadows cast on a day when the sun is hidden by a thin veil of clouds are softer and less contrasty. This diffused illumination is quieter and more restrained than harsh sunlight, so the resulting shadows are more subtle and have blurred edges. And the colors it produces are rich in tone and truer to the actual colors of the subjects.

Objects in light throw cast shadows, which reveal a number of elements. They indicate the direction and angle of the source of the light. They also show the shape of the object that is throwing the cast shadow and the form or planes that the cast shadow is lying on. These shadows also give a sense of volume and form to objects within the illusion of three-dimensional space.

If the object in light that is throwing the cast shadow is close to the plane that is receiving it, the edges of that cast shadow are sharp, distinct, and usually quite dark. On the other hand, if the object that is throwing the cast shadow isn't nearby, the edges of the cast shadow are soft. This is because light filters into the space between the object and the cast shadow, making the shadow more luminous and lighter in value.

The Scottish Rite Temple
Pastel on sanded board. 12 x 17 inches (30 x 43cm). Private Collection.

One morning, I was entranced by this lovely park in front of the Scottish Rite Temple in Santa Fe, New Mexico. Here, the cast shadows reveal the time of day. You can observe the various angles of cast shadows as the sun's illumination changes throughout the day. The dark-blue cast shadows of the snow provide a striking contrast to the light, warm colors of the snow in sunlight. These cast shadows also delineate the shape of the ground they're lying on. In this scene, you can see that it is relatively flat because the shadows go straight across it from left to right.

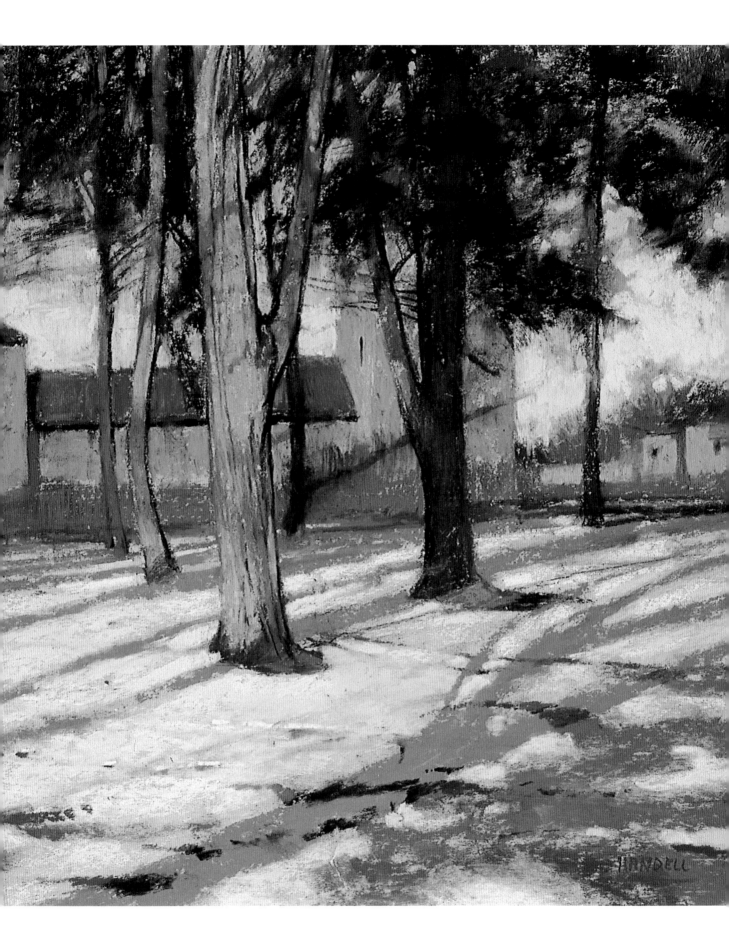

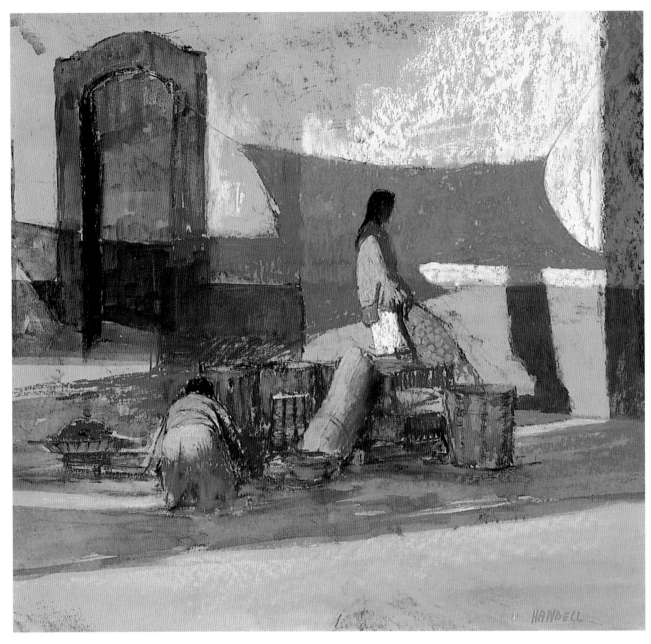

Time to Close

Pastel on sanded board. 15 x 16 inches (38 x 41cm).
Courtesy of the Ventana Gallery, Santa Fe, New Mexico.

Late in the afternoon, cast shadows are long and strongly
defined. Here, the low-angled light is streaming in from the
left. The cast shadows on the wall serve many functions. They
frame the young woman standing and the figures that make
up the center of interest. The cast shadows also indicate the
direction of the light source, as well as reveal the size and
shapes of the awnings that aren't visible in the painting. This
adds a sense of breadth to the borders of the painting. The
cast shadows that stream in across the ground help to create
the strong light that prevails throughout this painting. Finally,
they also help define the upright plane of the wall.

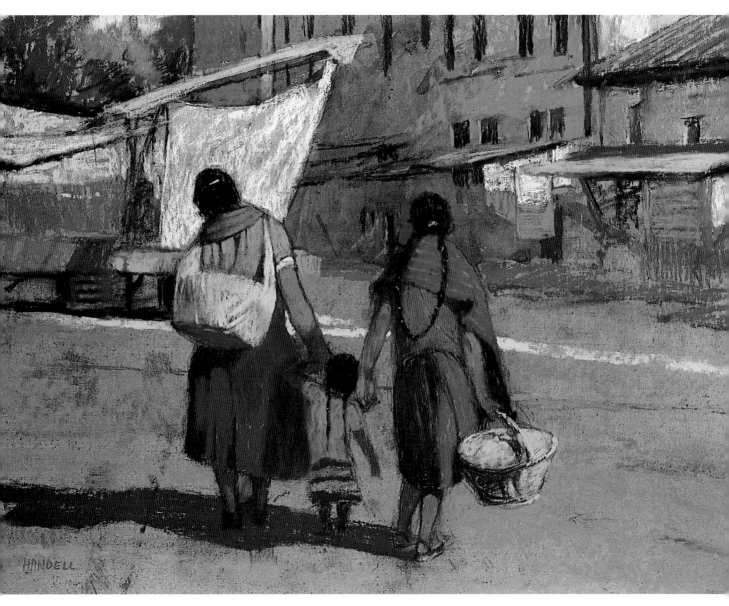

Enroute

Pastel on sanded board. 15 x 16 inches (38 x 41cm).
Courtesy of the Ventana Gallery, Santa Fe, New Mexico.

Here, two women and a child are en route to the central
marketplace in Patzcuaro, Mexico. The numerous cast shad-
ows in this pastel show the direction of the light. They also
add weight and interest to the figures. To get a sense of their
movement, I played down their feet to suggest and emphasize
the way they shuffled when they walked. Adding this sense of
motion draws the viewer's eye to the woman on the upper
left, who is rather tilted, and is framed by a hanging white
awning in sunlight. Comparatively, the woman and child on
the right are closer in value to the background cast shadows.
This creates lost edges and helps absorb these two figures into
the painting. Small touches of sunlight break up the cast
shadows, thereby suggesting the background market stalls to
the right.

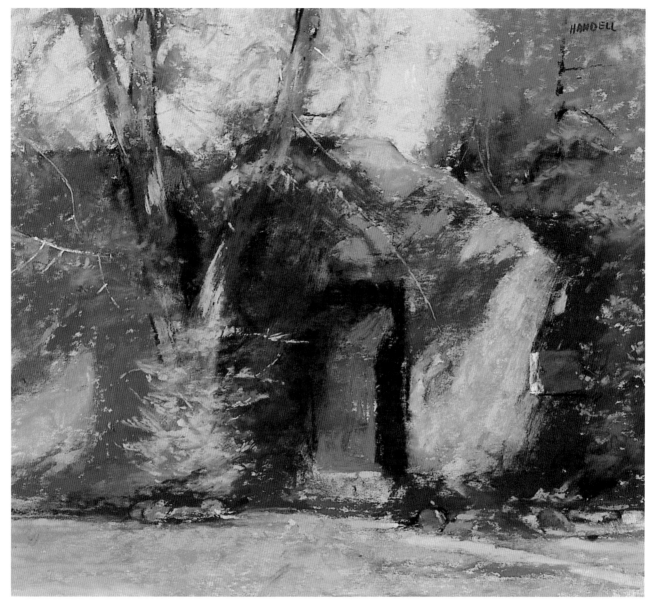

Shadowed Gate

Pastel on sanded board. 11 x 12 inches (28 x 30cm).
Courtesy of the Ventana Gallery, Santa Fe, New Mexico.

It is important to understand that shadows change con-
tinually, so that you aren't thrown off by them. Analyz-
ing and turning them into simple masses is essential.
The shadows in this painting not only suggest the
direction of the light, but also bring out the uncompli-
cated subject, a door and a wall with a tree in front.
But the intense illumination that casts strong shadows
makes the painting dynamic. When working with such
a complex play of light and shadow, you must establish
the strong patterns of shadow first.

Forest Defender

Pastel on sanded board. 11 x 9 inches (28 x 23cm).
Collection of Jochen Haber and Carrie Chassin.

This beautiful tree stands proudly, bathed in a wonder-
ful light. The shadows that surround not only frame
the tree, but also give a suggestion of the dense forest
behind it. In this type of lighting, it usually is best not
to look into the shadows for much detail. Instead, you
should simplify the shadows into patterns and play
down the details. I do this by squinting my eyes to
minimize details and to more fully observe the shadow
patterns. As a result, the shadows and the tree read
better and can be appreciated more fully.

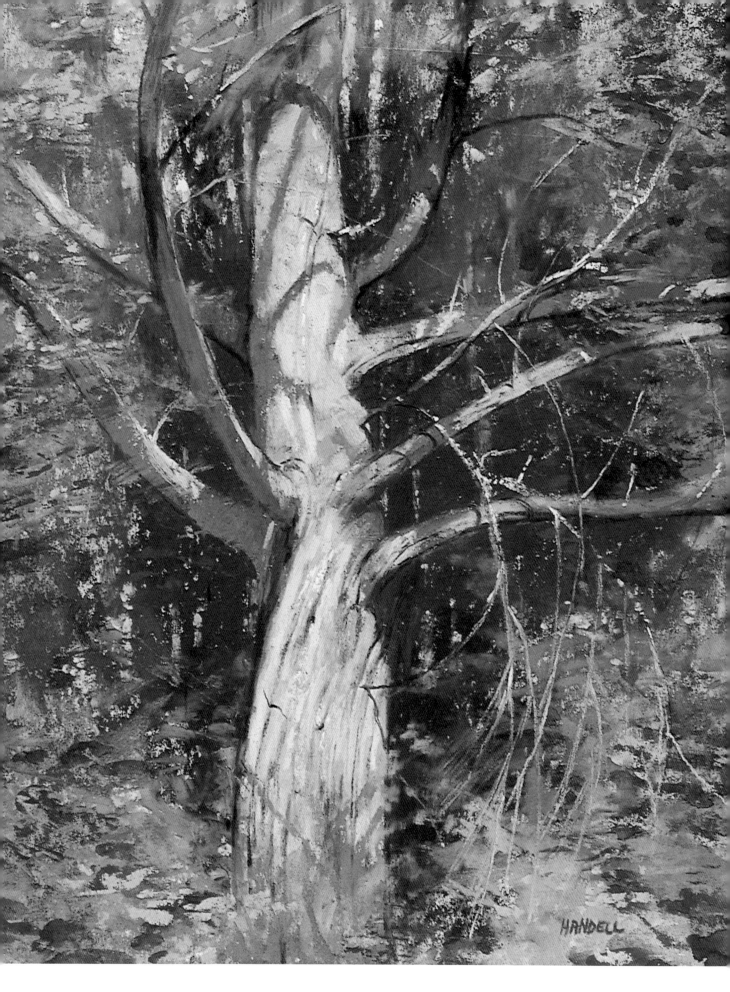

The Directional Movement of Light

As mentioned earlier, light is energy. As it travels, it illuminates the visible world we perceive. Light is never static; it is continuously moving. It bounces and reflects as it intensifies and gets brighter, and it diminishes and echoes as it gets weaker. These characteristics are true of both natural and artificial light.

As such, painters need to understand the actions of light that are predictable to some extent. In other words, artists should know how light acts in certain situations. But as with any rules, once you understand them and absorb them into your being and personal vision, you need to know when to bend them a bit. Stay in close touch with your reactions to the light you observe.

When objects are illuminated by light from one source rather than from multiple sources, the direction of the light and the directional movement of the light can be most easily observed and appreciated. The intensity of the light source and its direction affect both the atmosphere and mood of a subject and the impression of its form and substance. Remember, the earth revolves around the sun from east to west; therefore, the same objects look very different at different times of the day.

FRONTLIGHTING

With frontlighting, which is also called direct lighting, subjects are in front of the painters, and the light is behind them. Put another way, the artists are positioned between their subjects and the light source. The subjects are illuminated by a full frontal light, and there is little or no shadow. Here, you can see the forms of objects clearly. Strong local colors are also visible in their truest hue because they aren't in light and shadow; they are all simply illuminated.

In this lighting situation, the light illuminates and recedes as it travels farther away from the eye into the picture plane. The light becomes a little duller and a little weaker as it recedes. There are variations to this, but in general, flat frontlighting brings out the objects and their colors best in the foreground of an image and is less effective as it recedes. Here, your primary concern is determining how to effectively deal with the patterns and shapes of colors and values that make up your subject, not patterns of light and shade. Frontlighting, then, enables subtle movement of light and rich local colors to dominate a painting with only a modicum of shadow, if any at all.

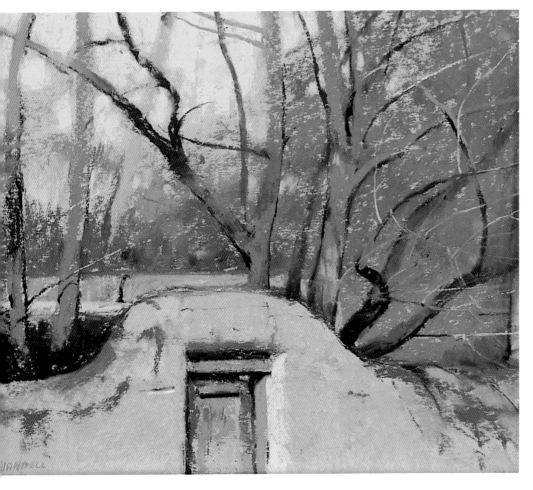

Delgado Gate
Pastel on sanded board.
9 x 11 inches (23 x 28cm).
Courtesy of the Ventana Gallery,
Santa Fe, New Mexico.

Frontlighting enables you to see objects most clearly because it produces very little shadow, so shadows and cast shadows rarely cut across the forms. This pastel is a good example of this lighting condition. The nuances of color changes are readily visible in this soft, gentle frontal light. The different local colors create the contrast in this painting. The light adobe walls stand out against the middle tones of the background trees.

SIDELIGHTING

In this lighting situation, which is also called halflighting, the source of illumination comes in directionally from the left or the right. As a result, subjects are usually in partial light and partial shadow. Sometimes the division is balanced perfectly, while at other times the ratio of light and shadow might be 60-40, 70-30, or 80-20. But whatever the proportions are, sidelighting always gives the subject both a light side and a shadow side.

This type of illumination creates strong patterns of light and shade and causes artists to carefully study each color as it moves from light into shadow. Start with the darkest color, observe how dark it is in shadow and how bright it is in light, and then paint it that the way. Repeat this process for both the richest color and the lightest color. The rest of the colors should then follow easily. On more rounded forms, you need to analyze the halftones of colors as the form moves from light to shadow. You can produce halftones by putting in the light first, then putting in the shadows, and finally by blending in the halftones. This can be quite exciting because sidelighting provides the subject with a strong sense of solidity and a three-dimensional quality. It also produces strong cast shadows that define the contours of the surfaces on which they fall and redefines the shapes of the objects that throw the cast shadows.

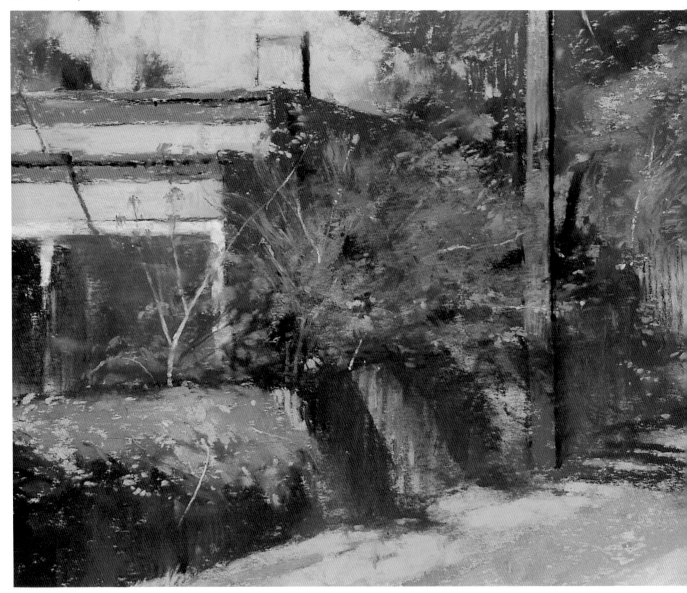

Mid Summer Morning

Pastel on sanded board. 9 x 11 inches (23 x 28cm). Courtesy of the Ventana Gallery, Santa Fe, New Mexico.

In sidelighting, one part of the subject is basically in light and the other part is in shadow. In this pastel, the front of the building is in light, and the side of the building is in shadow. This type of illumination captures the sharp angles of the building very forcefully. The distinct cast shadows show the direction of the light source, which was the midmorning sun of summer coming in from the left.

BACKLIGHTING

With backlighting, which is sometimes referred to as silhouette lighting, toplighting, or rimlighting, the subjects are between the artists and the light source. This positioning produces silhouettes and shapes of the objects in shadow, and their local color is somewhat secondary. The resulting shapes, which are determined in part by the lighting condition itself, are clear and dramatic. In these situations, the minimal amount of light that falls on the subject does so from behind and from the top. The upright planes are dark. Details are vague since it is harder to see details in the shadow areas than in illuminated areas. The overall impression is dark, and sometimes a halo effect is produced.

Backlighting can be very moody and atmospheric, and as such, it can create a sense of mystery. To achieve these powerful effects, you need to keep the colors darker and muted, playing down the details and edges within the silhouette. Allow the shape—the height and width of the subject—to dominate the painting. The light will hit the top planes, thereby producing strong edges that indicate the direction of the light.

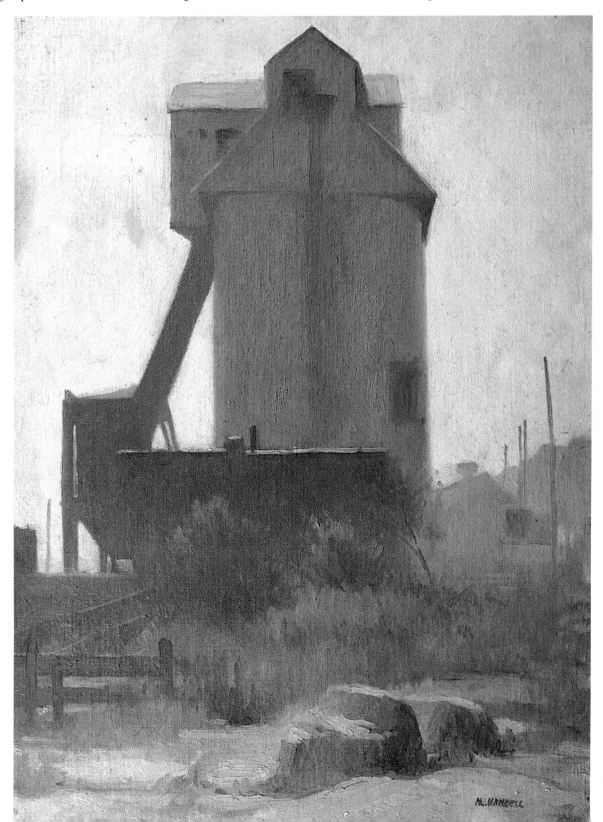

OVERHEAD LIGHTING

With overhead lighting, the light comes from above. Here, the top planes of the subjects catch the most light and the upright planes are darker. When working in overhead lighting, squint your eyes so the upright masses are more unified. Then looking into them, simplify them, painting them with softer edges. The top planes will stand out sharply as a result.

This kind of illumination works well for all subjects, but especially those with strong upright planes, such as city streets crowded with storefronts and houses. This lighting is so beautiful that in the past, many sculpture studios were traditionally illuminated with a soft, natural overhead skylight. The flat overhead lighting closely resembled outdoor light and enabled artists to see their subjects better.

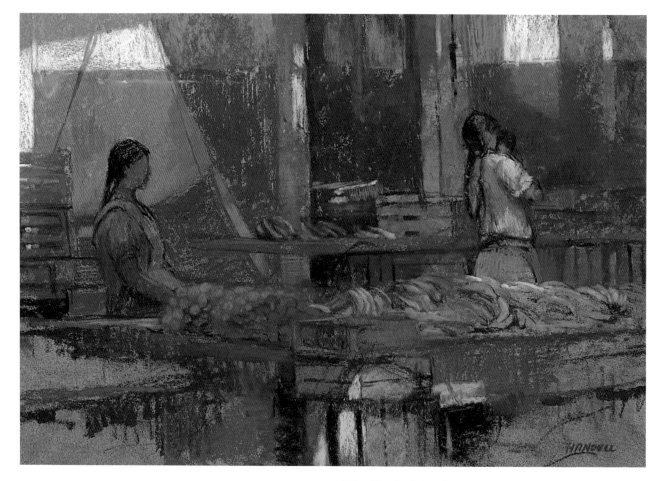

The Fruit Stand

Pastel on sanded board. 11 x 16 inches (28 x 41cm). Private Collection.

The overhead midday light in Mexican marketplaces can be intense. As such, vendors use protective awnings of many colors to block out the sun overhead and protect their produce. The red awnings in particular capture my attention because the translucent light picks up a bit of their color as it filters through and illuminates what is beneath. I had to paint all the local colors facing the awning with a bit of red in them. Everything takes on a reddish tinge, thereby transforming an ordinary scene into a visually extraordinary one. In this painting, the uneven overhead light is a little stronger in certain places. For example, it illuminates the bananas slightly more than the other fruit. A touch of yellow sunlight creeps into the lower part of the pastel, creating contrast as it illuminates the side of a wooden crate. Because of all the warmth in this pastel, I made my initial drawing with #263-P Nu-Pastel Indian red, which is reddish-brown, to harmonize the colors.

Coal Chute

Oil on canvas. 16 x 12 (41 x 30cm). Collection of the artist.

I painted "Coal Chute" on location when I was a young artist living in Brooklyn, New York. I found this chute in the Canarsie area, and I believe it still stands there next to the freight tracks. This looming structure had massive proportions and no frills. Painting it with backlighting brought out its character. I suggested distance in this painting by including the small house and the background trees to the right of the coal chute.

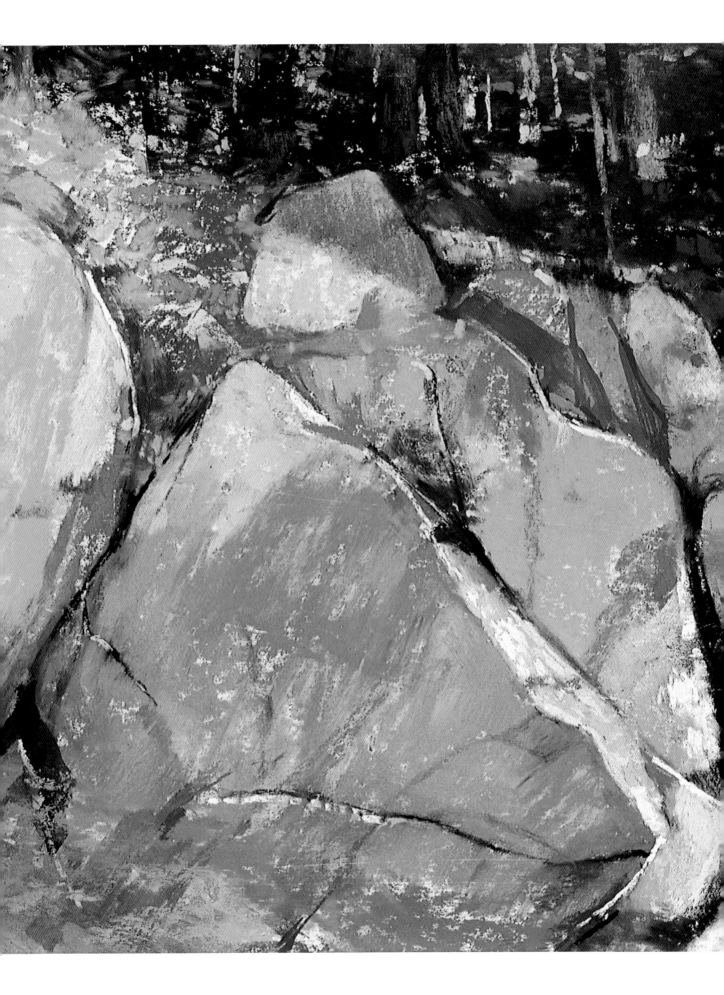

HANDELL

TECHNICAL CONSIDERATIONS IN PAINTING LIGHT

Each medium has its own unique properties to be appreciated and respected. Some mediums are transparent and permit the light to glow. Transparent watercolors are the best examples. If you prefer acrylics, you can thin them first and then apply them, like watercolors, in transparent color washes. Similarly, you can thin oils with turpentine. Although acrylics and oil paints are generally considered opaque mediums, they can show light in a dramatic way when applied and built up in this manner. The immediate dry medium of pastel, which is basically opaque, is excellent for quickly blocking in areas of light and dark contrast. Some techniques combine the two extremes of opaque and transparent colors, thereby enabling you to attain another type of beautiful lighting effect. ❧ Along with the characteristics of opaque and transparent painting, the tone and texture of the painting surface can combine to bring out various qualities of light. For example, transparent colors sing out more when applied to light-toned surfaces than to middle-value toned surfaces. You'll also discover that linen with a rough weave lends itself to opaque, thick applications of paint, while a smooth gessoed panel is better suited to transparent color washes. Obviously, you have a number of technical—and ultimately aesthetic—choices to make in order to effectively capture light in your work.

Painting Light with Oils

Working transparently with oils diluted with turpentine on a white ground creates bright, luminous areas of rich colors and dark areas of rich shadow. These transparent turpentine-oil color washes dry quickly on an absorbent ground. You can work endlessly and rapidly on top of this base, building and developing the painting. Thick applications of oil paints stay wet long enough to enable you to manipulate them until you're satisfied. You can overlay and repaint areas repeatedly or even scrape out entire areas. It is always best, however, to paint with a clear idea of your first impression in mind in order to achieve vitality and spontaneity in your work.

You can tone surfaces ahead of time when painting with oils. To do this, put down a middle-value tone, which can be either opaque or transparent. Later on, this can help to establish a uniform, low-key tonality that will maintain a harmonizing effect on all the colors of the painting.*(If you were to use a white ground, the resulting tonality would be higher in key and would produce sharp contrasts.) Palette-knife work and thick brush strokes can build up areas of opaque lights that will contrast with transparent dark areas. By doing this, you can quickly establish textural contrasts that suggest an immediate and strong sense of the light. Direct painting, scumbling, scraping, blending, glazing, and applying transparent color washes can be used alternately to create and change various lighting effects. (Scumbling involves applying a semi-opaque color over colors that are darker in value than it is.)

When glazing is done properly—the painting has to be completely dry for this—you can achieve rich, luminous, glowing color effects. This, in turn, helps capture light. When you apply transparent glazed color, underlying layers of color take on a deep glow. The beauty of glazing is that you can slowly build up desired depths of tone and the quality of the luminous glow in a controlled manner. Suppose that your finished painting has lots of white snow. You might decide to enhance these areas by applying ultramarine blue to them. Glazing permits you to make complete changes without having to repaint.

Blustery Afternoon

Oil on Masonite panel. 22 x 28 inches (56 x 71cm).
Collection of Charles and Beverly Rikel.

I painted "Blustery Afternoon" on a gessoed white ground, which was very absorbent and dried quickly. I used transparent oil-color turpentine washes at the beginning for the lay in. The light that illuminates the color goes through the paint and reflects back from the white surface. This initial stage has a luminous quality. I then used opaque colors that related in value to the transparent colors. I wanted to keep the painting high key since transparent colors are so much more luminous than opaque colors. This procedure enabled me to develop and resolve the painting without losing any of the luminosity I'd originally established.

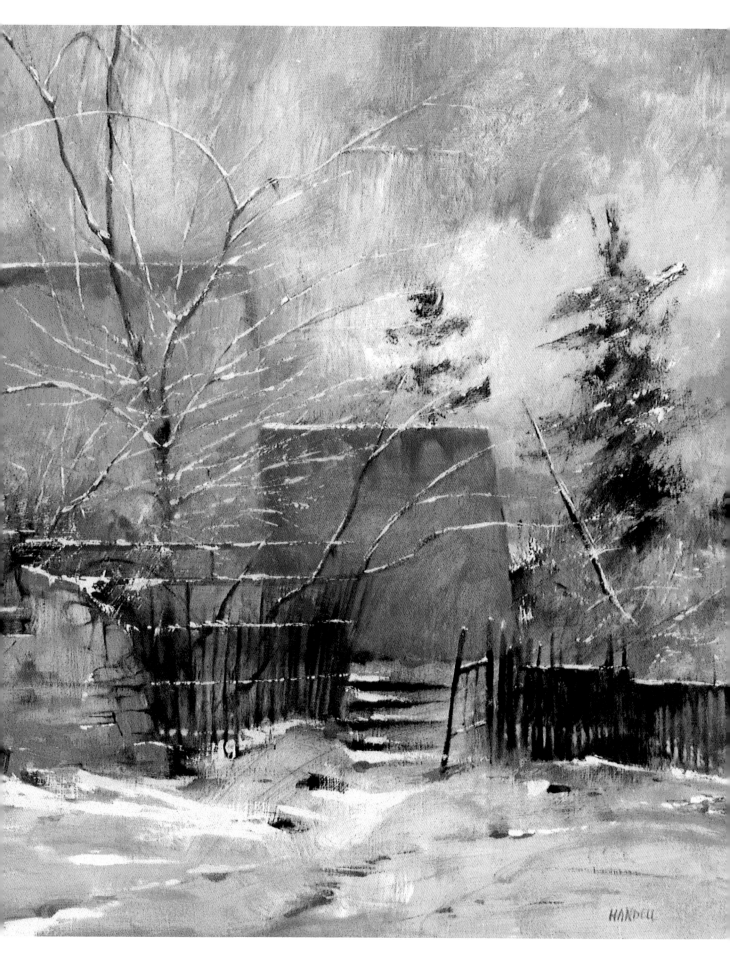

Painting Light with Pastels

Most pastel painters like to work on a toned ground. The choice of the tone used is an individual decision that requires a bit of thought. However, with or without a toned ground, pastel is an excellent medium for capturing light effects because it lets you quickly block in areas of light and dark contrast. You can utilize techniques, such as the bloom, feathering, layering, blending, or applying broken color within a mass, to vary the effects of light. Feathering, for example, makes a too-prominent object recede. And you can layer one color over another to make the bottom one warmer; for example, you can layer yellow over brown or green to achieve this effect. You may also want to try adding broken color to your painting. If you wanted to alter green, you could apply the same value of red or yellow to a small section of the green to enhance it.

The bloom is an especially interesting approach. It usually works most dramatically when you apply light-colored pastel over a dark ground. By varying the pressure on the chalk, you get different tones from the same color; the result is a lovely freshness in the light.

I have experimented with pastels extensively, applying them to both richly toned grounds and very light grounds. Different tones bring out different aspects of the paintings. I've found that when working on a middle-toned ground, I am able to establish contrasts of light and shade rather quickly, developing the color as I go. While working on a white or light-toned ground, I can obtain rich, luminous color by focusing on it first. I then work toward establishing the light-and-shade effect.

In recent years, I've started experimenting with transparent watercolor washes on light grounds. After I make sure the surface is dry—I don't want to scratch it—I block in large areas of color and paint them broadly with abandon. I allow the color washes and "accidents" to add to the texture of the painting. When these are dry, I then work on top of the underpainting with pastel. The result is a shimmering, radiant sense of light. I find that this technique comes in handy for summer scenes that contain an overabundance of green. Here, I use a reddish-brown base for green trees; the complementary color then shimmers through.

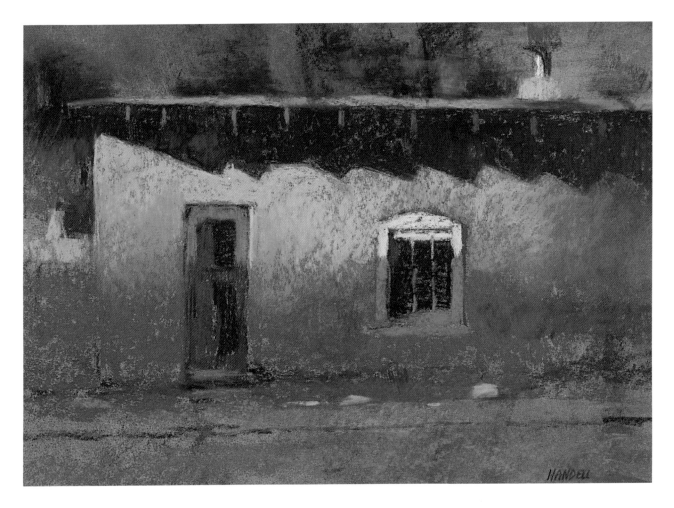

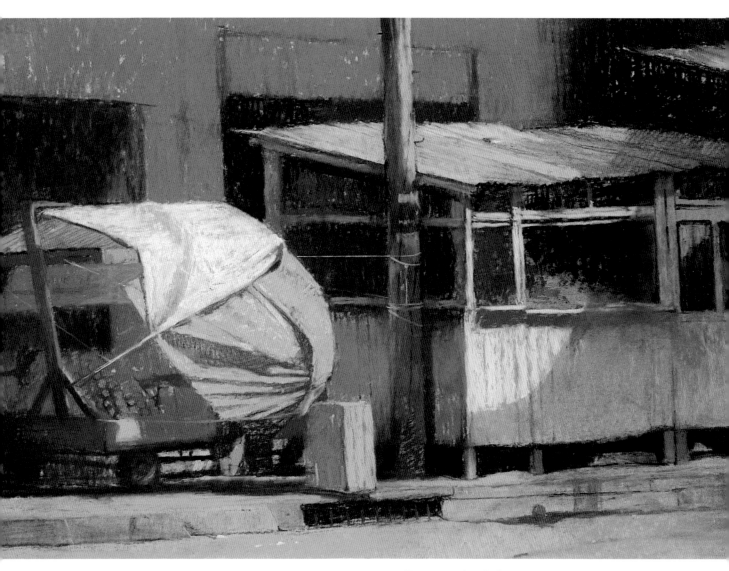

Oranges for Sale

Pastel on sanded board. 12 x 16 inches (30 x 41cm).
Courtesy of the Ventana Gallery, Santa Fe, New Mexico.

Here, by using pastel I was able to quickly develop the
color and the luminosity at the same time. This left the
background dark yet luminous with reflected light in
the shadows. First, I laid in a middle-value gray tone.
There is an appealing interplay of warm and cool colors
leading up to the bright-yellow tarpon in sunlight. The
bright-white tarpon resting on top of it brings out the
richness of its yellow color. On the left, the oranges are
also bright in color but are in shadow. This softens the
orange color and prevents it from competing with the
bright yellow. The subdued area of the shadows com-
plements the strong contrast in the lights, adding even
more excitement to the brilliance of the effect.

Behind the Rincon del Oso

Pastel on sanded board. 12 x 16 inches (30 x 41cm).
Courtesy of the Shriver Gallery, Taos, New Mexico.

Working on a middle-tone background permitted me
to quickly suggest the light and shadow of the adobe
building and the entire composition. The light on the
adobe is strong in comparison to the middle-tone
ground. To achieve this sense of light, I painted in the
darks under the roof. Next, I selected two or three col-
ors close in value for the illumination on the adobe
wall. By varying the pressure of these chalks, I was able
to marry these colors together and establish a sense of
light passing across the building. The strong contrast-
ing adobe colors enhance the beauty of the light and
allow the building to stand out strongly. The rest of the
colors of the pastel relate more closely to the original
middle tone.

Painting Light with Watercolors

The transparent nature of watercolor is excellent for capturing the special qualities of light. This medium is quick-drying, especially outdoors on sunny days. Watercolor can produce loose, carefree washes of color. And the most delicate of lines can be interwoven at the same time. Reworking in watercolor can be done, but it can be tricky. You must be careful not to lose the freshness of the initial response. When you apply wet transparent color washes over dried transparent color washes, you can achieve a very special sense of color and luminosity. You can also experiment with wet-into-wet color washes. Later, you can lift out areas of dry watercolor washes to brighten these areas.

Another unique quality of watercolor is that the unexpected can happen, producing lovely textural, luminous color and beautiful light—a sense of light you may not achieve even if you carefully plan your painting. For example, you can make a green tree more appealing by using a dark-green base and then dabbing the tree with a tissue in order to create texture. Pastels you may then choose to apply on top of this color will shimmer.

WATERMEDIA

Acrylics can be diluted and applied loosely and thinly as watercolor washes. Alternately, you can apply them thickly and opaquely like oils. Acrylics can be built up slowly by putting one layer of paint over the next. Their main advantage is that they dry quickly. Areas may be over-painted or glazed almost immediately in order to change the effects of light until you achieve the exact look you want. Sometimes, however, they may dry too fast, which can cause problems. It is, therefore, once again important that you work clearly and keep in mind what you hope to capture.

Capturing Light with Pencil and Charcoal

Most of the time, I draw with lines and tones. I keep the light lines for the light areas and use heavier lines for the shadows. This produces a simple clarity in the line itself that for me successfully captures the effects of light and shade. When applying tones of grays to my drawings, I can establish shapes and patterns of light and shade that add a beautiful sense of light. Sometimes I use the pencil eraser to gently blend the pencil lead on the paper in order to get smooth, delicate tones. On top of this I can add darker lines with an electronic scorer #350 pencil. Its versatile lead has a wide range of grays. I usually draw on two-ply Bristol board; the plate surface gives me sharp lines, while the kid surface produces lovely tones and shades of gray.

Growth

Watercolor on Bristol board.
10½ x 13 inches (27 x 33cm).
Private Collection.

The transparency of watercolor lends itself to showing light. Here, the energy of the growth and the patterns of the plant stand out distinctly from the white background. I made the initial stages of this painting in a straightforward manner. Later, I applied water to the already dried color washes and allowed them to run. This effect created beautiful accidents and contrasts in the light to the precise patterns of the leaves. Together, they add a special luminous quality to the light of this simple but compelling painting.

Portrait of Jane Goold

Pencil, soft charcoal and pastel pencils on sanded pastel paper. 20 x 14 inches (51 x 36cm). Private Collection.

Here, I worked with soft charcoal and an IBM electronic scorer pencil #350, making use of the beige color of the sanded paper. First, I established the grays and darks of the portrait. The model had reddish-brown hair, so I knew the tone I needed to translate it couldn't be too dark. After I made the general drawing of her features with charcoal, I then used the charcoal to block in the shadows. Next, I used two Carb-Othello flesh-tone pastel pencils, #29 and #26. With the darker #29 pencil, I was able to develop the midtones and tie up the light areas of the portrait, thereby giving it a good sense of light. I used the #26 pencil to bring up the lights, an effect which the portrait called for. I placed a final touch or two of white in the model's eyes to give the drawing extra sparkle.

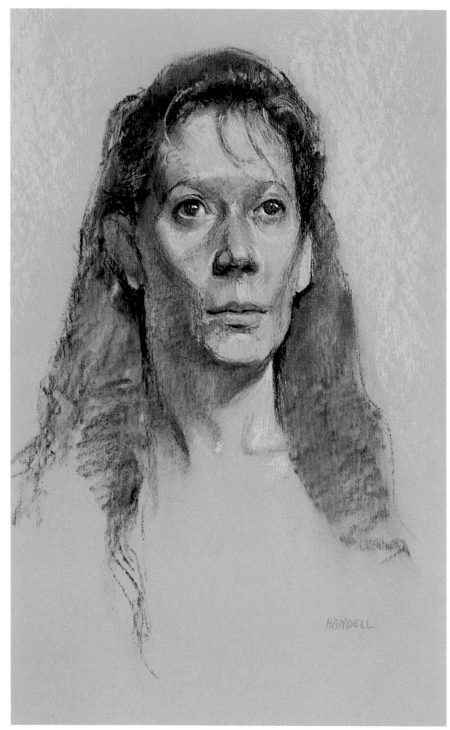

The Effect of Your Work Surface's Color

Choosing the right surface is a matter of preference and experimentation. Keep in mind that the tone can affect the mood of the painting. For example, a dark-toned surface can create a somber mood. The warmth or coolness of the tone can also affect the colors, harmony, and mood of the finished work.

TONED SURFACES

Working on a toned ground helps to achieve contrast immediately, yet keeps the painting harmonized. Letting the tone show through in the finished painting can enhance the light, color, and harmony. When working on a middle-toned ground, you can work up in value to the lights or down in value to the darks. A toned ground also offers you the opportunity to produce brilliant and contrasting sections of light and shade since the light areas stand out more on a dark ground.

To best understand how a toned ground influences the sense of light in a painting, you'll find it quite beneficial to experiment with both opaque and transparent toned grounds. To produce a transparent toned ground, all you have to do is take any color and scrub it on so that it is transparent rather than opaque. When you scrub on different color tones, observe how the light and shade and local colors read on them. In this way, you can discover both your own preferences and new, exciting ways to suggest the effects of light in your work.

Using a white surface enables you to keep the entire key of a painting high. The applied colors appear richer and more brilliant. As such, you must pay careful attention in order to keep them harmonized. Transparent colors work particularly well on a white ground. By thoughtfully selecting toned surfaces, you can create paintings with a radiant sense of light.

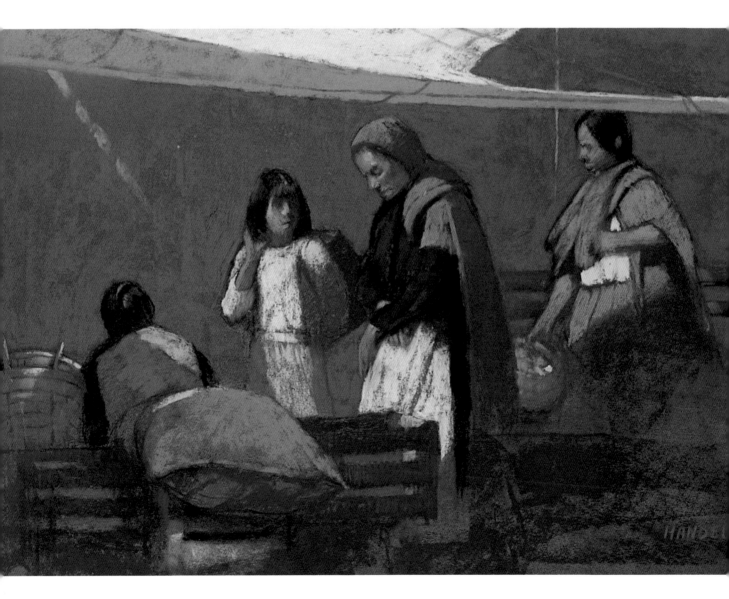

Summer's Roses

Pastel on sanded board.
23⅛ x 18 inches (59 x 46cm).
Courtesy of the Ventana Gallery,
Santa Fe, New Mexico.

The subject matter of this pastel, a floral arrangement without a vase or other visible container, seems to float. I find that this quality adds to the sense of rhythmic growth, especially when I paint flowers, which move and dance in the slightest breeze. The middle-value tone of the surface I was working on was close to that of the background drapery. As a result, I easily made the transition from life to the toned, sanded pastel board. After immediately establishing contrasts that provided a lovely sense of the frontlighting here, I developed the work, concentrating on the light-colored flowers and dark leaves in the foreground. I continued painting the flowers until I believed that it was necessary to actually paint the background. Because I thought that the drapery had folds that I felt would distract from the light and the flowers, I took the liberty to eliminate them. This simplified the image. Finally, I designed the background tones and shades, so that they would effectively complement and emphasize the light on the foreground roses.

Bargaining

Pastel on sanded board. 11 x 16 inches (28 x 41cm).
Courtesy of the Shriver Gallery, Taos, New Mexico.

When I work on a toned surface, creating a suggestion of light and shade is one of my first concerns. This gives me an immediate sense of these two elements; the initial tone of the paper works as a middle tone for the painting. I then continue to develop the details and the color to help bring out and resolve the initial establishment of the light. The warmth or coolness of this tone can make a difference. In "Bargaining," I used a cool middle-tone gray. It added weight to the colors, a certain solidity to the figures, and a richness to the light.

TEXTURED SURFACES

Naturally, you can paint on many different types of textured surfaces. When you work on cotton or linen, you can take advantage of the weave, which shows through. On another occasion, you may prefer the smooth surface of a gessoed Masonite panel, which reflects its own unique sense of texture. On this type of surface, every brushstroke stands out and looks exactly the way it was applied. On a rough, unevenly textured surface, thin color washes appear more opaque, and opaque paints will have to be applied more thickly, probably with a palette knife.

To give both Masonite panels and fabrics rough textures, simply apply a layer of ground with a palette knife. A textured ground always reflects paint applications differently than a smooth ground; the result depends on the behavior of reflections in general. Your personal experiences will teach you much in how different textures can subtly affect the sense of light in a painting.

Fanfare
Pastel on sanded board. 22 x 28 inches (56 x 71cm). Collection of Mr. and Mrs. Phillip Corso.

As a pastelist, I work primarily on very smooth (7/0 grit) sanded pastel paper. It is available in a light-buff color that is perhaps one value down in scale from white. This is a very bright, light-colored background for a pastel painter to work on. Here, I panned in on my subject, which enabled me to observe the movement and rhythms of the flowers easily. I worked on a buff tone and used mostly dark colors. Because details appear rich in color on light-tone surfaces, I could also see the patterns of the flowers clearly. This tone also permitted me to develop a good sense of the color as I developed the light. Usually when I work on a light-tone ground, the colors that make up the painting are lighter in key. This is because light bounces out of light. As such, I have to make sure that this doesn't weaken the painting. Obviously, then, the placement of dark accents and rich colors is important because they add weight to the picture.

Portrait of Joey Bradley
Pastel on sanded board. 13 x 15 inches (33 x 38cm).
Courtesy of the Ventana Gallery, Santa Fe, New Mexico.

Painting a portrait on a light buff-tone ground is a delight for me. With the exception of white and some very high-key colors, I can see most other colors quite readily on a light-tone ground. And because this surface lets me paint with lighter, richer colors, I can create dramatic effects and a wonderful sense of illumination. Instead of concentrating on building strong light-and-shadow patterns, I work with the colors. I also focus on developing the portrait and the illumination by observing the nuances of color found in the model's head as they relate to the features. I chose frontlighting for this because it produces very little shadow. I find that using lighter value colors ordinarily results in a more luminous portrait.

How Different Subjects Absorb or Reflect Light

The nature of each subject you choose to paint determines the degree to which it absorbs or reflects light. Both dark and matte surfaces absorb more illumination, while light and metallic surfaces reflect a great deal of light. For example, bodies of water require you to focus on their highly reflective nature. In order to successfully capture light in your paintings, you need to know how to handle its effects on a wide range of subjects.

DISTANT LANDSCAPES

Distant landscapes are usually characterized by strong colors, tones, textures, and details in the foreground. The background becomes a comparative haze with muted edges, tones, and colors. This is caused by aerial perspective, which weakens colors and softens edges. In the Southwest, the air contains little moisture, so the effects of aerial perspective are minimized. In the Northeast, however, the high amount of moisture in the air makes aerial perspective an unavoidable issue.

When painting distant landscapes, you must give special consideration to the placement of the horizon because it is so important to the sense of light in the finished painting. When you work on location, be aware that the horizon line is at your eye level. If you place the horizon high, your painting will contain little sky but plenty of land leading into the distance. Conversely, if you place the horizon line low on the surface, you'll emphasize the sky in the painting. Obviously, this approach will result in a more luminous work. Finally, you can place the horizon line closer to the middle of the surface. This will cut the image in half, which can be a pleasing effect.

The terrain itself is another consideration when you paint landscapes. For example, in the Southwest you find wide-open stretches of dry land and great expanses of sky, which usually enable you to see for quite a distance. In addition, the air is dry, so the lack of moisture makes the effects of aerial perspective less pronounced. On the other hand, in the Northeast mountains, less sky is visible and the forest-dense terrain absorbs a great deal of light. This affects the colors of the subjects and often creates a more subdued sense of light and atmosphere.

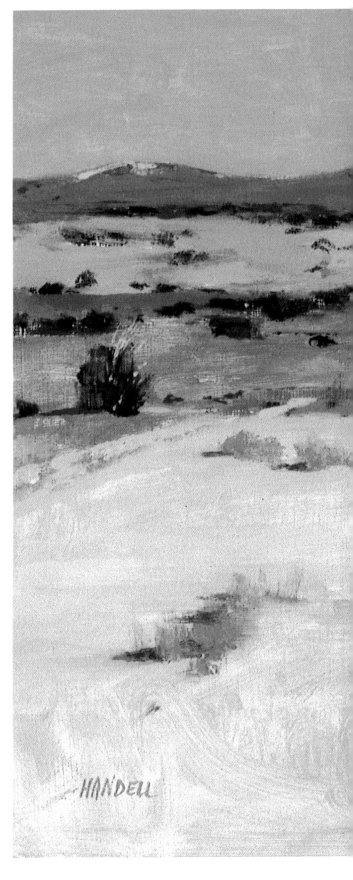

New Mexico Vista

Oil on Masonite panel. 12 x 16 inches (30 x 41cm). Private Collection.

The light in this oil painting suggests the color and the distance in this landscape. The shapes of the land are round and curved in the foreground and appear to flatten out in the background. The colors, values, and details change as the viewer's eye is drawn into the painting. The large area of light sand in the foreground increases contrast and interest because it reflects more light than the desert brush that surrounds it. I had to delicately paint the suggestion of detail in this large area, without too many strong darks. Eliminating these darks helps establish the luminosity both in this section and throughout the entire painting.

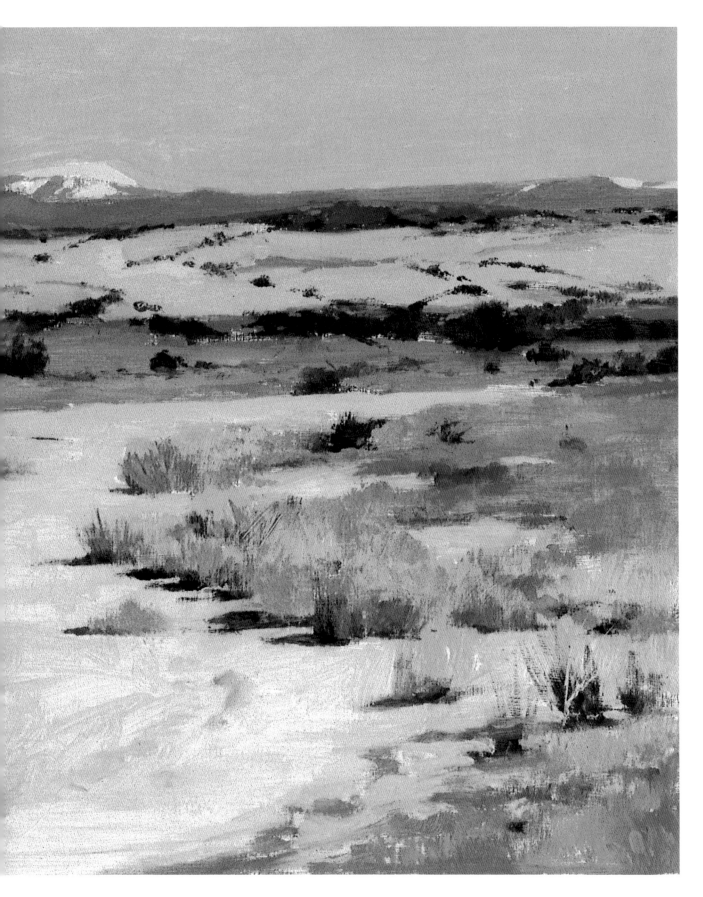

WATER

Water is a fascinating subject. It moves without ever really stopping, except in small puddles. Although lakes may appear still, water continuously feeds into and out of them. In waterfalls, water breaks apart and when it lands, it again forms a solid mass that can be entered. When you paint water, your primary concern is suggesting light's impact on it. Water is transparent, but as a body of water it has a color, and when viewed at different angles, it can appear transparent, reflective, or dense.

As a subject of a painting, water can be regarded as a mirror. Smooth, calm surfaces are quite effective at reflecting the images of nearby objects almost exactly. When working on a reflection in water, you should sense and study the light and colors of your subject being reflected, and then paint its overall shape in order to suggest the presence of the water.

Moving water poses a different challenge. Imagine that the reflecting mirror is fragmented, producing a kaleidoscope of colors and shapes that create the illusion of water in motion. Water also has planes. The upright planes are usually darker than the flat planes that reflect the sky. These darker upright planes help describe the movement of the water.

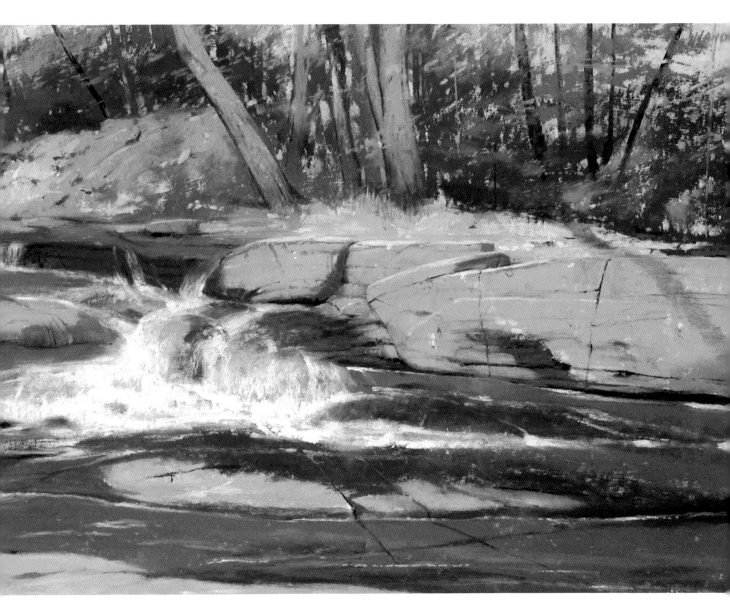

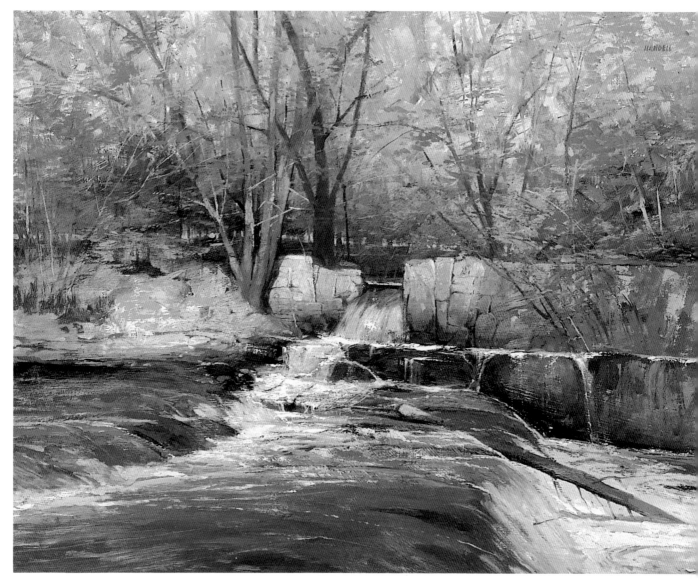

The Waterfall

Oil on Masonite panel. 22 x 28 inches (56 x 71cm).
Collection of Bernyce Besso.

Water is a fascinating subject. The water in lakes and streams is always moving even when it doesn't seem to be. As water moves and tumbles over rocks, it oxidizes and white water is created. The shapes that white water assumes can be very important to a painting's composition because they are bright and reflect a great deal of light. The rest of the water is painted in darker colors. Here, the water is rushing directly toward you and continues down to the right. This infuses the painting with motion and makes it exciting. The wet areas of rocks surrounding a waterfall can be the darkest areas of a painting, thereby providing a strong contrast to the lighter colors. Here, I started with ultramarine-blue and burnt-sienna transparent color washes, using turpentine as the medium. After these dried quickly, I scrubbed an off-white oil-paint mixture that I'd made, onto the water to make it more semi-opaque and less brilliant. I then used a palette knife to paint on more of this paint mixture in specific areas, adding texture to the white water.

The Millstream

Pastel on sanded board. 12 x 17 inches (30 x 43cm).
Courtesy of the Ventana Gallery, Santa Fe, New Mexico.

To suggest the rapid flow of water over rocks, I first paint the rocks and other dark areas with rich, dark colors. And to capture the tumbling motion of white water, I use white and off-white pastel colors, so that this turbulent water stands out from all the other elements of the scene. As such, the white water is the brightest part of the painting. The surrounding dark colors seem to absorb the illumination, while the lighter colors seem to reflect it.

ROCKS

To successfully paint rocks, you must convey a sense of their weight and solidity; you don't want them to seem like powder puffs floating around the finished image. Backlighting brings out these qualities by rendering rocks as silhouettes. Sidelighting, on the other hand, makes rocks look dramatic. Another approach is to work with frontlighting. Because this type of illumination produces little, if any, shadow, it brings out the details in and the colors and planes of the rocks most clearly. Here, the light flows softly over the rocks. Incorporating the planes of the rocks enables you to define the character of the rocks and the nature of the light illuminating them.

Rocks are great subjects because the many minerals they're composed of make them vary in color. And every so often, you'll come across rocks with veins that differ in color and stand out prominently. Rocks can also have deep, dark accents that can look like sharp slivers or heavier darker lines when the rocks rest on the ground. These accents help show the form of the rocks and the surface they're leaning on. Their crisp lines bring out the light that accentuates them and adds to the sense of the rocks' weight. Although the rocks' planes can be seen in almost any kind of light, I prefer frontlighting. Here, everything is in light, and the variation of the colors and the planes is subtle yet distinct.

Rocks Along the Alameda

Pastel and watercolor on sanded board. 12 x 13 inches (30 x 33cm).
Courtesy of the Ventana Gallery, Santa Fe, New Mexico.

I found this group of exposed rock formations along
the Santa Fe River. The extremely tight grouping on the
right side of the image suggests that the rocks tumbled
into place. Rocks have always been one of my favorite
subjects because I enjoy how the light plays on them.
And when you come across rocks near bodies of water,
you see that the water can be so much more reflective
and so much darker in color than the rocks. To success-
fully paint these rocks, I focused on the lower three-
quarters of the composition while working on location.
Later in the studio, I put a watercolor wash in the
remaining quarter of the pastel to suggest more water
in the distance. Here, I also used watercolor quills with
watercolor paint to redraw some of the very delicate
lines of the cracks and the linear accents found in the
rocks. Because these rocks don't have strong shadow
patterns on them, you can see them clearly.

Portrait of a Rock

Pastel and watercolor on sanded board. 10½ x 10½ inches
(27 x 27cm). Collection of Dr. and Mrs. Edward J. Urig.

The sharp angles and planes of these rocks, along with
the colors found in this scene, attracted my attention.
When you take a close look at this pastel of a gray rock
reflected into water, you realize that a diversity of har-
monized color is embedded within the strata of the
rock. Slight changes in color are also visible on the sur-
face. The surrounding areas of this pastel are just sug-
gested enough to establish a sense of place and to bring
out the character of the rock. I used watercolor washes
for the colors of the ground in the upper part of the
pastel. The color of the gray rock itself is so much
brighter and lighter than the surrounding colors that it
seems to attract all of the light. In order to create this
feeling without having the image look staged, I had to
keep the remaining colors high in value. The body of
water is light green. Naturally, I had to harmonize the
rich, luminous watercolor washes with the rest of the
opaque pastels.

TREES

I've always been fascinated by and in love with trees. I regard trees as individuals, possessing their own personalities and characterized by their particular species. I've spent many years studying trees, observing their growth and movement, and coming to understand them as living beings.

There is truly a vast visual difference in trees, the same trees, between winter and summer. You can truly appreciate the rhythms of the trunks and branches and the laciness of the twigs in winter. Most of the skeleton of the tree is hidden in the summer when the trunks are covered by foliage that is difficult to read into. But you can take advantage of the many shapes of leaves and shades of green you encounter during the summer months to make your paintings richer and fuller. You'll find that you can easily read leaf shapes on cloudy days because the outlines of the leaves silhouetted against the bright sky or white clouds stand out (you can, of course, do this just as readily in the spring and fall).

During the summer, the dark, dense, green foliage of the trees absorbs a great deal of the light illuminating them. The foliage is usually denser toward the middle of the trees. When you study trees at this time of year, you should view the foliage as large shapes that are dark in value. Sometimes this approach can make the trees dominate the painting, which will consequently take on a darker key.

You must then carefully consider including sky holes of different sizes in the foliage. These holes are located at the far ends of tree branches where the space between the leaves are bigger than they are in the dense center of a tree. The smaller the sky hole, the less energy its light has, so it will tend to be a bit darker than the rest of the visible sky.

Suppose the scene you want to paint includes a light-blue sky and a tree with dark-green leaves. If you see plenty of green leaves and little blue sky, you should use a darker blue for the sky. This will prevent the sky from seeming as if it is sitting on the tree. Conversely, if you see a lot of blue sky and a few dark-green leaves in front of the sky, you should use a light blue for the sky, and a duller green for the leaves.

You can observe and analyze trees more readily in the winter. Because all but evergreens lack foliage in the winter, you can study the growth and movement of the trees as the light illuminates the twists and turns of their branches. The branches growing toward you in the light show their bottom planes, while those growing away from you show their top planes more clearly.

Illuminated by soft winter light, trees often produce beautiful cast shadows. The large, naturally occurring sky holes bring more light into the painting. And because these sky holes are more intense than small sky holes, they relate more closely to the value of the entire sky.

Trees are upright planes and are usually darker in value in the foreground. As they recede into the distance, they're affected by aerial perspective; as a result, background trees are lighter in value. For example, in the summer a dark-green tree in the distance appears gray in comparison to a dark-green tree in the foreground.

The Grove

Oil on Masonite panel. 12 x 16 inches (30 x 41cm). Collection of Newcomb and Kitty Rice.

In early spring, the skeletal forms of the trees are still visible and are surrounded by the most beautiful yellow greens of the year. The light greens in this painting vary subtly since they work as a background for the young trees. As I painted the darks and lights of the trunks and branches, I always kept in mind the movement, growth, and grouping of these trees. The high-key illumination in this oil painting is revealed in the light colors that reflect it. The dark colors of the trees seem to absorb the light. Here, I used ultramarine blue for the cool, dark trees on the left, and burnt sienna for the warm, reddish trees on the right.

Monhegan Island

Oil on Masonite panel. 20 x 24 inches (51 x 61cm). Collection of Rosalie Golser.

In this painting of the Cathedral Woods on Monhegan Island, off the coast of Maine, light shades of green cover the ground area, and dark greens define the upright foliage of the trees. The dark blue-greens frame and bring out the light greens of the ground. The ground plane is on an angle that extends from the lower left to the upper right. This immediately makes the scene more interesting. The sky holes vary from one large diamond-shaped area to several smaller ones. I purposely eliminated intermediate-size sky holes in order to simplify the massiveness of the trees. A very gentle light floods this scene. I tried several different "correct" skies for this painting—light blue, turquoise—but somehow they didn't complement the illumination. It wasn't until I decided to go with a yellow sky that the whole painting felt right. I'd observed such a sky during an approaching summer storm. When I painted the yellow sky simply and flatly, the work was suddenly resolved. I never know what a painting will look like from beginning to end, and I am a firm believer in "letting a picture sit" until it talks to me.

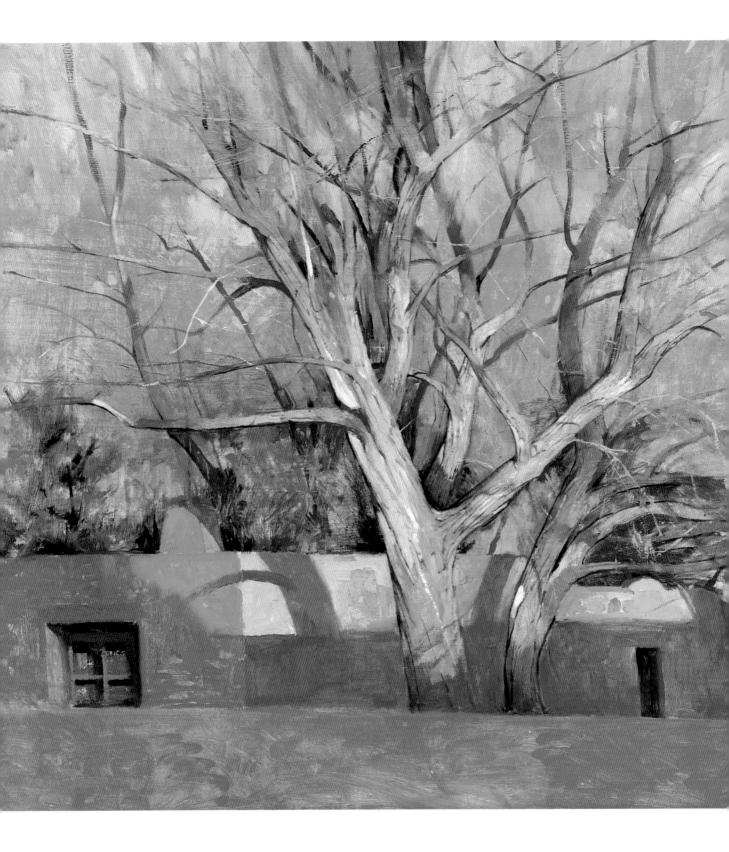

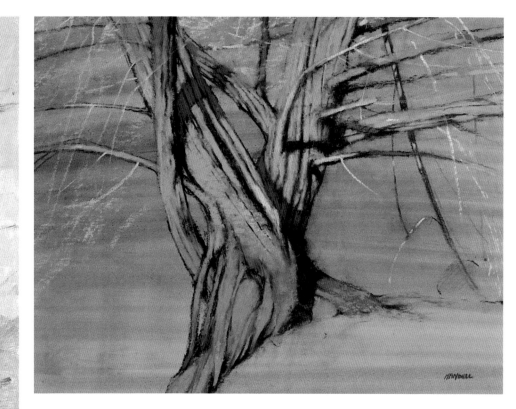

The Cottonwood Tree

Oil on Masonite panel. 30 x 40 inches (76 x 101cm).
Collection of Walter and Lee Dietzer.

I partially achieved the sense of light in this
large oil painting by allowing the transparent
colors of the underpainting to show through. In
the tree itself, a little bit of the underpainting is
visible on the upper left and where the trunk
goes from yellow to purple. I brushed the back-
ground on from left to right, and the move-
ment of the brush strokes adds excitement to
the image. I made this painting of Corrales,
New Mexico, from a photograph that I used for
the pastel entitled "Corrales" (see page 98).
Here, you find the strongest contrast to the left
of and behind the trunk of the cottonwood, on
the yellow adobe wall. This contrast grabs your
attention, and as you look at this area you can
get a peripheral sense of the rest of the tree. I
did this on purpose. I designed the light in this
painting in a way that permitted me to lower
both the brightest brights and the general color
key ever so slightly on the tree. This, in turn,
allowed me to paint a less contrasty light within
the tree itself and to more firmly establish a
sense of the tree and the surrounding colors.
Still, when compared to the strong contrasts on
the adobe wall, the light, colors, and contrasts
of the tree are subtle.

Kiba Dachi

Pastel on sanded board. 15 x 16 inches
(38 x 41cm). Private Collection.

"Kiba Dachi" is the name for a solid
yet flexible fighting stance in Shotokan
karate. This strong tree captures the
essence of this position. Here, I wanted
to show how winter light can bring out
the subtle variations in the color of a
tree. These subtleties are easier to dis-
cern in winter when the intense greens
of summer no longer dominate. To em-
phasize the light and color of winter
even further as I developed "Kiba Dachi,"
I chose a gray ground that wasn't too
dark in value. This tone represents the
general tones of light and color present
during the winter. On top of this gray
tone, I worked exclusively on the tree.
Its dark areas seem to absorb the light,
while its light parts seem to reflect
the light.

LIGHT IN SKIES

The sky, which is usually the largest element in a landscape, is changing all the time. Skies can be rather simple expanses or magnificent, complicated elements. The variety is enormous. Skies can range from being clear blue, to being filled with rapidly moving cloud patterns, to looking as if a storm is approaching. The sky is a source of illumination that rules everything. The quality of the light coming from the sky determines a color key and has a direct influence on everything it illuminates. Naturally, this affects the atmosphere and mood of the landscape.

The sky and the land are separate areas of a painting, but the color and tones of one section always influence the color and tones of the other. In general, the tonal values of the sky are lighter than those of the land. The color of the sky affects the color of the land. For example, at dusk the sky is dark blue and veils the earth in the same tone of blue.

When you paint skies, you'll find that it is best to select and simplify them. As you practice and gain experience, you'll discover that the sky is usually lighter near the sun and grows increasingly darker as you look away from the sun. On a clear day, notice the sky directly above. It is usually a clear brilliant blue that varies from light to dark as it nears the horizon. You can observe this effect even when the sky is filled with cloud formations.

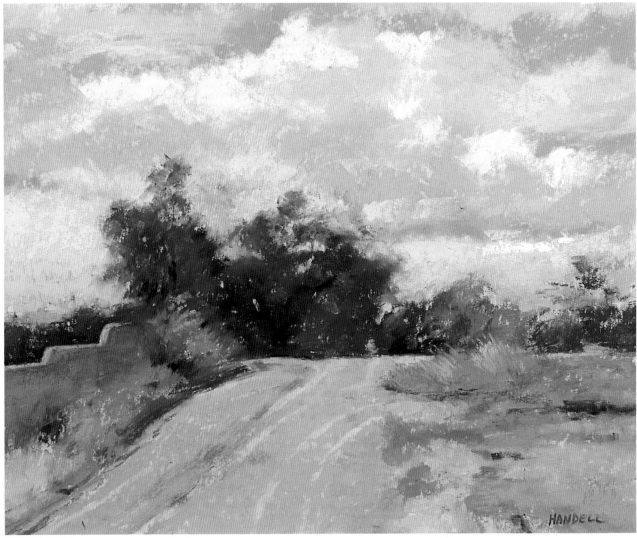

Road to Cumulus

Pastel on sanded board. 10 x 12 inches (25 x 30cm). Collection of Ed Davies.

Cumulus clouds make dramatic formations that change all the time; here, they floated from left to right. They are usually the brightest area in a landscape, and the lightest element in a painting. In fact, they are often so brilliant that they seem to be a secondary light source. As a result, you need to paint the rest of the landscape in a way that accommodates this aspect. Notice how this adobe-colored dirt road, as bright as it is, is lower in value and intensity than the clouds. In this pastel, the strongest lights are clearly in the sky.

CHANGING CLOUD PATTERNS

Changing cloud patterns are visually exciting. The clouds themselves have forms and shapes that create continually shifting patterns. And the sunlight that breaks through the clouds at times produces compelling visual havoc. At times I've watched in wonder as a favorite grouping of trees changed dramatically when the sun suddenly broke through and then disappeared again behind the clouds. These variable and rather unpredictable lighting situations are always fun to experience. As I study subjects under these types of conditions, I observe two radically opposed kinds of illumination. One is the light of the sun at its full intensity, and the other is the complete absence of sunlight. In between these two extremes, I've noticed crescendos of light as the sun comes out from or hides again behind some clouds.

Clouds assume a number of varied shapes and have planes that are always changing. You'll usually notice that one plane is brighter than the others and faces the sun, and that the bottom and side planes are darker and reflect color and light from nearby clouds. The earth ordinarily appears darker than the clouds, too, and seems to frame them. At times, you'll see that the dark grays of the clouds are close in value to the blues of the sky. When this happens, the edges become softer, thereby adding to the mysterious beauty of the light.

Finally, when you encounter shifting cloud patterns, you must take into account aerial perspective. The presence of moisture in the air affects clouds just as it affects objects on the land. Here, the light and shadows near foreground clouds contrast more than those surrounding clouds in the distance.

To successfully record these changing lighting conditions, you must first observe and remember the initial pattern of light and shade. Next, you need to look for areas that stand out and relate them to the composition. You can also attempt to combine a mélange of effects: integrate the light you observed at 8 A.M. with the light you saw at 10 A.M. Here, your initial painting becomes your underpainting. The inspiration for your desire to repaint may be something as simple as a different reflection in a window in a building or a sudden, unexpected change or buildup of light. Feel free to try an unorthodox approach. Place more emphasis on a subject in beautiful light than on authenticity. Just be sure to limit yourself to a few hours during a specific part of the day, otherwise the finished painting will be too unorthodox—in other words, a wide-ranging failure.

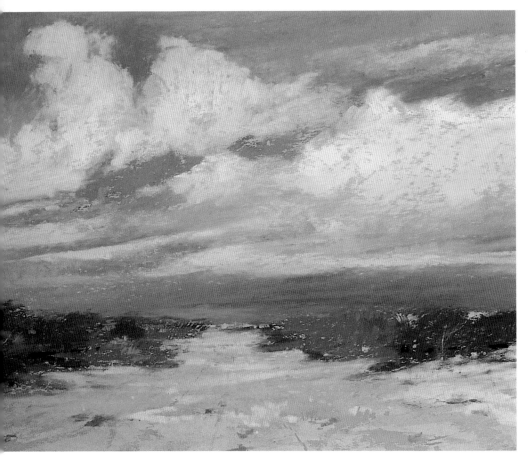

Afternoon Build Up
Pastel on sanded board.
13 x 14 inches (33 x 36cm).
Private Collection.

Here, the clouds are the most reflective elements in the scene. And since clouds are often quite high, their reflective qualities aren't always noticed nearly as much as their brilliance. I wanted to capture their brightness in this pastel. I started with #255-P Nu-Pastel cool azure blue. No other area in this painting competes in value with the bright whites of the clouds on the left. All the other parts of the sky contain purple, mauve, or blue. As the sky and ground recede, the local colors fall off. The warm and cool purples indicate where the sky and distant earth meet. As such, these two areas are related from foreground to background.

STORMS AND RAIN

Some of the most dramatic atmospheric effects occur just before, during, and immediately after a downpour. Because these sometimes last only an hour or two, a sense of urgency accompanies the desire to capture the light. Approaching storms are often ominous, moody, and threatening. Then after the rain, the sky sometimes brightens, and wet surfaces act like mirrors, reflecting light through a clear atmosphere. And when the sun comes out after a rainfall, you often have a diversity of colors and values to capture. For example, the sky may be cool, dark purple one moment and bright bluish-white the next.

The presence of fog and mist also indicates that the air contains a great deal of moisture and water vapor. When it is misty out, it is hard to see through the vapors, and the outlines of objects at short distances become soft and blurred. The diffused light of both fog and mist have a veiled mystery that can turn an ordinary scene into a magical one. This is especially true later in the day when the blues and mauves of evening appear. Colors fall away and values are subtle because the water vapor acts like a filter, neutralizing bright colors, flattening masses, and softening contours. Value contrasts appear less intense since mist disperses the light filtering in and causes objects to melt into a blur. Fog and mist work well with subjects with upright planes, such as piers and buildings.

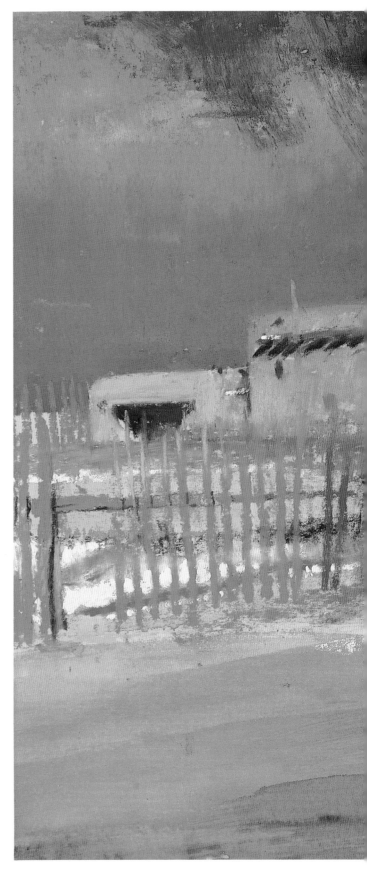

Taos Thunder
Pastel on sanded board.
12 x 17 inches (30 x 43cm).
Collection of Leslie Trainor Handell.

The period before a thunderstorm is filled with exciting and dramatic moments. You can smell the moisture in the air. And as the clouds build, the sky darkens. An eerie light illuminates the landscape, while the background sky is dark and ominous. The rain will begin momentarily. I tried to capture this mood in this pastel. The sun was still shining on the buildings and fences at the Taos Pueblo in New Mexico. The dark-gray sky contained a bit of purple, #548-7 Rembrandt blue violet, as well as #727-7 Rembrandt bluish gray and #709-7 and #709-8 Rembrandt green gray. These cool, dark colors effectively complemented the warm tan and brown colors of the haunting landscape. The light was compelling. Just 20 minutes later it poured.

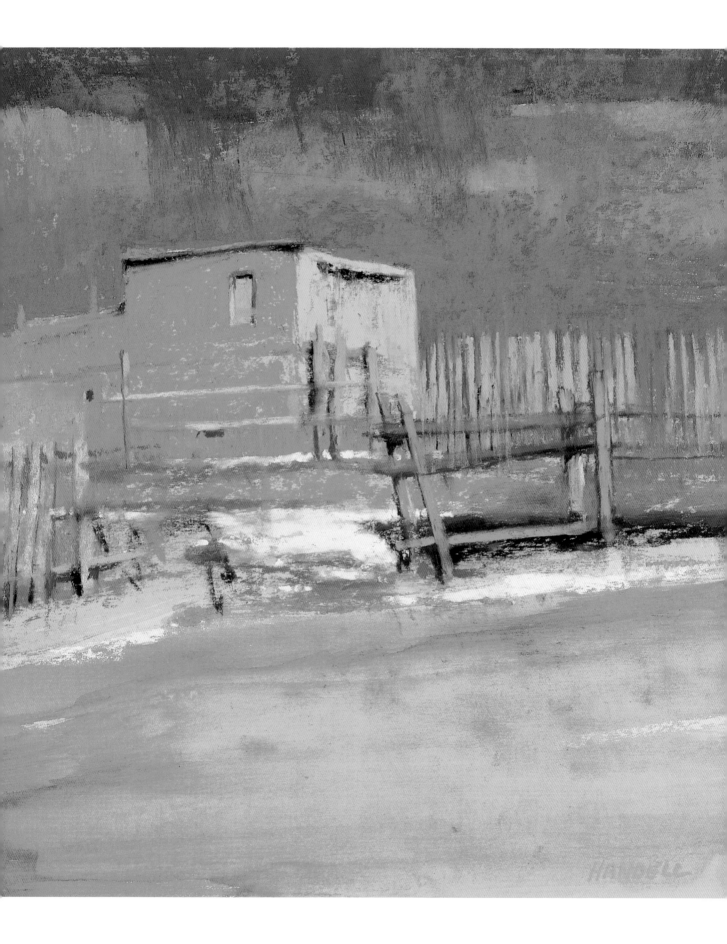

SNOW SCENES

Snow is magical, day or night. When it snows, I usually stop painting and go for a stroll simply to enjoy its beauty. Snow is basically white, which contrasts well with gray, mauve, and brown, the predominant winter colors. White isn't necessarily white. For example, you might see snow that is primarily off-white with a bit of yellow mixed into it. Also, snow in sunlight, while white, may look slightly orange, yellow, or red as it recedes, while snow in shadow areas will be darker and cooler; they may appear mauve or bluish-gray. These variations add dimension to the winter landscape. Snow usually rests on the top planes, bringing them out more forcefully. On sunny days, the interplay of warm lights and cool shadows add variety and interest to the landscape.

Because winter landscapes lack the overpowering, intrusive greens of summer, they appear more tonal. The snow helps to enhance these tones. On overcast days, with the right lighting conditions, the snow can be lighter in value than the sky. The dark shapes of trees or buildings stand out in sharp contrast to the lighter values of the snow. On sunny days, the mood that characterizes snow scenes is different. The snow seems like a white sheet of paper with bluish-purple shadows and warm highlights. And in the early morning or the late afternoon, the upright planes reflect the warmth of the sunlight. The cool blue of the sky is reflected in the snow on the lying-down planes; it darkens slightly as it recedes. At other times, however, the light is dazzling as it reflects off the snow.

If I have a large area in sunlight and the angle of the sun is such that the upright planes in the snow facing the sun are the brightest, warmest whites, first I establish this large, overall snow mass. I then darken it a bit with ultramarine blue, and I might add a touch of Thio violet to cool off the white. In order to achieve the brightest whites, I add a very small amount of cadmium yellow to the whites on the upright planes.

Fresh Tracks

Pastel on sanded board. 9 x 13 inches (23 x 33cm). Private Collection.

Light shows up beautifully on snow. Although snow is supposed to be white, under certain lighting conditions it can look anything but white. In this late-afternoon scene, the angle of the sun is low, and the light has a reddish tinge. Notice that the upright planes are the lightest and the warmest. The remaining areas of the snow are cooler, both in the light and in the shadow. The coolness of the sky reflects into these areas.

BUILDINGS AND STREET SCENES

Solid buildings create their own special light effects as they catch the light in some areas and block it entirely in others. This is particularly true when they are close together, such as in urban environments. Patterns of light and shade are usually clear and defined in these environments, especially in bright sunlight. Most urban environments lack the delicate diffusion of light that is present, for example, in a forest as light filters through the trees.

What buildings are made of is also a consideration because some materials absorb more light while others reflect more. Consider concrete; its smooth surface reflects more light than adobe buildings, black tar, and bricks. And when you add to this the reflections from the pavement, windows, and cars, the play of light in street scenes can become quite interesting and complicated. The weatherbeaten qualities of older buildings that have been left alone are quite beautiful and tell the history of the building. Wooden buildings don't reflect as much light as their windows do. Keep in mind that seasonal changes, snow, and rain provide you with even more opportunities to paint these subjects in different lighting situations. The study of light in the urban environment can be an absorbing, lifelong project.

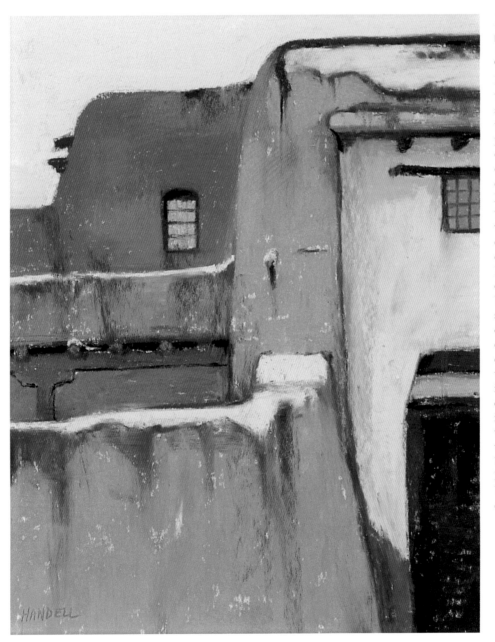

Lingering Light
Pastel on sanded board.
11 x 9 inches (28 x 23cm).
Collection of Janice and Lewis Muir.

Buildings have their own aesthetic appeal, especially if the architecture is varied and features unusual textures, proportions, and colors. I painted this closeup of a corner of one such building on a gray day. Because I wanted to look into the shadow area of the building itself, I lifted the values just a bit in order to easily pick out shapes, colors, color transitions, and details. I enjoyed painting the detail of the snow on top of the bottom wall. Part of the snow had melted and dripped, making darker tones down the lighter wall. This detail also adds an element of time to the painting. The illumination is diffused and even. I translated the sky into a single negative shape that complements the positive shapes of the building. A building like this can show how clearly this type of light brings out the local colors of objects.

MARKETS AND TRANSLUCENT AWNINGS

The play of light and the variety of light effects that are possible with these subjects combine to make them exciting. Outdoor marketplaces are often characterized by intense illumination, which produces rich patterns of light and shade. Translucent, brilliantly colored awnings can infuse the light of a painting with a special magic. They can also create dark shadows with patches of light shining through. Translucent tones of the local color of the awnings can filter through and flood all of the objects beneath them, thereby enhancing these shadow areas. A suggestion of sunlight can be painted through the translucent light of awnings. To do this, you simply have to use value and color contrasts to show the figures and objects under the awning, thereby making them appear distinct from those in the direct sunlight.

Be sure to keep your shadows strong and simple. Many times, their importance supersedes that of the individual local color—but not always. Sometimes very intense local colors with lots of reflections reflect back into the shadow area, raise the values, and disturb the simplicity of the shadow areas, thereby weakening them.

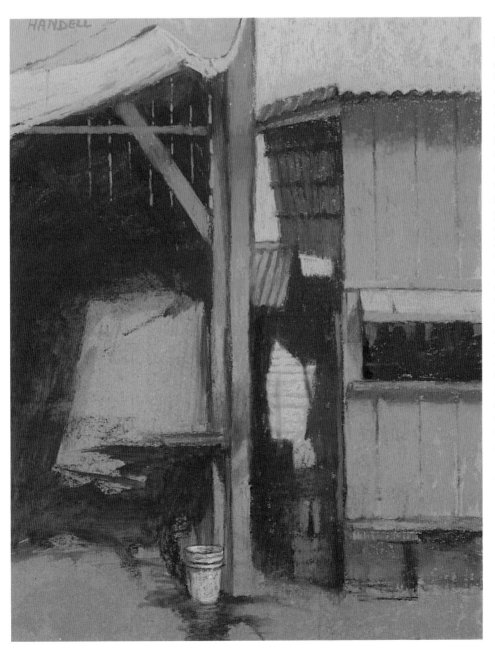

Vera Cruz Blue

Pastel on sanded board.
14 x 11 inches (36 x 28cm).
Courtesy of the Ventana Gallery,
Santa Fe, New Mexico.

The stalls at an outdoor marketplace in Vera Cruz, Mexico, are snuggled between several buildings, which you can see in the background. A few scattered vendors were opening up and getting ready for the crowds. This particular stall was still closed. The early-morning light filtering down through these structures gently illuminates them. This subject and the soft light in this pastel are simplified and seem somewhat abstract. The strong cast shadows suggest that the awning is pink. The lighting also makes this scene seem a little mysterious and magical. Large, box-like shapes with bold verticals divide the picture plane. Furthermore, as you look at the space between these two shapes, you see a number of small shapes; the resulting contrast is quite appealing.

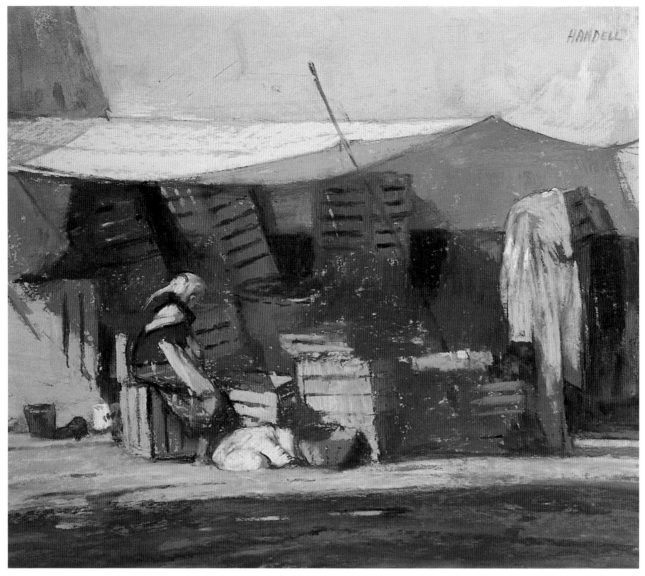

Midday Market, San Miguel de Allende, Mexico

Pastel on sanded board. 9 x 11 inches (23 x 28cm). Private Collection.

During the light of midday, awnings in marketplaces play an important role in the vendors' minds: they protect the produce. For artists, however, they create exciting and interesting light effects. Here, the white awning absorbs and blocks the sunlight. This, in turn, allows translucent light to pass through the material, thereby making the shadows lighter in value. In addition, the whole general area appears more luminous. The figure of the elderly vendor merges subtly with the surrounding tones and colors because I loosely painted this scene in certain places.

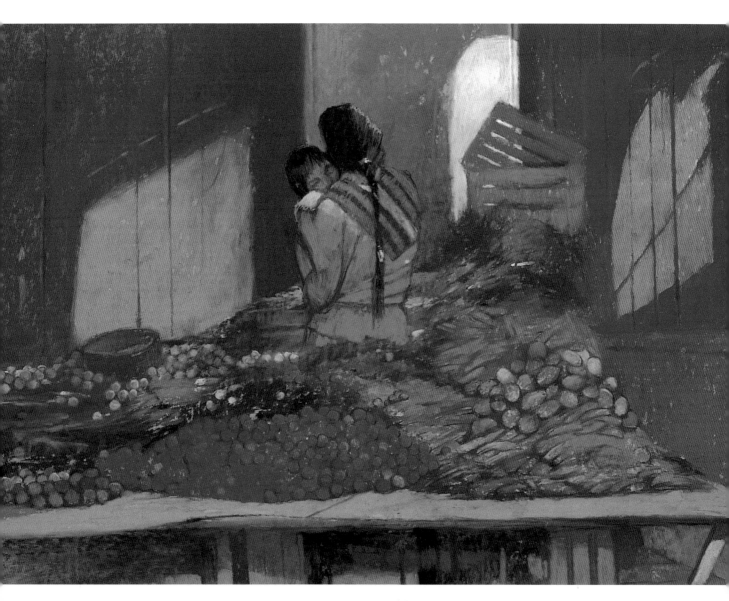

Midday Rest

Pastel on sanded board. 16 x 22 inches (41 x 30cm).
Courtesy of the Shriver Gallery, Taos, New Mexico.

For this portrait of a mother with her child napping on her
shoulder, I wanted to bring out the overhead light of midday.
The awnings that cover and protect these fruit and vegetable
stalls provide strong patterns of light and shade that help cre-
ate the variety of abstract shapes seen in this composition. I
applied the pastel vigorously to the orange and white wall
behind the awnings, which was in partial shadow and strong
sunlight. The colors in this painting are quite rich, and you
can see into the shadows under the awnings. This element
adds to the luminosity of the painting.

INTERIORS

I often compare painting an interior to painting a large still life, especially when no humans appear in the scene. When you paint interiors, you usually have several sources of illumination to choose from: natural light, artificial light, or a combination of them. If the sun isn't shining into the interior, you basically have a controlled, steady lighting situation to work in. This is helpful because it enables you to capture the truest local colors of the subject.

When you paint interiors, you'll learn that creating a sense of light, weight, and space is important. While achieving a sense of atmosphere is also necessary, it isn't as critical or dramatic as it is outdoors. But you must pay attention to the mood that results from the interplay and integration of indoor light and these other aesthetic considerations.

Although the general tones of colors in an interior are unique, they're usually darker than those found outdoors.

On sunny days, more light may enter the interior and reflect off walls, floors, and ceilings. Then as the patterns of light and shade change throughout the day, the sunlight and the colors of all objects are altered. I prefer the golden illumination of the late afternoon.

The presence of a single small window may create a dark, dimly illuminated interior. Strong sunlight shining into an interior can also project cast-shadow images of the outside world into it. For example, trees and branches can cast their shadows through open doors and windows, thereby producing dancing patterns on the floors and walls. And reflections in glass from windows, doors, or mirrors always add an extra dimension to the painting. Clearly, light entering through open windows or doorways can add an extra dimension to a painting of an interior by providing endless possibilities in the light effects that you can explore.

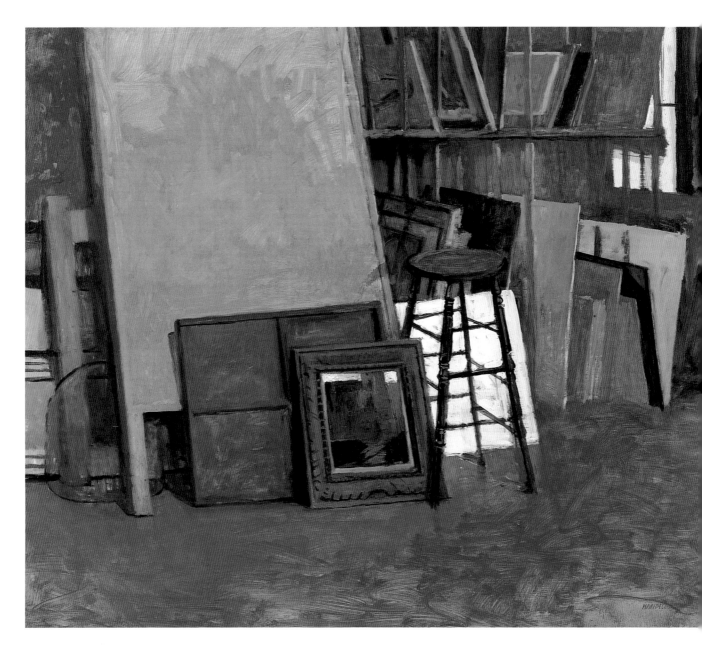

STILL LIFE

I believe strongly in painting only what inspires you. Still-life painting can be intensely absorbing. It can take quite awhile just to create a still-life arrangement. In addition to coming up with just the right subject, you usually have to control the lighting carefully. With still-life paintings I am, however, most drawn to accidental arrangements. My interest is captured by the way in which light may suddenly strike the corner of a room or studio, or by the casual stacking of dishes or pots and pans drying in a dish rack. For me, ordinary objects composed on a painting surface become extraordinary when they're studied and observed in terms of light.

Since distances don't define paintings of indoor subjects, the individual forms of the subjects become fuller and more important. As such, you have to incorporate a sense of space and atmosphere. If you don't, the forms become static.

Throughout most of my life, I've painted in natural, northlit studios. These environments produced cool lights and warm, dark shadows for my still lifes. At various times during my career and for different subjects, I set up still-life arrangements in the back of my northlit studio where the light was weaker. I positioned a shaded lamp in such a way that the light bulb wasn't visible. I used an ordinary 100-watt kitchen light bulb as my main source of illumination; it threw strong, steady, warm light on everything. The shadows, on the other hand, were darker and comparatively cooler, thereby establishing a delightful, dramatic contrast.

The Wicker Chair
Oil on Masonite panel.
24 x 24 inches (61 x 61cm).
Private Collection.

If I'd painted the glossy, white enamel finish of this wicker chair in full light, it would have been much brighter and more reflective. Since this wasn't the effect I wanted, I set up and painted the chair in halflighting. Although this lighting situation is complicated, it enabled me to see through the upper part of the wicker. Some sections of the chair are light and stand out against the dark background. In other parts of the image, the chair is a dark, absorbing silhouette in relation to the background. This interplay, along with the suggestion of the room, brings out the prevailing light in the painting.

Corner of My Studio
Oil on Masonite panel. 30 x 36 inches (76 x 91cm). Private Collection.

In this oil painting, the center of focus is a dark corner of my studio where the natural light was low in key. The shadows were rich and deep. The local colors of objects are dark in value. This corner of the room has a door with glass panels, which is partially visible in the upper-right-hand corner of the painting. I intentionally decreased the intensity of this secondary light by blocking the panes of glass with the painting racks and a canvas. I also played down the reflections in the mirror quite a bit. Together, these two bright light sources could have negated the more subdued illumination that I was going after. I also wanted to suggest depth in the reflection in the mirror.

PORTRAITS AND FIGURES

When painting a head-and-shoulder portrait, I think that it is critical to position my model at just the right angle. Some angles bring out my subject's likeness better than others. Also, some models hold their heads quite naturally at a particular angle, leaning back, forward, or to the side. Remember, it is good to relax sitters by talking to them. I usually keep a sharp eye when we take breaks because that is when models truly relax, and I may sense a more flattering or natural pose. When I paint a portrait that doesn't focus on my subject's head and shoulders, I'm painting a gesture. I refer to this as the portrait pose. This, too, should look unforced and casual.

Once I've decided on the pose, I consider the lighting conditions. Painting a portrait or figure in indoor light calls for the same considerations that painting a still life or any other indoor subject calls for. I pay special attention to the effects of light on flesh tones in order to make the portrait seem real and vibrant. When you paint portraits in natural light, keep in mind that light-toned flesh has a pearly, translucent appearance and is also highly reflective. Olive skin tones have a purple cast, while dark skin tones vary from dark, warm reddish-browns, to very dark purplish-browns, to mixtures of burnt sienna and ultramarine blue. In addition, skin tones are strongly affected by the color of the prevailing light and by the color of nearby objects or the subjects clothing, all of which reflect back onto the skin.

When I paint portraits, I find myself drawn to the play of light and moisture in the eyes. Usually the most exciting highlights are found in your subject's eyes. I consider them to be a person's most expressive facial feature and as such to warrant the most attention. To achieve detail in the eyes, I may play down the interest and at times the light of the rest of the portrait. For example, I don't make my subject's lips as dark as they seemed to be when I studied them. I observe my model's eyes and then paint the relative value of the lips.

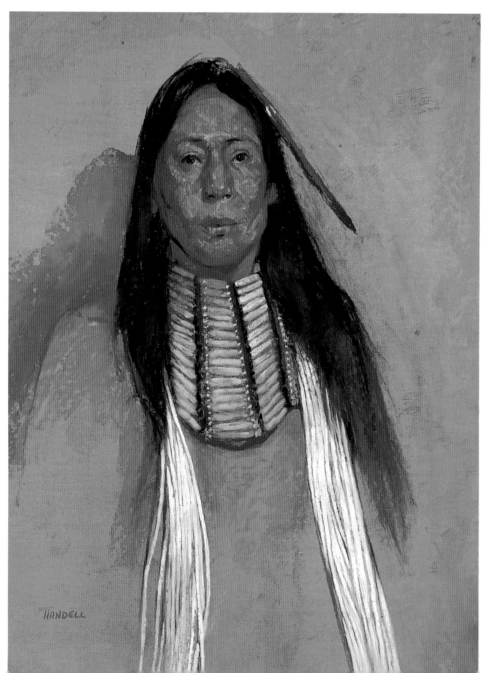

HANDELL

Portrait of Frank Wolfe, Omaha Nation

Pastel on sanded board.
22 x 16 inches (56 x 41cm).
Collection of Bernyce Besso.

In this portrait of a member of the Omaha Nation, the light enhanced my subject's dignified pose and brought out the beauty of his traditional garb. I decided not to put in too much shadow because I felt that it would detract from the subject, so I chose frontlighting. I also minimized the highlights and the reflected lights on the subject's forehead for the same reason. Rather than change the background tone and possibly disturb the flow of the illumination, I kept the transparency of the background tone to complement the opaque applications of the pastels.

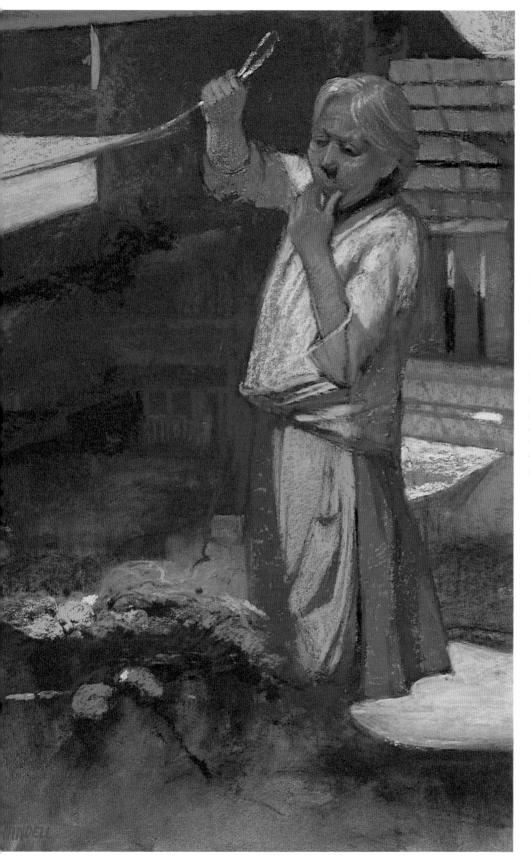

The Old One

Pastel on sanded board.
16 x 10½ inches (41 x 27cm).
Private Collection.

This model's gesture is an integral part of the portrait. Here, an elderly woman puzzles over how to attach the corner of a blue awning. I thought that her expression and this gesture told it all. She isn't sad; she is simply working. Still, I was more drawn to her gesture than to the look on her face. I designed very strong, dark shadow patterns in order to frame her in an intriguing way. Next, I focused on her portrait and the bright clothing she was wearing. The light passes the woman and echoes with some touches of white on the ground and some lights on a background crate. The predominant light on the figure adds dignity to the scene. In essence, she glows. I wanted to provide a sense of the woman, not create a literal representation of her.

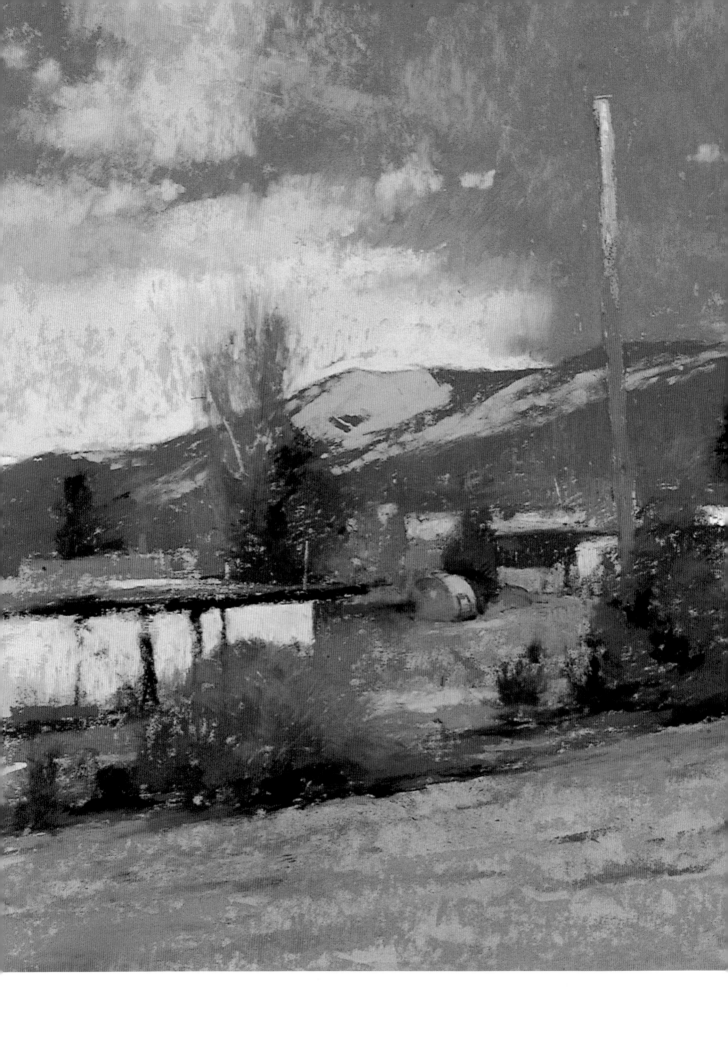

CAPTURING THE ILLUSION OF LIGHT

Every painting is, in a sense, a painting about light. Whatever the subject, light illuminates it, explains it, and puts it into space. This is what creates the special magic that captures your attention and imagination. The medium you decide to paint in is an individual choice. The many options available to you can help you achieve the sense of light that provided your original inspiration. ❧ I've found several approaches that work well for me. Some of my most successful techniques involve: painting from photographs, slides, drawings, and memory; varying color temperature; simplifying the subject into patterns and shapes; eliminating details; establishing the direction of light to create continuity; using lost and found edges; and applying color washes. Ordinarily, I combine several of these techniques, letting one dominate, in order to capture the desired quality of light. ❧ I am a painter who responds to the moment and the initial impact of a first impression. This experience is often a transitory or a fleeting moment, particularly when I work outdoors in natural light. I continually gather these experiences of different lighting conditions to draw on later. The interactions of light, color, and value constitute a delicate but important relationship, so I think that you should have a thorough knowledge and understanding of how these factors affect a subject's appearance and, ultimately, your painting.

Transitory Moments

Every moment can be considered a transitory moment that will soon change and disappear right as you're experiencing it. In painting, these moments most often deal with natural light outdoors where the illumination can change in any way at any time. No matter how transitory, these moments always provide you with a first impression. As such, when choosing a subject to paint, you should try to have a clear idea of what you want to capture before you begin. Try to sense, analyze, and nail down on your canvas what makes up your first impression. Then try to intuit what is about to change.

Remember, when you paint outdoors, the light is unpredictable. On sunny days, depending on the angle at which you view the light-and-shadow patterns, they can change comparatively rapidly, and the effect on the illumination of your subject may be drastic. And don't be fooled by overcast days when it may seem easier to paint because you don't have to worry about the sunlight changing direction, the illumination can nevertheless vary from moment to moment. Clouds are continually changing and moving. What happens if the sun breaks through for a few seconds or for 10 minutes and then disappears again? Suddenly you're enthralled with what you see and decide to incorporate it into your painting. You're now immersed in dealing with a transitory moment, and you need to work fast and decisively.

In order to capture these impressions and moments, you must paint quickly and spontaneously, relating the shapes and colors of the entire picture as soon as you can. Stay aware of the patterns. It may be helpful to work on a smaller scale, making sketches that just capture the light. You can use these sketches later in your studio to recall the subject and the lighting conditions. Don't get bogged down with details too soon; strive to capture the patterns of light and shade, using the colors and shapes you've decided upon. Seeing the entire painting in terms of these patterns of light, shade, color, and shape will help, particularly if the light shifts.

Once you have a sense of the whole picture, select an area that truly interests you. Paint this section as carefully, accurately, and quickly as possible. In this way, you'll manage to capture and anchor that transitory moment. Next, you should work out from this center of interest, keeping in mind at all times your overall first impression of the light. And remember to keep in touch with the changes occurring in that light.

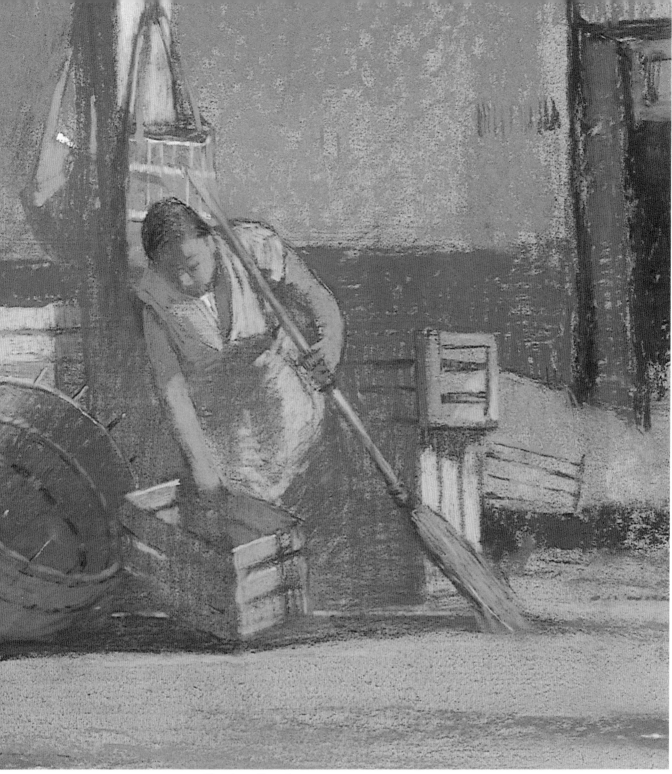

Getting Ready

Pastel on sanded board. 11 x 16 inches (28 x 41cm). Courtesy of the Ventana Gallery, Santa Fe, New Mexico.

For me, observing the activities of people in marketplaces defines a transitory moment. I consider a marketplace to be a stage set with unrehearsed characters walking about, bending over, talking with each other, and carrying goods. This sense of transition is enhanced by the age range of those present, which often includes infants, the elderly, and everyone in between. When you want to study and paint marketplaces, you should arrive early. Fewer people are about, it is quieter, and you can get a better grasp of some of these intimate yet transitory moments. In this pastel, I felt that the light, the proportions of the vendor with her broom, and her motions of leaning over and moving various empty crates were special. Through the use of drawings and photographs, I was able to capture this transitory moment and completed this pastel later in my studio. I played down details because I didn't want them to interfere with the sense of movement in the scene or with the fleeting moment.

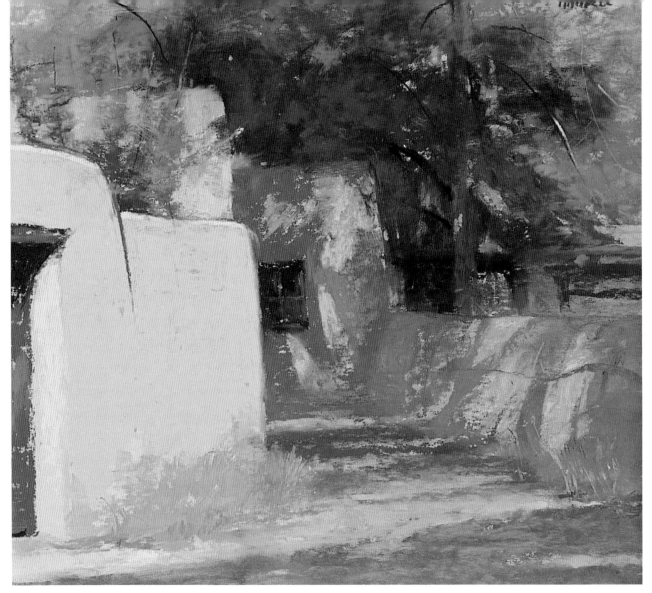

The Corner

Pastel on sanded board. 9 x 11 inches (23 x 28cm).
Courtesy of the Ventana Gallery, Santa Fe, New Mexico.

Santa Fe, New Mexico, has many old narrow, winding streets. When I came across this one, I was excited about the makeup of the strong patterns of light and dark colors, which I knew would soon change. To record this transitory moment, I quickly established the darkest darks first. I applied #298-P Nu-Pastel bottle green over #411-3 Rembrandt dark burnt sienna. I then added a subtle bit of dark purple, #536-3 Rembrandt violet, to this combination. Next, I added the remaining darks and the darks of the adobe. I then painted the adobe colors that were in light. I kept the details to a minimum; I included only those that helped suggest the colors and shapes. Although my painting time was short, I had to paint all of the colors and patterns correctly and have them relate to each other. Once I made these connections, I continually made subtle refinements until I felt the pastel was resolved.

Corrales

Pastel on sanded board. 14 x 20 inches (36 x 51cm).
Collection of Margaret A. Potter.

This pastel is composed of a complex arrangement of shapes and colors that make up a group of trees. I set these trees against a relatively simple foreground, thereby leading the viewer into the painting. The foreground includes the yellowish adobe wall that contrasts with the trees behind it. I knew the angle of the light streaming over my left shoulder would change, so I made a detailed drawing of the subject; I took note of the shapes and patterns comprising the trees. I also photographed the scene every half hour during the two hours I remained there. Later, upon viewing my slides, I realized that at one moment the light had a particularly magical, transitory quality. I made both an internegative and an 8 x 12-inch print of this slide, and then let the idea simmer for a while. Then during one of my workshops, I got a strong sense of place, of the town of Corrales, and of the light of that moment. Without any hesitation, I immersed myself in the painting. I painted rapidly, trying to recapture the feelings associated with the memory of a specific moment that in reality was lost forever.

Painting Light from Photographs, Slides, Drawings, and Visual Memory

When you paint light from photographs, slides, drawings, and visual memory in the studio, your understanding of light, color, and reality come to the fore. An advantage to this type of painting is that you have plenty of time to produce exactly the image you want. You aren't chasing after changing lighting conditions or dealing with bad weather, which you may otherwise be if you were painting outdoors. This approach enables you to plan your painting, design it, and make preliminary studies if need be. Also, when you work with oils, you can plan your painting so that you can achieve a unique quality of light through glazing and scumbling. Both of these steps are done at the very end when the painting is completely dry. Glazing and scumbling can result in a beautiful sense of light that direct *alla prima* painting doesn't offer. Paintings completed in this manner take time: paint quality can be built up painting session after painting session, letting you achieve a special depth in your finished work.

Photographs, slides, and drawings all trigger the visual memory and intuition. They feed my imagination and memory bank, which comprise the intuitive part of me. I am able to remember colors, light, and a sense of place simply by glancing at a slide. But I never try to copy it exactly. I've never seen a photograph in which I feel the light and every other element is just so perfect that all I have to do is duplicate it, making use of my more vast range of color to improve it. In relation to painting light from photographs and slides, I consider the light I paint subjective in orientation; this, of course, governs how I paint quite a bit.

New Mexico Richness
Pastel on sanded board. 16 x 22 inches
(41 x 56cm). Private Collection.

In this scene I noticed the warm blue of the sky and the cool blue of the cast shadows. These two blues are close in value, but they shouldn't be. The cool blue of the cast shadow on the ground should be much darker. I decided that for the sake of getting a general sense of light that I could lift the value of the cast shadow to where it is in the painting. This allowed the illumination to flow into the shadow area. It is framed on the bottom by the dark-brown colors of the ground. These dark colors, in turn, relate in value to the dark greens that are in sunlight. I was able to experiment here because I was working from a photograph.

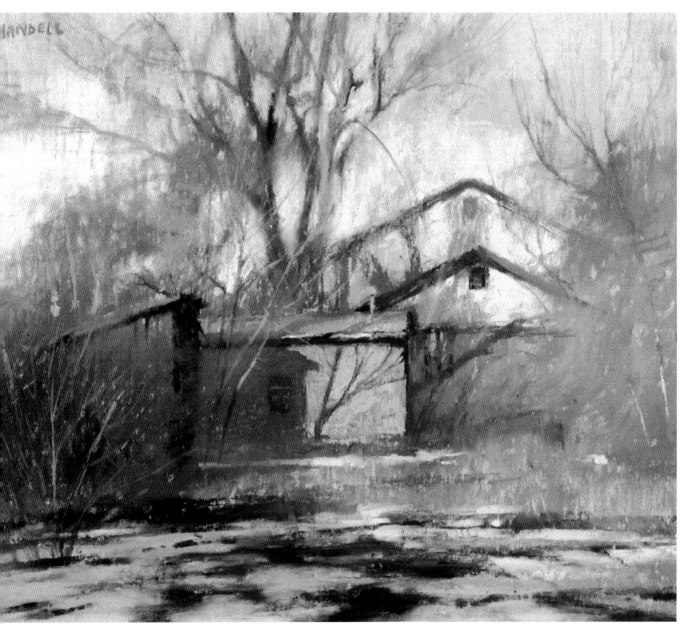

The Tin Roof
Pastel on sanded board. 9 x 11 inches (23 x 28cm). Collection of Glenda Spinks.

When viewing the slide of this scene, I realized that the darks in
the slide were much too dark. They became spotty and hampered the
flow of the light. In order for the light to radiate throughout the
entire painting, I translated the colors and the values so they were
lighter. I changed them so that they would relate better and not
appear quite so black or dark. I mixed three Rembrandt soft-pastel
colors: #408-5 raw umber, #409-5 burnt umber, and #548-5 blue
violet. These dark colors successfully translated the even darker colors
in the slide. Although I often don't think the images in photographs
and slides adequately capture the beauty of the light I want in my
paintings, they are nonetheless excellent references for me to compose
from. They serve as reminders of what is out there and touches what
is already inside of me; the colors, the understanding of lost and
found edges, the sense of weight, the understanding of massing, and
the flow of light that permeates an entire scene. I'm convinced that
my sense of light and my sense of color lie within me.

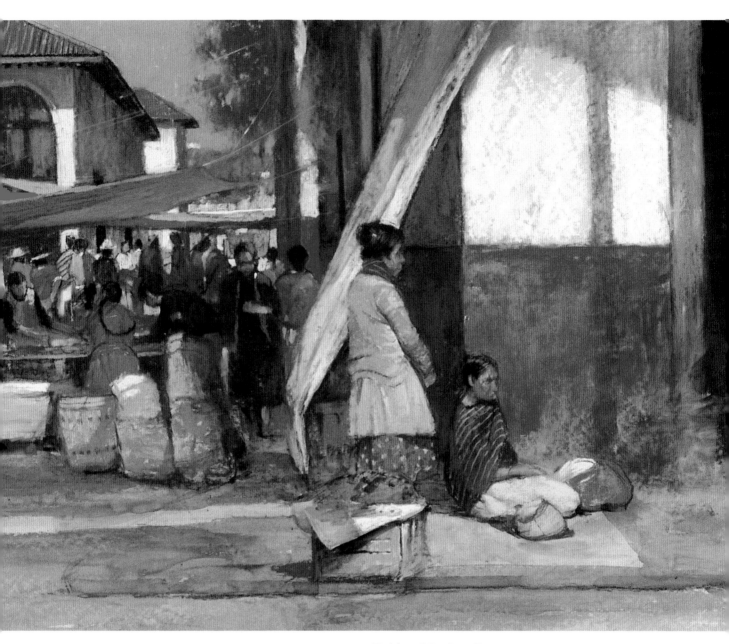

Friday Market, Patzcuaro

Pastel on sanded board. 22 x 28 inches (56 x 71cm).
Collection of Diane and Oscar Bassinson.

The material for this subject matter, shoppers milling about a crowded marketplace, is complicated. I recorded its complexity instantly through a few photographs. They captured the subject momentarily and enabled me to quietly study the scene and to compose as desired. Too many details in a photograph force me to choose which ones to include and which ones to eliminate. In one photograph, the standing vendor appeared to be wearing a dark-purple sweater, which stopped the flow of the light. I felt that a sweater the same color but lighter in value would allow the light to flow more freely from her yellow apron upward into her portrait. I played down the patterns of the shoppers and the white walls in the background. These patterns of white, which move from left to right, silhouette the shoppers. This effect, in turn, emphasizes the foreground vendor.

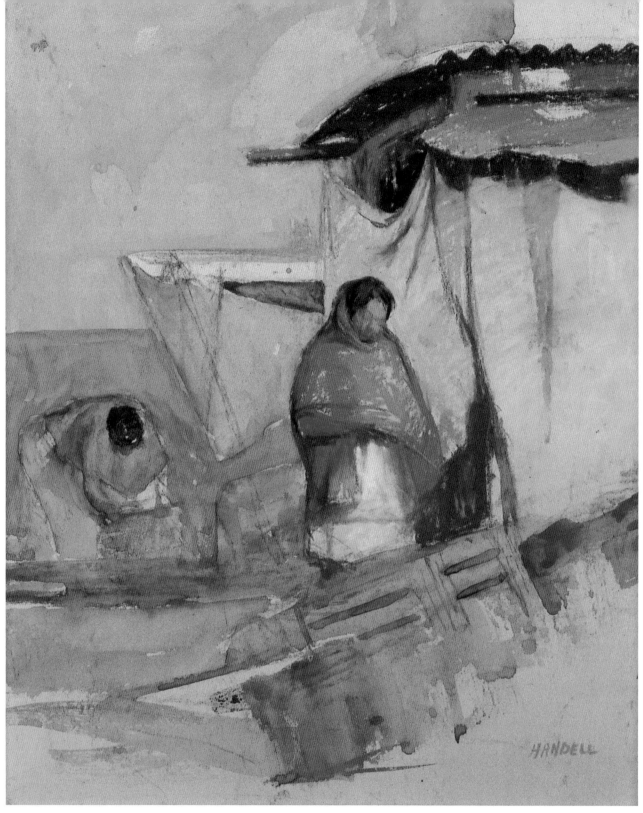

Early Morning Market

Pastel on sanded board. 11 x 9 inches (28 x 23cm).
Collection of Gary E. Van Acker and Pamela T. Bleier.

I painted this image of a young girl shopping at the open-air marketplace in San Miguel de Allende, Mexico, from a drawing. Unfortunately, I didn't have a great deal of time to complete the sketch so when painting this pastel I relied somewhat on my visual memory and my feel for the place. Although I worked the pastel loosely, it contains a good sense of the figure, a lovely sense of light, and a strong sense of place. I think that this loose feeling enhances the illumination of the entire work. To round out this quality, I used complementary colors and watercolor washes in the underpainting.

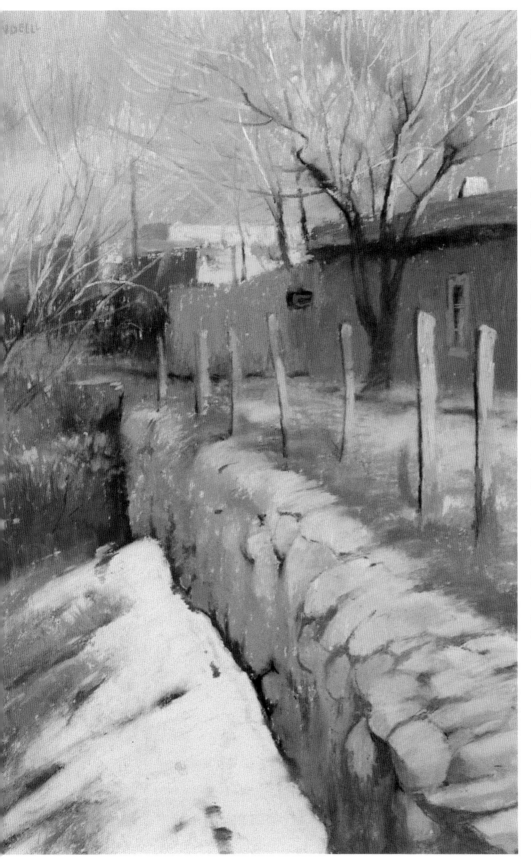

Upper Canyon Road

Pastel on sanded board.
13 x 19 inches (33 x 48cm).
Private Collection.

Because I'd made a detailed drawing of this subject, I wasn't too worried about what was in sunlight and what was in shadow as the light changed. Furthermore, while I sketched the scene, I wasn't concerned with developing a dramatic light effect. I designed the light-and-shade patterns later. In order to keep the viewer's eye moving throughout the entire work, I lifted the values of the cast shadows. To make them as light as possible without weakening them, I worked with Rembrandt soft pastels. I chose #409-5 burnt umber for the darkest bush in the shadow. I used #231-3 gold ochre and #227-3 yellow ochre for the lighter grassy areas, and #548-8 blue violet, #506-7 and #506-9 ultramarine deep for the snow. This lightening permits the viewer to see into the shadows and to enjoy them more. I was able to subtly alter these values and resolve these areas through the information available in my drawing. The sketch also worked as a diary. When I looked at it, it brought back my experience and conjured a sense of place from my visual memory.

Prevailing Light

For me, prevailing light means a source of illumination that diffuses over all the objects and colors in a painting. For example, prevailing light could take the form of the warm glow of late-afternoon winter light; in this painting, all the colors would have an orange tinge. This light is so strong that it doesn't matter if it is striking the dark greens of evergreen trees or the distant mauve-gray hills. All of the objects in the scene reflect the warm orange tones of the prevailing light.

This pervasive quality characterizes other types of prevailing light as well. Consider the rich blues and mauves of dusk. Before nightfall, just after the sun sets, a cool bluish tone usually dominates the landscape, a result of the prevailing bluish light of the sky. Then as the light becomes darker and more subdued, a purplish-blue tinge is visible in all the colors of the objects perceived. Thus, the entire scene is bathed in a cool prevailing light. While you can readily discern prevailing light in the winter, especially when snow is on the ground, you can also enjoy it during the long, lingering evenings of the summer months after the sun sets.

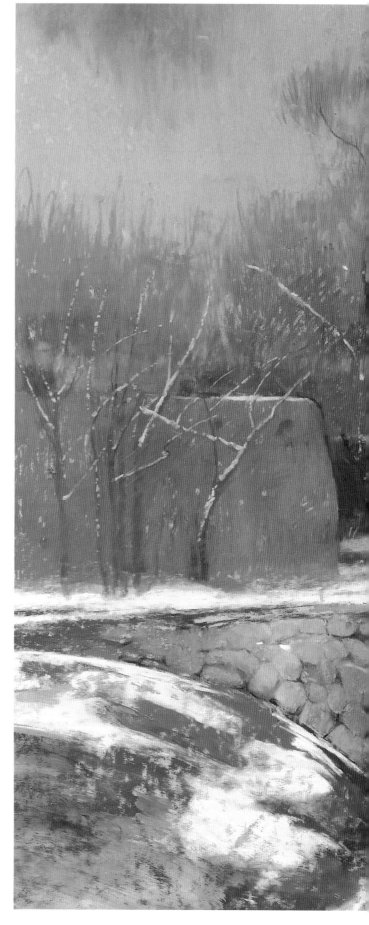

Spectacular Day
Pastel on sanded board.
16 x 22 inches (41 x 56cm).
Collection of Mimi Filley.

I painted this moody pastel with its complex arrangement of subjects on a rare Santa Fe gray day. To capture the mood and prevailing light, I softened all the colors by floating lots of browns, mauves, and grays throughout the painting. And because I softened the edges, too, the viewer's eye can drift from one color to another. Here, the fine-tuning of colors and edges makes the atmosphere and illumination in this scene realistic.

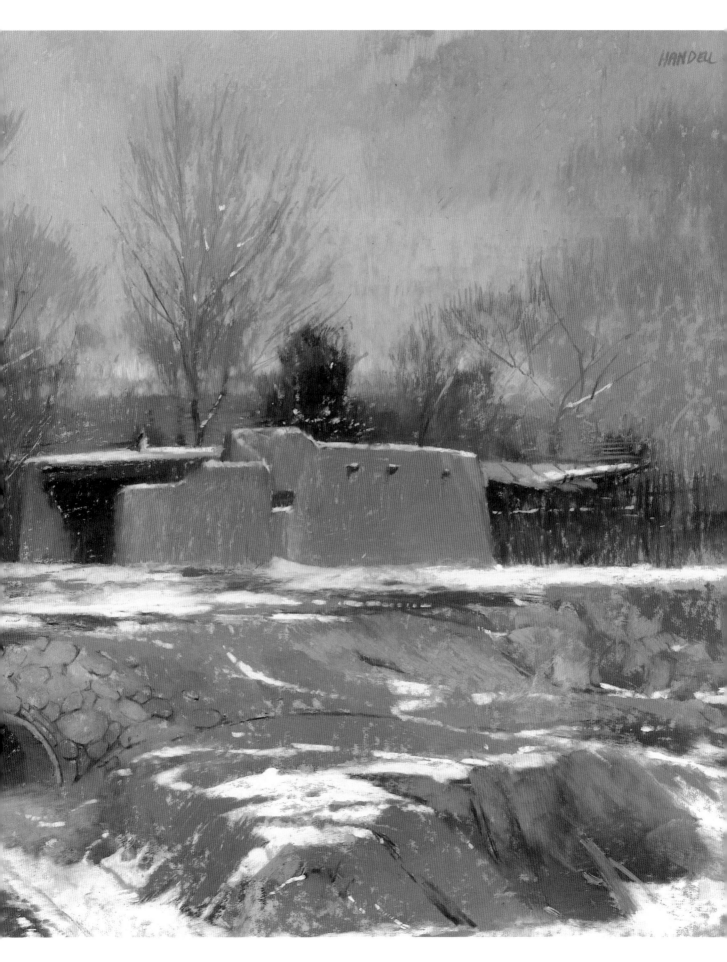

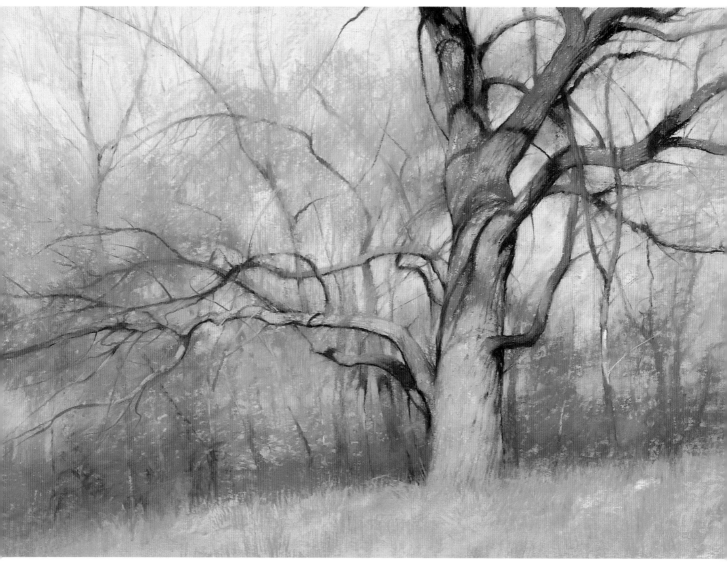

Le Grand Arbre

Pastel on sanded board. 22 x 32 inches (56 x 81cm).
Collection of Daniel J. O'Friel and Monica Steinhoff.

This tree stands majestically in the prevailing light of a winter morning. To adequately record its power, I simplified and played down the background contrasts. Next, I needed to harmonize all the objects and colors because I wanted to establish the feeling of place and to capture the light. Within this glow, I painted delicate but strong darks and subtle color variations to help accentuate the tree itself. Here, I used different colors of similar values. I limited the details and contrast to the tree in order to bring out its beauty. Here, I chose Rembrandt soft-pastel colors. To paint the sky, I used #572-10 turquoise blue, #570-10 phthalo blue, #538-10 violet, and #547-9 deep red violet. And for the darker blues at the base of the sky, I combined #506-7 ultramarine deep and #548-7 blue violet.

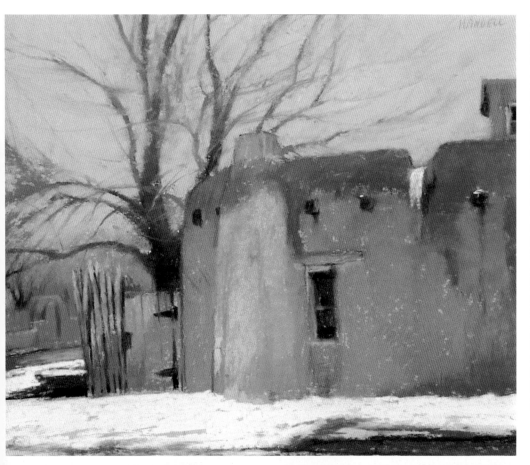

December

Pastel on sanded board.
9 x 11 inches (23 x 28cm).
Private Collection.

This pastel shows the prevailing midday light of a gray day, which is an unusual event in Santa Fe, New Mexico. I incorporated a bit of grayish purple in all of the colors in the painting. And by adding the smallest tinge possible in the white snow, I was able to harmonize the colors and obtain contrasts at the same time. Adding more blue or a purplish-gray color to the white snow would have suggested late-afternoon illumination. To establish color harmony, I used purple and purplish grays because I realized that they would complement the yellows of the adobe. Using blue would have made the painting too cold.

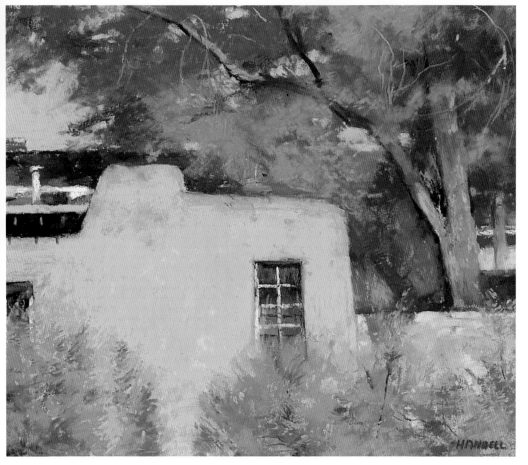

West San Francisco Street

Pastel on sanded board.
11 x 13 inches (28 x 33cm).
Courtesy of the Ventana Gallery, Santa Fe, New Mexico.

The prevailing light of a summer afternoon can be subtle primarily because the greens of summer are so intense. Although the greens in this pastel differ, they are warm throughout. This helps the viewer's eye, and the colors themselves, flow smoothly from the adobe color into the greens. The subject is bathed in a gentle glow that doesn't overwhelm the local colors. I used #273-P Nu-Pastel Tuscan red and #283-P Nu-Pastel Van Dyke brown to lay out the drawing and to balance the browns. I also used #298-P Nu-Pastel bottle green, for the darkest greens and worked up to my lights. The rich foreground greens are #608-5 Rembrandt chrome green.

The Interactions of Light, Color, and Value

Every color has a value, which can be either light, middle tone, or dark. These values relate to the gray scale in black-and-white photography, in which all colors are translated into values on a scale ranging from 1 to 10. When artists talk about color, they're automatically referring to value.

Light brings out the local color of an object. This is because each color absorbs some light rays and reflects others. The relationship or ratio of absorption and reflection determines the local color of an object. For example, when you see a yellow flower, this means that the flower has absorbed all of the colors of the spectrum except yellow. The flower reflects the yellow back, which you then perceive as the local color of the flower. If all colors are reflected back and none are absorbed, you have white. If all colors are absorbed and none are reflected back, you have black. If you were to translate a light-yellow flower into values, you would have a light-gray value on the photographic gray scale.

Light has an effect on the intensity of colors. When there is a complete absence of light, a color can't be seen no matter how intense it is. When there is little light and what is present is low-key, a color's intensity is also low. When more light is present, the same color is more intense. This is when an old saying rings true: "If you have the right value, you do not necessarily have the right color. But if you have the right color, you also have the right value."

There is, however, a fine point between light and color intensity. When the light is at a certain brightness, a particular color is at its most vibrant. But if the light increases and becomes too bright, the same color will begin to bleach out. With this understanding and awareness, a painter can express a great sense of light through color.

Mid Summer

Oil on Masonite panel. 20 x 24 inches (51 x 61cm).
Collection of Gene and Betsy Hackman.

Deep in the woods at midday, the contrasting patterns of light and shadow are strong. You must watch carefully, however, for moments when rich blues or purples sing out and define the shadows. When you paint strong colors, the challenge is to recognize their values, as well as to maintain their intensity while harmonizing them with the rest of the colors in the painting. When you achieve this, the colors stand on their own and accentuate the beauty of the light. For the very strong darks of the water and rocks, I used a combination of sap green and burnt sienna. Then as I raise the value of this color mixture, I add Naples yellow and Titanium white for the middle tones.

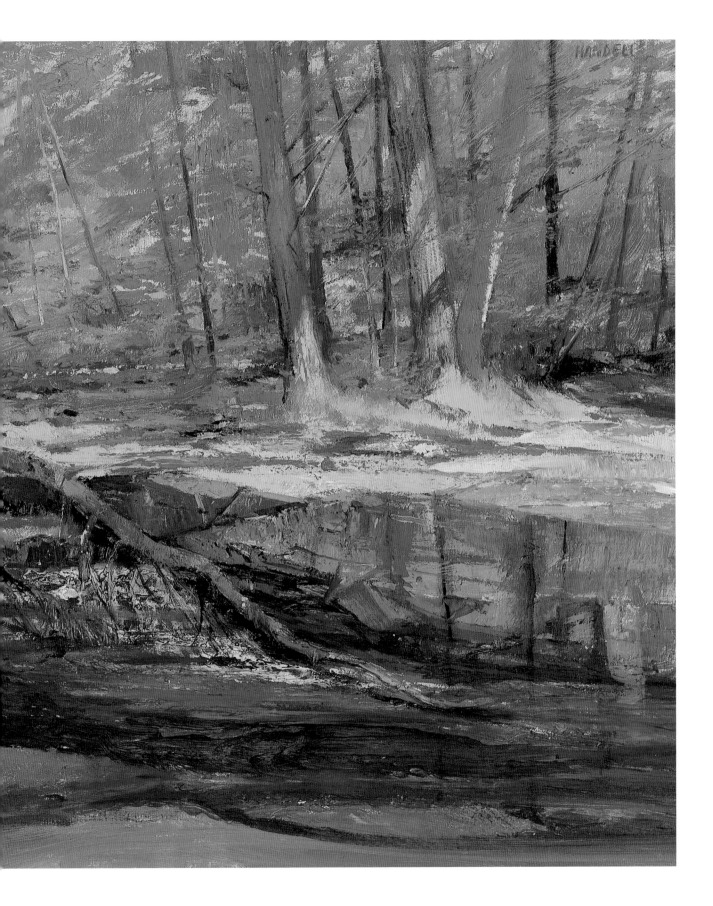

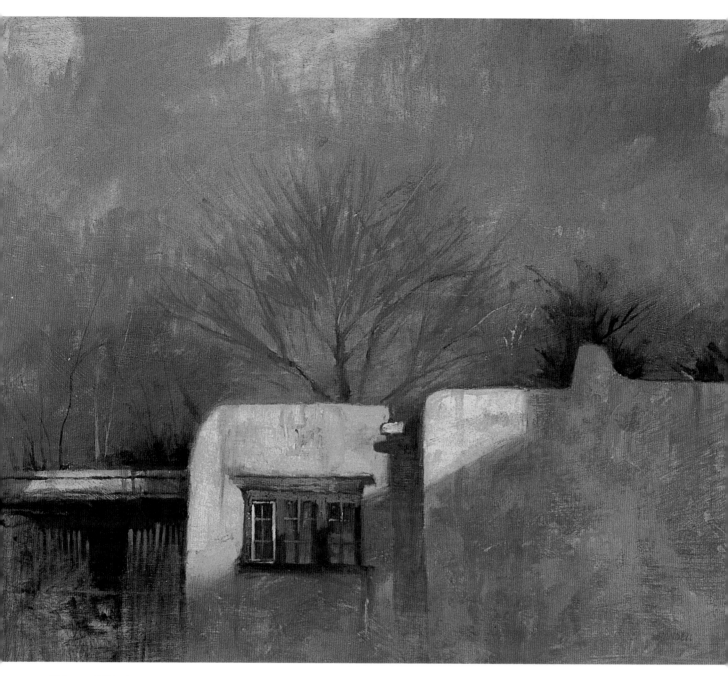

Hint of Light

Oil on Masonite panel. 24 x 30 inches (61 x 76cm). Private Collection.

This scene depicts a dramatic time of day. A yellow adobe
building that is partially in sunlight works quite well against
an ominous purple sky. This creates a dynamic sense of illumi-
nation because the colors of the sky and the adobe are strong
and have contrasting values. The reds of the trees are also
quite intense, but because they are so close in value to the
purple of the sky, they don't stand out. Certain types of light
are so luminous and have so much energy that I tend to
intensify colors by keeping them higher in value and transpar-
ent. In this way, they best express the sense of light I want.

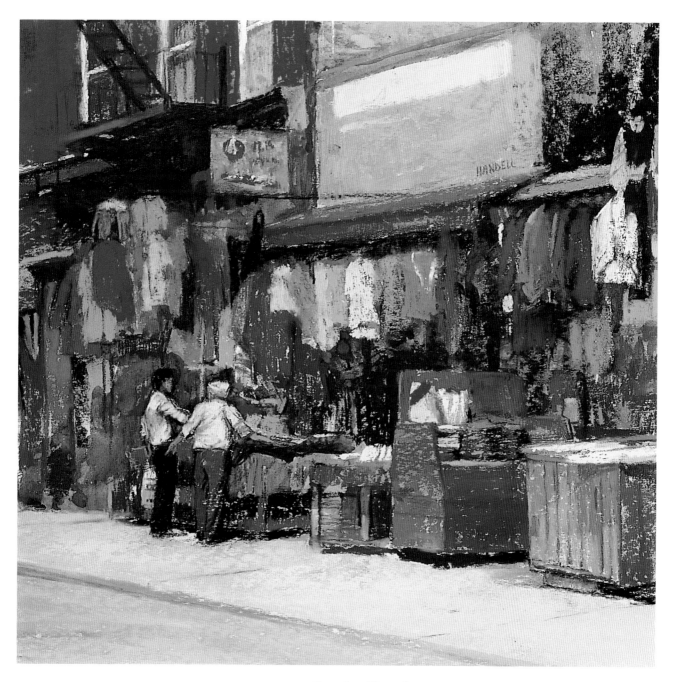

Sunday Shopping

Pastel on sanded board. 13½ x 13½ inches (34 x 34cm).
Collection of Jochen Haber and Carrie Chassin.

This work captures the light, color, and flavor of one of the many clothing and fabric stores on Allen Street on the Lower East Side of New York City. A strong light with contrasting values and intense color dominates this painting. The vibrant colors of the hanging clothes, the red building, and all the paraphernalia in the scene, including the street signs, are translated into rich patterns. The many contrasting colors actually cancel each other out, thereby establishing harmony and a breathtaking light and enhancing the composition. I began this richly colored motif with two Nu-Pastel colors. I used #263-P Indian red for the warm areas and #244-P blue violet for the dark areas. When necessary, I used black, too. All of the clothes in this scene were vibrant, but the sweater in the center of the image caught my attention. To render it effectively, I selected #675-7 Rembrandt phthalo green.

Light and Color Temperature

Color temperature describes how warm or cool a color is. Red, yellow, and orange are generally warm, while blue, green, and purple are generally cool. Every color, though, has its own degree of warmth or coolness. Objects have local color, but the color or type of illumination influence the warmth or coolness of this local color. Outdoors, local color is always modified by the color of the prevailing light, which comes from the sun or the sky or is the light reflected from nearby surfaces.

Color-temperature changes caused by light are important in conveying a true impression of a particular place and time of day in a painting. Early-morning light is often quite cool. Conversely, late-afternoon light is often very warm. Similarly, a fluorescent light bulb gives off a cool, greenish light, while a yellow light bulb throws a warm light. The light from a northlit studio is cool. Each of these kinds of illumination adds a specific vitality and luminosity to a painting. Warm colors come forward, and cool colors recede.

You can use color temperature to great advantage through optical color mixtures. Applying cool colors over a warm underpainting or warm colors over a cool underpainting and allowing the underpainting to show through enables the colors to vibrate and sing out.

Tucked Away.
Pastel on sanded board.
16 x 22 inches (41 x 56cm).
Collection of Lee and Thais Haines.

In this pastel, the colors are strong and subdued, yet quite harmonious. The tones in the background sky and mountains are warm and cool purples that are close in value, but with contrasting color temperature. The line of the dark green trees separates these background colors from the foreground. The foreground field of snow patches is rich with muted warm and cool colors in the yellow and tan families. A subtle interplay of grays and mauves slips in and out of the entire painting, tying together the illumination.

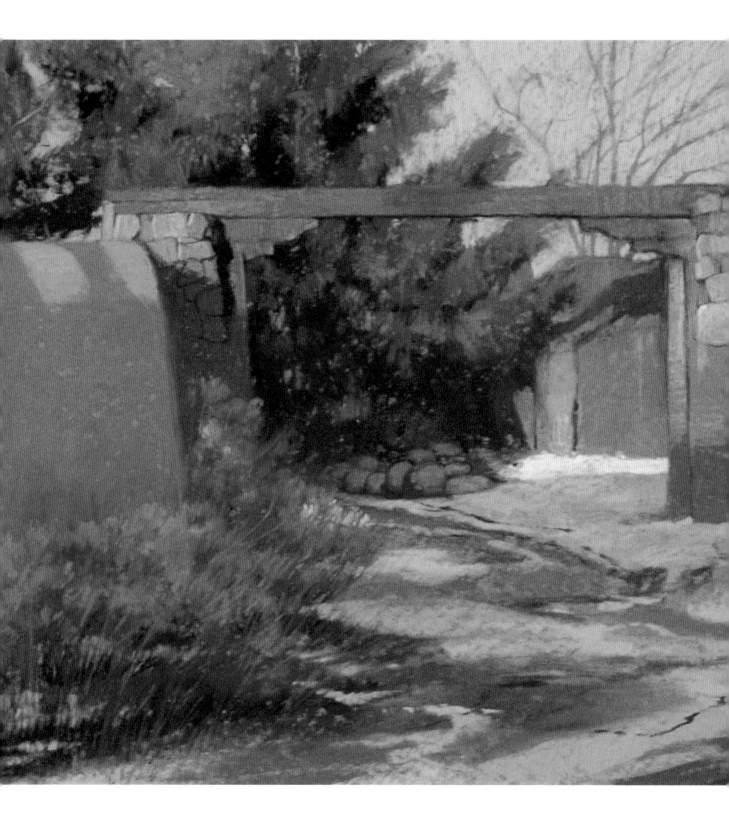

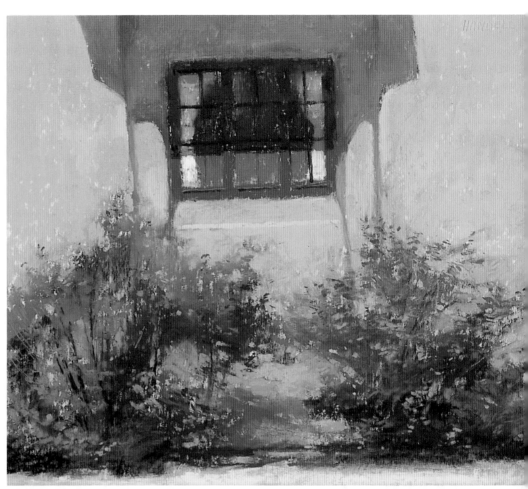

The Window

Pastel on sanded board. 9½ x 12 inches (24 x 30cm). Courtesy of the Ventana Gallery, Santa Fe, New Mexico.

Here, both the tones of the dark, cool greens and the darker, cool shadows of the adobe contrast with the warm, pink tones of the adobe that is in light. This combination was striking and added a sense of reality to the painting. The thin yellow border at the base of the composition, which is very bright and warm, gives a sense of the earth colors in strong light.

The Main Entrance

Pastel on sanded board. 16 x 22 inches (41 x 56cm). Collection of Dick and Donna Carlen.

In this pastel, the warm colors of the light areas beautifully complement the cool colors of the shadow area. Here, I watched as the light of the setting sun grew warmer as the afternoon slipped by one winter day. The late-afternoon light of this season provides ideal opportunities for blending warm and cool complementary colors.

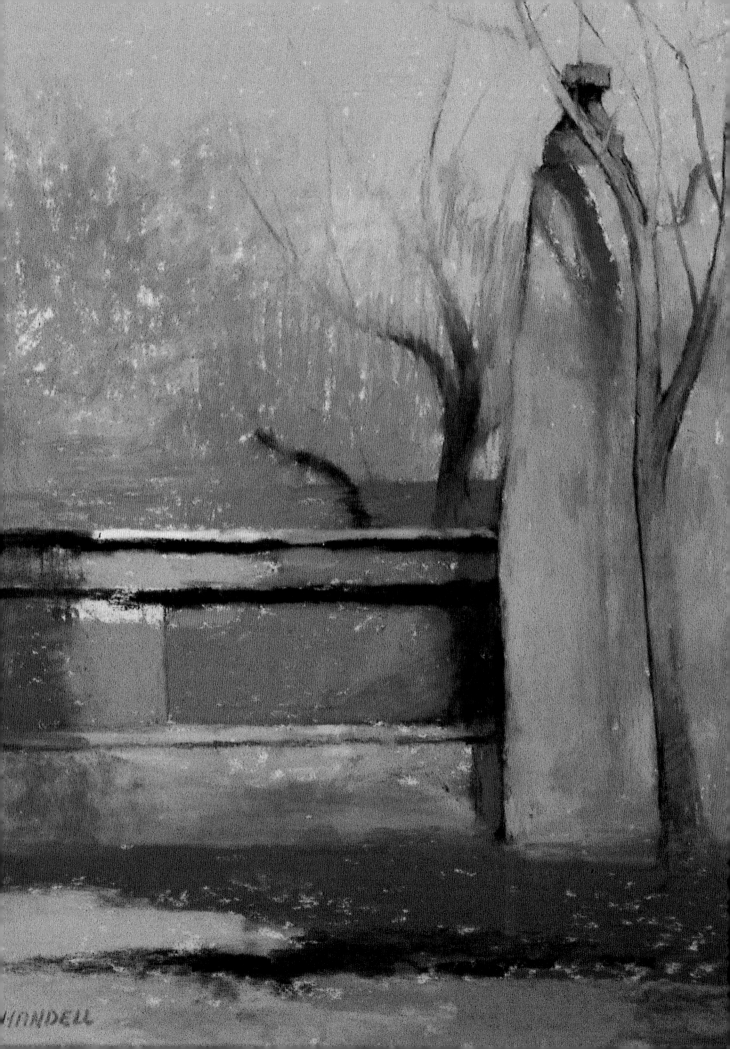

HANDELL

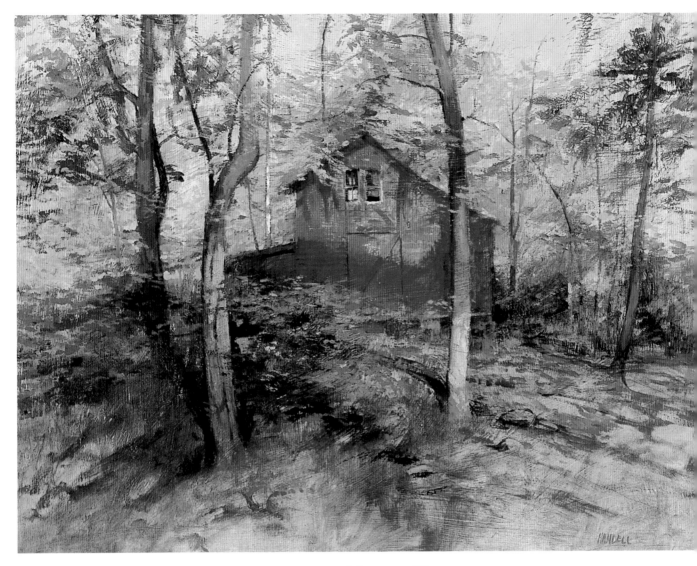

Afternoon Glow

Oil on Masonite panel. 18 x 24 inches (46 x 61cm).
Courtesy of the Ventana Gallery, Santa Fe, New Mexico.

To achieve this beautiful illumination, I had to take advantage of both color temperature and complementary colors. The red building and the reds of the lower ground work well with all the greens in the painting. Notice the subtle interplay of cool and warm greens, particularly right across the middle and top of the painting. This effect enhances the suggestion of space and light. The transparent underpainting, which immediately established a glow, shows through in the final stage. It adds yet another dimension to the light and the use of color temperature. I laid in the underpainting with turpentine on top of a white gessoed Masonite panel. I used very light, transparent yellow-greens in the top of the painting. Next, I applied an opaque yellow-green that was close in value. On top of this, I added cooler, richer greens for the details in the leaves. For the bottom of this painting, I started with Grumbacher Thio violet, Windsor Newton ultramarine blue, and burnt sienna. On top of this, by the red house, I used Thio violet, viridian, and sap green to tie the image together.

Solitude

Pastel on sanded board. 11 x 9 inches (28 x 23cm).
Collection of Jerry and Suzanne Owens.

In this pastel, the color temperatures of the warm oranges and cool purples interact effectively. The different temperatures of these colors, not their value contrasts, also establish the scene's compelling sense of light. This play of color temperature is visible throughout the painting, but it is particularly evident in the upright wall to the viewer's right. I used cooler colors in the lower part of the pastel, and warmer colors to bring out the subtle lights in the upper areas of the adobes and background trees. I kept the background purple of the sky cool in order to complement the warm lights of the foreground.

Composing with Light

As mentioned earlier, when you work, you must pay close attention to your first impression of a subject and then try to capture a sense of the light that is present. Always remember that the light in a painting is as important as the objects themselves, if not more so. Artists aspire to observe and record this illumination as effectively as possible in their work.

Composing with light has a great deal to do with the art of massing. To capture a radiant sense of light, you must accurately assess the values and colors of each area; you must also transform complex areas into masses. When organizing and massing in areas, whether they are in light or in shadow, you're designing and simplifying these areas. Sometimes you must take artistic license to accomplish this.

If you are able to translate an entire scene into simple, powerful masses and to design the masses into strong shapes and patterns that relate to each other, you can achieve a great sense of light as you compose your painting. This awareness of the massing will help you create a striking composition.

Remember, your first response to your subject was triggered by your excitement about the way it was illuminated. This is what captured your attention in the first place. Then as you successfully recreate the illusion of light falling on objects, a sense of reality enters your paintings.

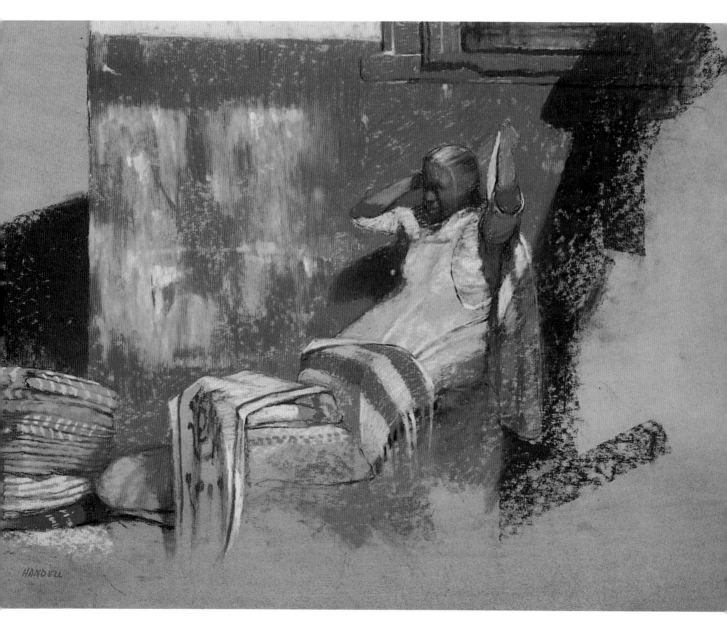

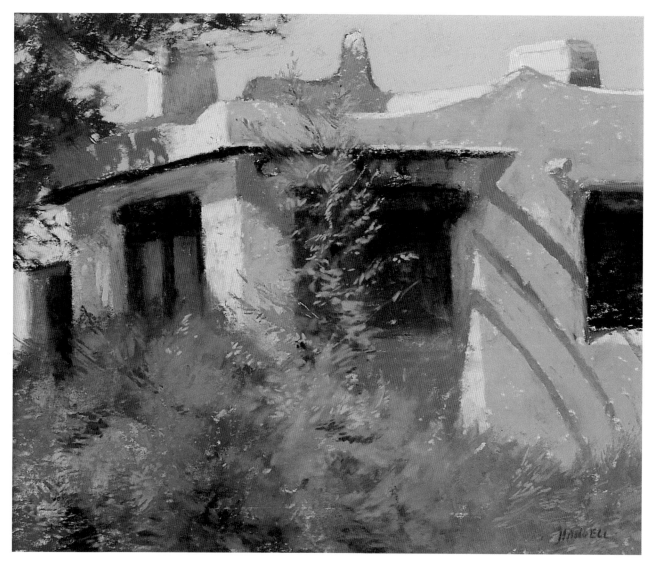

The Elderly Vendor

Pastel on sanded board. 16 x 22 inches
(41 x 56cm). Collection of Ed Davies.

Technically, I began with a middle-value gray tone. I
left it untouched on the bottom and right-hand corners
of the pastel, as well as in the upper left-hand area.
These parts of the work create interesting negative
shapes that surround the positive shapes of the vignette
of the painted areas. These untouched sections also
added to the careful placement of the darks, which help
to organize the light areas. I composed the light area
with colors close in value, so that the light would flow.
I increased this sense of fluidity even more by strength-
ening the dark areas. As a result, the viewer's eye can
travel easily in the light area between the garment the
subject is wearing and the objects she is selling. I used
#343-3 Caput Mortuum red, the richest, darkest red-
dish-brown Rembrandt color available, for both the
cast shadow on the red part of the wall and the hori-
zontal cast shadow on the wall to the vendor's right.
Then for the cool cast shadow on the left side of the
work, I used #727-3 Rembrandt bluish gray, which is
very close in value to the red.

The Adobe on Garcia Street

Pastel on sanded board. 9 x 11 inches (23 x 28cm).
Courtesy of the Ventana Gallery, Santa Fe, New Mexico.

The light in this painting is strongly directional. I never
lost sight of this as I worked all morning on this pastel,
even as the lighting conditions changed. Painting on a
hot June morning at one of my favorite locations in
Santa Fe, I lightly established the whole painting first. I
then worked out of the center of interest, the window
with the green foliage in front of it. Later in the morn-
ing when I finally got around to working on the upper
left-hand corner of the painting, the illumination had
changed quite a bit. The patterns of light on the build-
ing were now quite different from the patterns I'd
established earlier. I decided to dismiss them and work
with the original light instead. I continued to compose
the light and the cast shadows so that they interrelated.
This made the building seem solid and defined the
directional light.

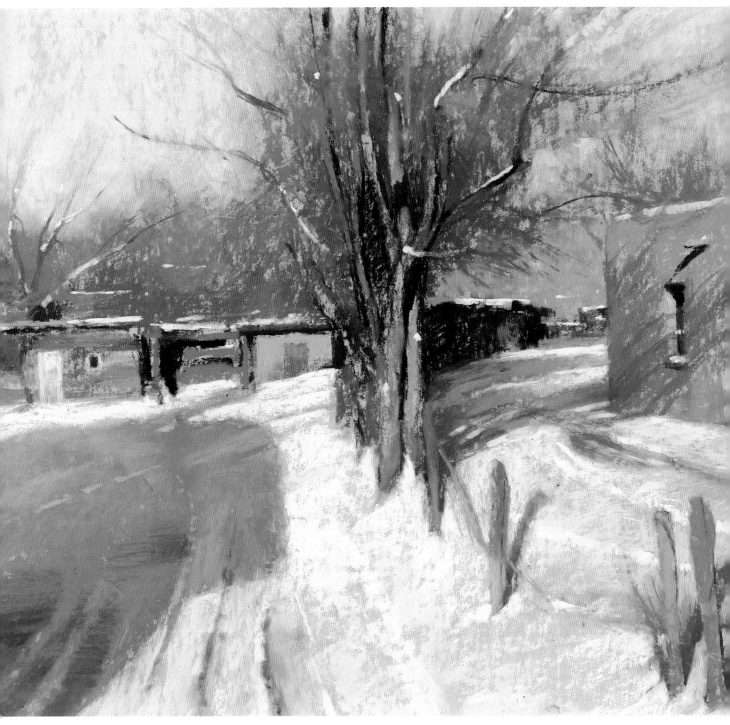

Winter Glory

Pastel on sanded board. 12 x 17 inches (30 x 43cm). Collection of Roberta Remy.

The cast shadows in this painting show the direction of the light, and coupled with the dark branches of the foreground trees create an interesting arrangement of shapes. These, in turn, surround the areas that are in light. While composing these parts of the painting, I minimized the number of details because I wanted the play of light to dominate the scene. As a result, the viewer's eye moves with the illumination, which isn't static. For example, I played down the details of the background buildings and the background trees on the left side, rendering them primarily as patterns and shapes. And by minimizing or completely eliminating some sharp lines and details and composing the light, I was able to merely suggest this area. Only a dark accent or two stand out on the buildings; I painted them with #409-3 Rembrandt dark burnt umber. I treated the snow in sunlight in the foreground in a similar manner: I kept details to a minimum, left the edges soft, and designed the area so the prevailing light seemed to flow gently throughout the pastel.

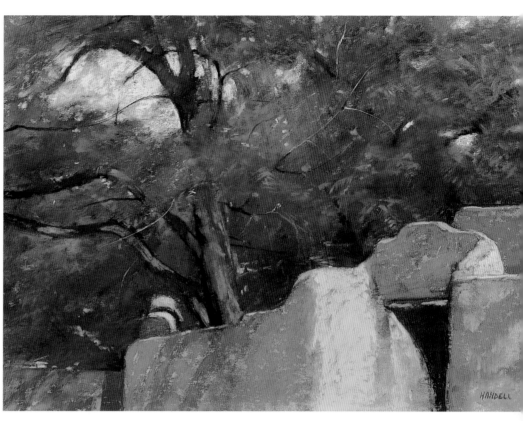

The Adobe Wall

Pastel on sanded board. 12 x 17 inches (30 x 43cm). Courtesy of the Ventana Gallery, Santa Fe, New Mexico.

In this painting, the light illuminates two distinct areas: the textured dark green foliage of midsummer and the light, warm, soft adobe colors. I had to place the line that separates the top of the adobe from the dark trees on the pastel board with utmost care. I moved this line down on the page, thereby lowering the adobe so that I could suggest the height of the trees. I painted the trees with #609-5 Rembrandt chrome green deep, a cool green, and with warm pastels, #608-5 and #608-7, both Rembrandt shades of chrome green light. Next, I subtly composed the light on the dark foliage in such a way that the tree area remained dense; I used #409-5 Rembrandt burnt umber, a reddish brown, into the foliage. I painted the light on the wall in a manner that brought out the different planes of the adobe. I then designed and played down the placement of the lightest areas on the wall in order to lead the viewer's eye into the painting. This also helps achieve a sense of space.

High Key and Luminosity

The tonal color key of a painting comprises the overall value and color taken from the different values of all the colors in the painting. It encompasses the lightness or darkness, the warmth or coolness, or the actual color itself. This color key can affect the finished painting's mood and luminosity.

In a high-key painting, the colors and values remain light in tone, thereby providing a sense of brightness. High-key paintings relate to feelings and personalities as much as they do to their subject and lighting conditions. They strike a happy, lyrical note. When working on a high-key, luminous painting, you should keep strong value contrasts to a minimum. You don't want any element to adversely affect the mood you want to establish. The overall impression that a high-key painting leaves should be one of lightness, brilliance, and softness.

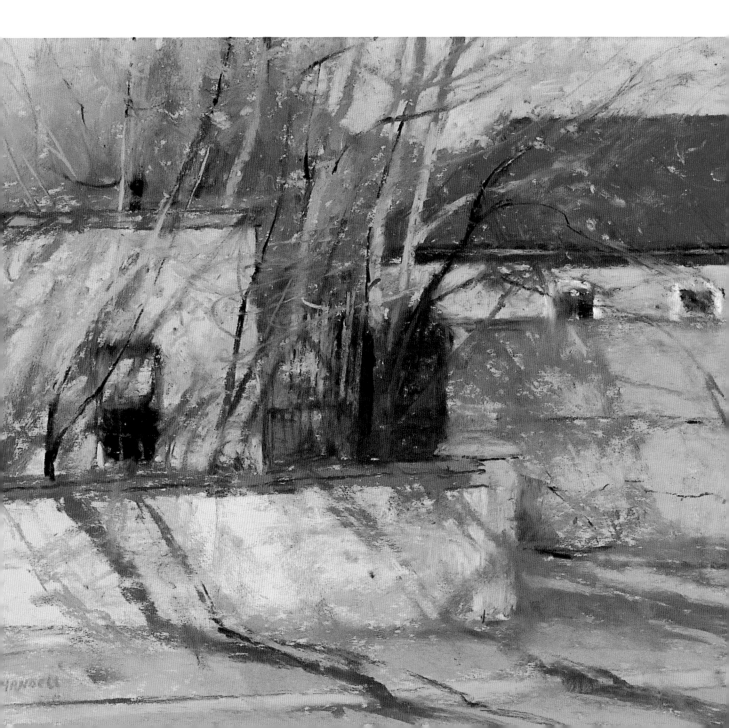

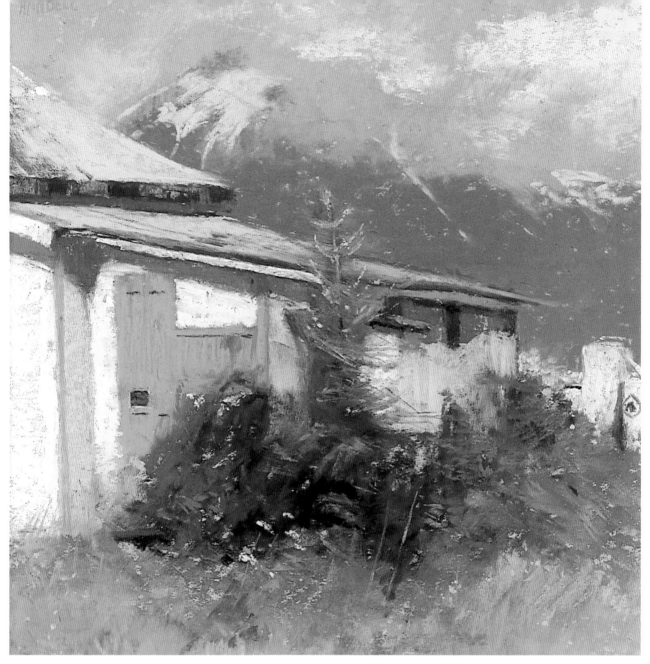

Mountain Whispers

Pastel on sanded board. 10½ x 10½ inches (27 x 27cm).
Collection of Kimberly Nesselhauf and Don Gregg.

While on a painting trip with friends in Alaska, I came
across this old white building near the pier in Sitka. The
sky was cloudy yet luminous, casting a strong prevailing
light over the entire area. At times the sun broke
through the clouds, hitting the white building and rais-
ing its value still more. The greens in the foreground
were quite rich, contrasting nicely with the whites of
the building. I added some purple to these colors in
order to provide a contrast to the overall colors of the
painting. The different shades of purple brought out
the distant mountain. This bolt of color contrasts effec-
tively with the subtle nature of the painting.

Garcia Street

Pastel on sanded board. 10½ x 12 inches (27 x 30cm).
Courtesy of the Ventana Gallery, Santa Fe, New Mexico.

On a sunny winter afternoon at about 2 P.M., I noticed
this arrangement of high-key colors that made up
buildings, trees, and sky. I realized immediately that the
whole scene was luminous. The foreground buildings
and wall were quite warm, and the right-hand building
was capped with a rich, red roof. The roof contained
some of the richest and darkest colors of the painting.
Although the red was comparatively intense, it actually
wasn't very dark at all. All the other colors were light
and airy, manifesting only subtle variations of color that
separated different areas of the painting. I kept the cast
shadows relatively high in key but on the cool side for
contrast and clarity. The brilliance of these high-key
colors added to the overall luminosity of the subject.

Low Key and Resonance

A low-key painting is characterized by darker colors that relate to the lower end of the value scale. These darker colors resonate, especially in oils, and sometimes produce a somber, mysterious feeling. Low-key paintings that lean either to the warm or cool side read better; the warmth or coolness increases the paintings' resonance. And adding relatively small touches of brightly illuminated areas to low-key paintings can sometimes have a powerful effect. For me, the choice of the key of a painting can be conscious or unconscious. I always keep in mind that moods can be created. For example, a scene painted in a low key could seem quite serious and dramatic. Then if you were to paint the same subject in high-key colors, the finished painting might suggest joy and contentment.

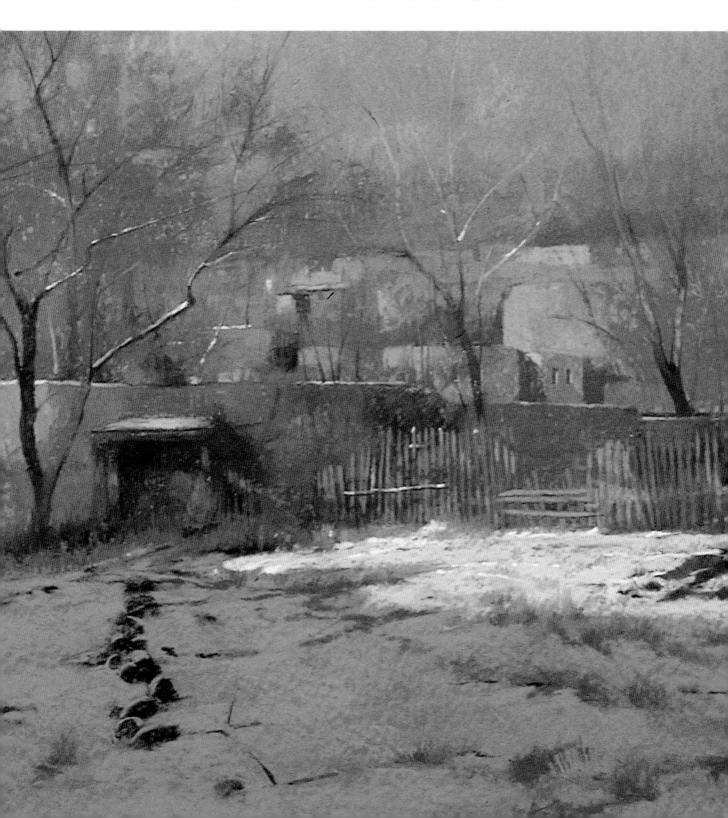

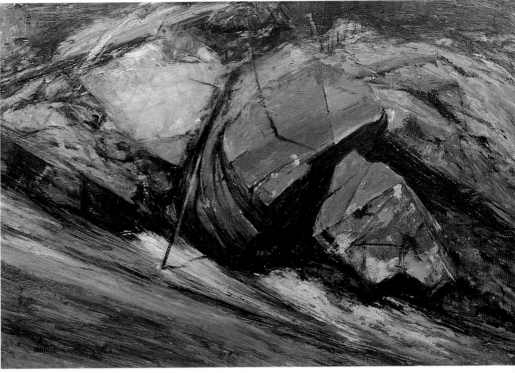

Full Tilt

Oil on Masonite panel. 16 x 24 inches
(41 x 61cm). Collection of the artist.

Here, I focused on a group of rocks
and earth that provide the image with
a well-defined tilting sensation. A fast-
moving runoff rushes past them, wash-
ing away even more of the soil. The
day was cloudy, so all the colors were
low in key but rich. Once I'd estab-
lished the color pitch of the painting, I
was able to work on the variations and
specific parts of the rocks that held my
interest. This called for a great deal of
observation and painting of detail. To
make the rocks dark, I used a great deal
of ultramarine blue and a little burnt
sienna. The whites in both the water
and the rock help produce the reso-
nance of this work.

A Touch of Red

Pastel on sanded board. 22 x 28 inches
(56 x 71cm). Private Collection.

In general, I kept the colors in this pastel low
in key and played down the warm, light col-
ors on the adobe. To achieve this, I included
little bits of blue-gray of the same value as
that of the adobe. The sky appears ominous,
which adds to the richness and resonance of
the painting. I modified the intensity of the
white snow to keep this area in harmony with
the low-key colors and overall resonance of
the work. Because of this, you feel as if you
can walk into this area.

Achieving Luminosity Through Variations of Different Colors of the Same Value

Nothing is ever dull in nature. Light and luminosity are always present, vibrant and dancing. The quest of the artist is to capture this. I regard luminosity as light with energy. It can be the sun, the source of natural light, or it can be the light energy as it travels and echoes, illuminating objects as it fades away into space.

To achieve luminosity in a painting, you don't have to change values in order to produce a variety of vibrant color. On the contrary, varying the colors without altering the values can lead to rather beautiful and intriguing effects. This is especially true of large, well-massed areas in which you don't want to break up their simplicity. Cast shadows provide good examples of such areas. Sometimes they are quite big and strong. Since they can separate the light and the dark parts of a painting, you don't want to interrupt or lose them. In this way, the viewer's eye is able to flow from one color to another; it isn't jarred by abrupt changes in value. This allows for soft edges between colors, for more subtlety, and for a play of color that creates an appealing sense of luminosity and harmony.

Shadow areas have darker colors and usually contain less value variation than light areas do. However, many shadow areas do contain some variation of color and value because, in part, of the presence of reflected light. If you want to achieve a sense of mystery within the shadow areas when the reflected light isn't too strong, you should blend several different colors of the same value; you can also layer them within the area. Both techniques result in a radiant glowing luminosity. You can use the same approach for the light areas, but the effect is less obvious and more difficult to achieve simplicity because the eye sees more in the lighter areas.

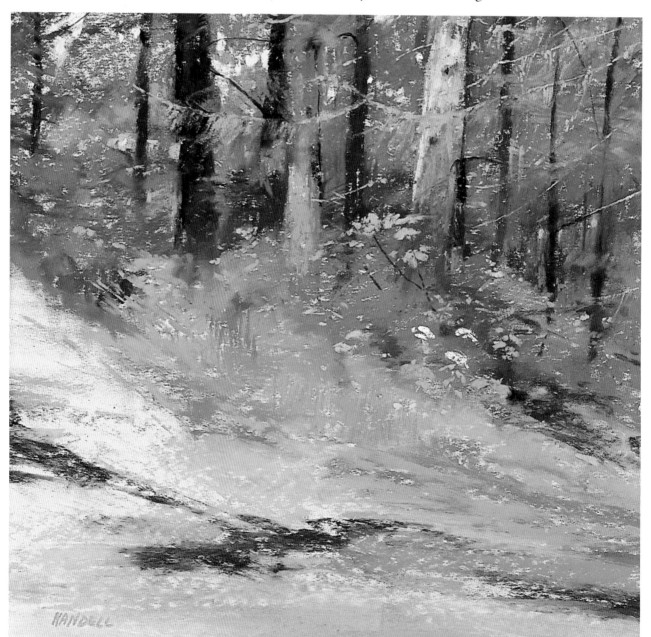

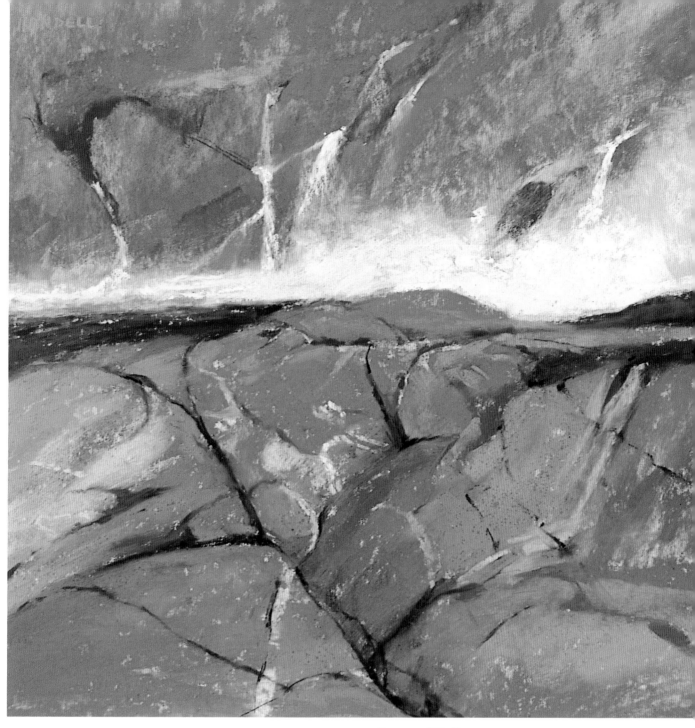

Baranof Falls

Pastel on sanded board. 10½ x 10½ inches
(27 x 27cm). Private Collection.

I designed this luminous pastel by composing with
large subject areas. The foreground group of rocks
holds the viewer's interest and attention. To capture
the beautiful light on them, I simplified the rocks by
interpreting them as a strong mass. I then painted
into the area with pinks, purples, grays, and greens
that are close in value. They add to the general sense
of light and provide a striking contrast to the white
foam and dark water. This arrangement of color also
allows for detail work in the strata of the rocks. The
background rocks are less detailed. The variety
achieved in them primarily results from the interplay
of different colors that are close in value.

Petersburg Woods

Pastel on sanded board. 11 x 9 inches (28 x 23cm).
Collection of Dr. and Mrs. Roger Eichman.

This work has a rich, light quality. The top half of the
painting has much more tonal variety than the lower
half. Although I used some semi-darks in the ground,
I basically painted it with yellowish and reddish colors
that are close in value. These colors drift into the
underlying greens that touch these areas and are close
in value to them. All of these high-key colors permit
the viewer's eye to pass from one section of the paint-
ing to the next, thereby helping to create the flow of
light throughout the pastel.

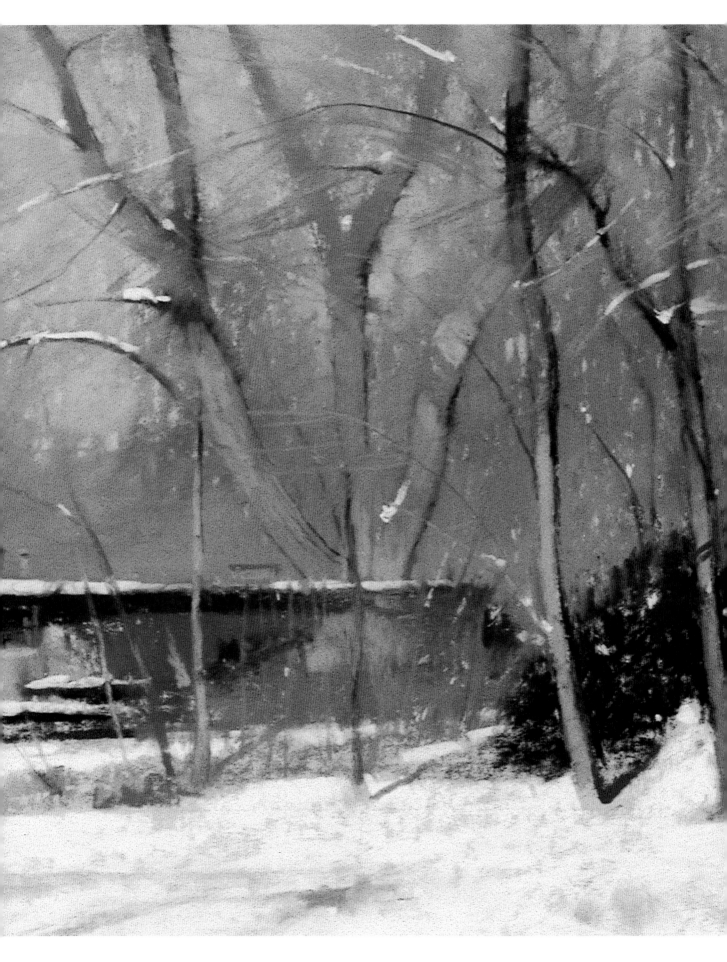

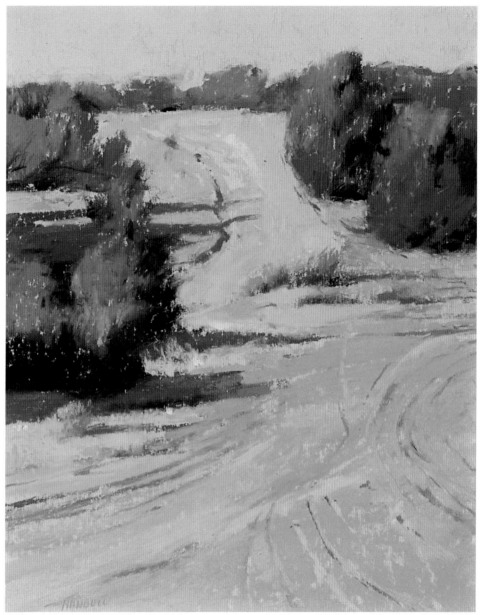

La Tierra

Pastel on sanded board. 11 x 9 inches (28 x 23cm). Collection of Dave and Barbara Rickel.

For this simple pastel of pinon trees, adobe, earth, and sky, I placed the horizon line high. The painting contains basically three areas of color: the adobe colors of the ground, the greens of the pinon trees, and the blue sky. I painted the blue of the sky as a flat matte area with #062-M Schmincke ultramarine blue. Then to provide even more contrast, I painted the shape of the exposed adobe-colored ground and earth by changing only the colors within these areas, not their values. The entire area reads clearly and is bright and luminous with subtle color variations of light oranges and pinks. I repeated this effect slightly in the pinon trees, thereby enabling the illumination to flow throughout the pastel without interruption.

Too Cold For a Picnic

Pastel on sanded board. 9 x 11 inches (23 x 28cm). Private Collection.

Although the background of this pastel is varied, I wanted to keep the suggestion of the background trees simple and uncluttered. My main goal here was to have the trees enhance the painting's luminosity. I used rich complementary colors from the Rembrandt soft-pastel line that are close in value. As a result, the background doesn't come forward or impede the flow of prevailing light. For the warm areas, I selected primarily #227-3 yellow ochre and #231-3 gold ochre. I balanced these sections with #547-5 red violet deep and #548-7 blue violet.

Defining Form Through Patterns of Light and Shade

If the light in a painting comes from one source, then all the planes facing that source will be the brightest planes in the work. Conversely, all the planes facing the opposite direction—away from the light source—will be the darkest planes in the painting. The sense of form will be quite strong, and the patterns of light and shade will reveal the direction the light is coming from. Usually all the planes that are illuminated receive the same light throughout the entire painting even if the form is square or round, or even if the light becomes weaker. This also applies to shadow areas, as well as to the areas that make up the halftones. There is a continuity to both the halftone and the shadow planes, which explain the form elegantly. This results in a unifying effect that clearly shows the various directions of the planes, which comprise the rich forms, and shows the direction of the source of light.

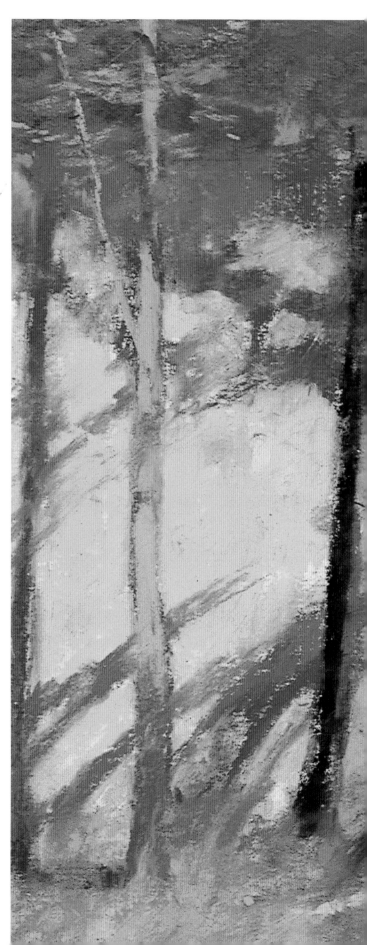

Shadows

Pastel on sanded board. 9 x 11 inches
(23 x 28cm). Collection of the artist.

When I came across this simple subject, the angle of the beautiful morning illumination indicated that the light was going to change quickly, and it did. The patterns of light and shade made me realize this immediately. This is important because the planes that are in light and the dark patterns against the light patterns are intrinsic, unifying parts of the painting. I established them quickly and kept them even after the light changed. My next step was to develop form and detail, working on one area, finishing it, and then another. As I completed each area to my satisfaction, I was better able to relate the next contingent area. Although some may think that this subject borders on the mundane, the painting is interesting because the complexity and beauty of the patterns of light and shade tie it together. Furthermore, the forms in the scene are quite appealing. After painting the various grays of the stacked poles and young trees, I contrasted them with two strong adobe colors: #04-H Sunproof yellow 3 deep and #042-H Permanent red I pale. These Schmincke soft-pastel colors are close in value and so are easy to mix.

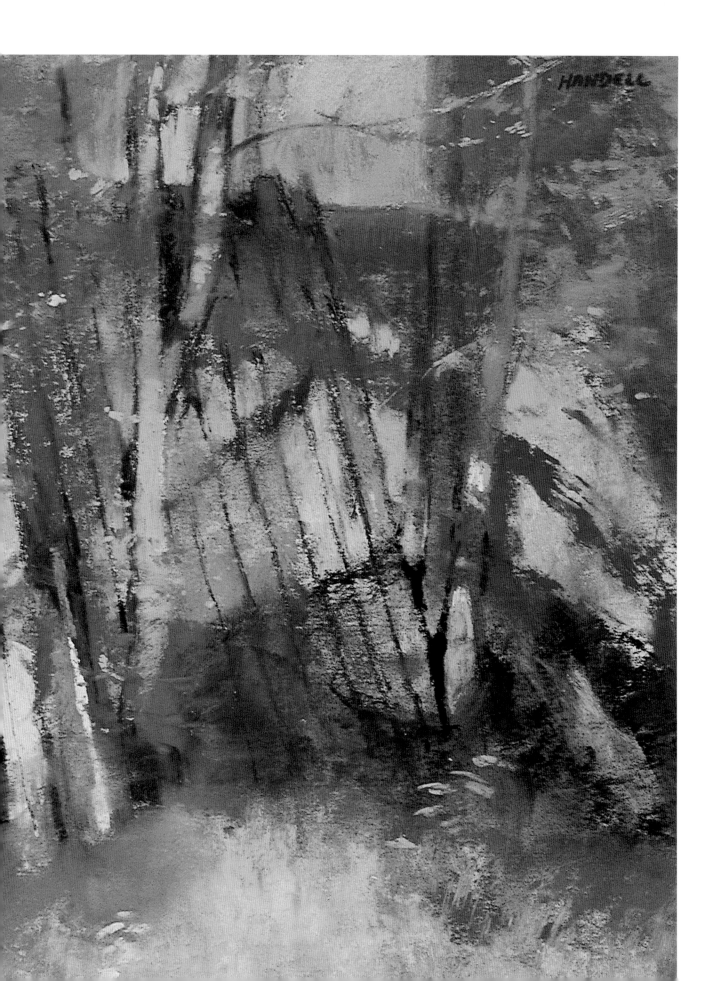

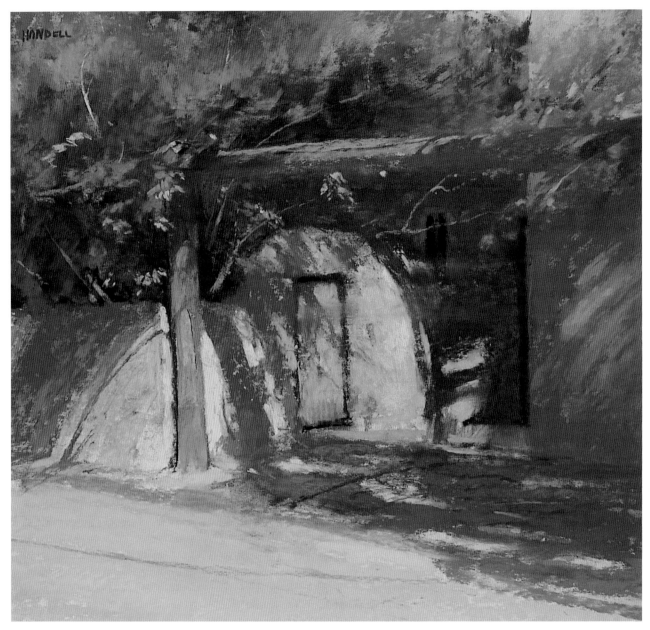

Hacienda Gate

Pastel on sanded board. 12 x 12 inches (30 x 30cm).
Courtesy of the Ventana Gallery, Santa Fe, New Mexico.

This pastel proved to be a complicated challenge. Here, I was in close in to
the subject, which is actually simple in nature; the play of light on it was fas-
cinating. I immediately had to establish the patterns of shadows and light
and the form within the doorway. Working from dark to light anchors the
tonal relationships of a painting. The patterns were strong and decisive—and
are the true subject of this pastel. The remaining patterns of light and shade
rounded out the composition. Then to resolve and unify the painting, I
included carefully selected details. Weaving the patterns of light and shadow
and varying the colors of the objects play important parts in making this
painting beautiful. To do this, I choose primarily one color to represent the
shadow area. Here, I used #343-5 Rembrandt Caput Mortuum red, applying
it heavily and lightly in different sections. Then I selected Rembrandt soft-
pastel blues and greens that are close in value to this shade of reddish brown
for the remaining areas of shadow. I used #608-5 and #608-3, chrome green
light, for the green areas, and #727-5 bluish gray for the cast shadow. These
different colors add variety to a large shadow mass.

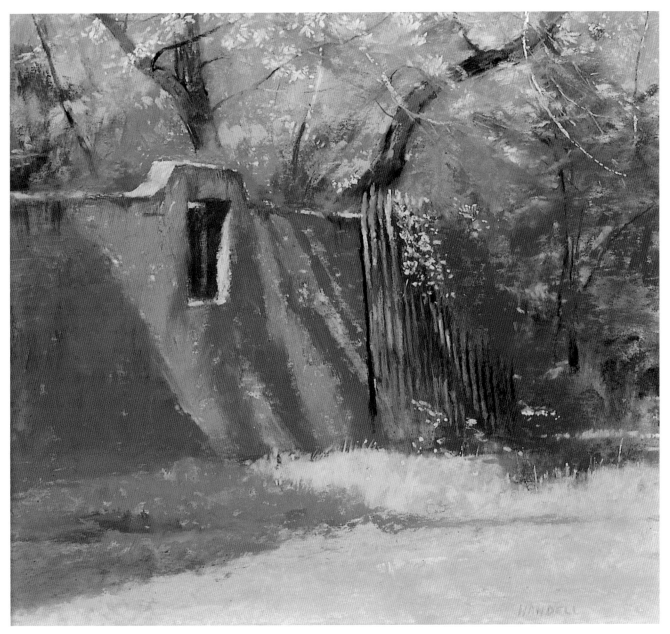

Hidden Vista
Pastel on sanded board. 9 x 11 inches (23 x 28cm).
Courtesy of the Ventana Gallery, Santa Fe, New Mexico.

In "Hidden Vista," the exquisite patterns of light and shade and the strong forms not only unify the painting, but also are the subject of interest. In fact, without them this pastel wouldn't exist; they are, essentially, the backbone of this work. My understanding of light, patterns, and form served me well here. As I worked on this pastel, the light-and-shadow patterns and the forms changed rapidly. I decided, however, to stick with my original observations. I put them in with #283-P Nu-Pastel Van Dyke brown, a rich, dark-brown pastel. I then blended slightly lighter reddish-browns into that color. These forms and patterns define the light that falls on the adobe wall and the surrounding areas. I finished the window first, determining its proper size and placement on the wall. I then translated the shadow into a simple, dark shape. Next, I established the plane that receives the strongest light, both on the side of the window and the top of the wall. The painting continued from there. Every section of this pastel contains patterns of light and shade and form that read beautifully.

Light, Atmosphere, and Lost and Found Edges

The art of lost and found edges is delicate. Nevertheless, you can achieve a strong sense of light and atmosphere through their use. Furthermore, they help create the illusion of three-dimensional space on flat surfaces. Lost and found edges also help to define the advancing and receding planes of objects, as well as how the light affects them.

As mentioned earlier, a lost edge is an edge where objects of different colors but of the same value meet and touch. These objects can be in the foreground, the background, or a combination of both. When their colors meet and touch, they automatically have a soft edge. This linkage permits the viewer's eye to travel from one object to another or from one area to another. This adds to the visual flow and the sense of light and atmosphere throughout the painting.

When the different colors of similar values are dark colors in the background, the viewer's eye moves easily from one color to the other. This color scheme also makes the background seem mysterious. In addition, the soft, nebulous use of boldly established lighter colors with contrasting sharp edges is easy to read and produces a radiant sense of light.

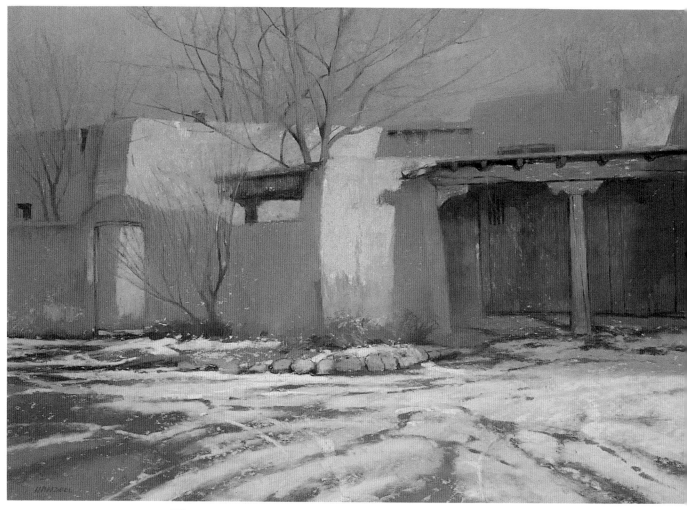

Winter Revue
Pastel on sanded board. 16 x 22 inches (41 x 56cm). Collection of Chuck and Sharon Trauth.

The light and atmosphere of "Winter Revue" contribute to the special mood of this work. They're enhanced by a subtle play of lost and found edges. The contrasting edges stand out, so they're easy to find. But it is the lost, or played-down, edges, that are important in terms of the mood in this pastel. The light colors on the adobe stand out against the sky, which is a rich purple-gray color. The shadow colors of the adobe are close in value to those of the sky. This is where the edges are lost. This adds mystery to the work and at the same time provides a lovely sense of atmosphere and light. Finally, the patterns of the snow patches on the ground lead the viewer's eye into the painting.

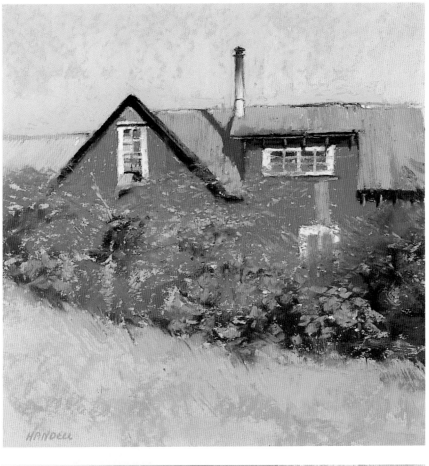

Green Mansion

Pastel on sanded board.
10½ x 10½ inches (27 x 27cm).
Collection of Ray and Peggy Bailey.

During a painting trip to Alaska, I discovered this subject in one of the small Indian villages my friends and I visited. The subject of this painting, a rich, blue-green house, is very strong in color. The color of the warm-green hedges in front of it has a fair amount of gray in it. Within the context of this pastel, the values of these two greens are close. Although the house was stronger in color and perhaps a bit darker in areas, I was able to soften the edge between the house and the hedge. Sometimes I blend the colors with my fingers. This unites the two areas, allowing the light to flow between them, and creating a sense of light and atmosphere. I then painted the various subtle color variations of the hedge and some of the details of the leaves. The brighter, high-key colors above the house and below the hedge frame them. I softened some of the edges of the roof and sky in order to increase the mystery, flow of light, and atmosphere in this pastel.

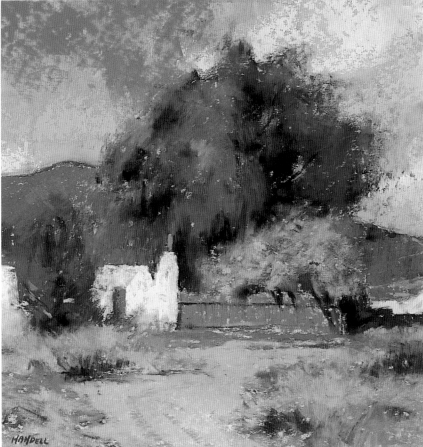

Oasis

Pastel on sanded board.
11 x 11 inches (28 x 28cm).
Courtesy of the Ventana Gallery,
Santa Fe, New Mexico.

Beautiful light permeates this pastel, thereby enabling the viewer to enjoy all of its components. The colors in the foreground are high key for several reasons. First, the sky began to cloud up on what had been a sunny afternoon. In order to bring out this exciting effect as the light struck the foreground, I had to paint the tree and mountain in darker colors, simplifying them. As a result, the edges of the tree and the mountain are lost. But after taking in this quiet area, the viewer is suddenly jolted by the bright colors and sharp edges of the building. This effect creates a wonderful sense of light and atmosphere and emphasizes the richness of the colors found throughout this pastel.

Using Light to Create Volume, Depth, Atmosphere, and Space

To perceive volume and depth, which exist in space, you need light. When you paint, you create the illusion of volume and depth by capturing a sense of light and atmosphere within space. Choosing light that comes from a single source and a single direction lets you achieve maximum volume and depth. Too many lights coming in from different directions eliminates the form of an object; therefore, its sense of weight or volume gets weakened. Light and space create atmosphere both in front of and behind each object. This also results in an illusion of distance.

We live in a world of color that is illuminated by light. Colors lose their hue and energy as they recede in space. Light colors get a bit darker as they recede, while dark colors get a bit lighter as they recede. This adds to the sense of depth and atmosphere.

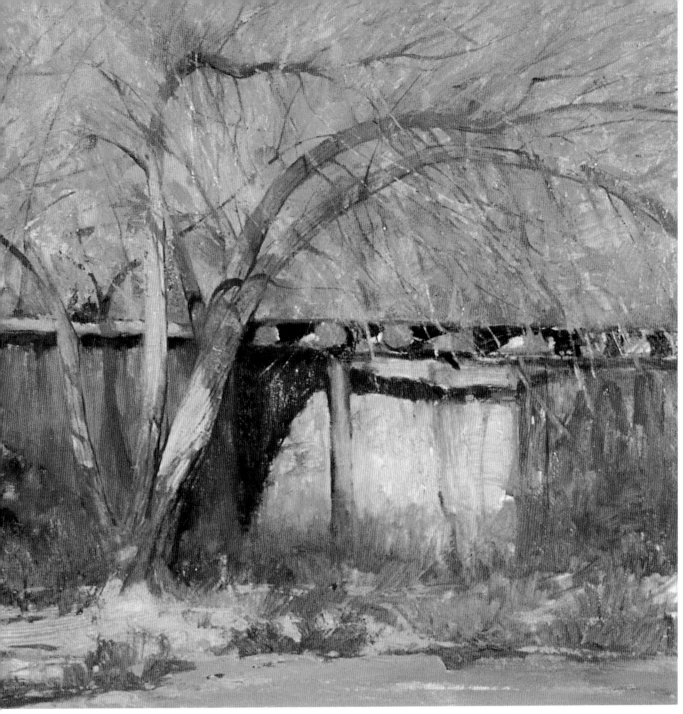

My Favorite Tree

Oil on Masonite panel. 23½ x 31½ inches (60 x 80cm). Private Collection.

When artists think about space, they think of painting with lots of distance. But space is everywhere, even when you pan in on a subject. The light in "My Favorite Tree" captures the colors of a sunny winter afternoon. The simplified, warm illumination in the background trees helps create volume in the foreground by adding depth and atmosphere to the sense of space in the painting. In this way, the viewer remains interested in the foreground building and the tree. And the yellow of the building that is in light draws the viewer's attention by increasing the volume of both the building and the tree. The remaining suggestions of detail and light help establish the painting's strong sense of weight, depth, and atmosphere.

Ready To Go

Pastel on sanded board. 9 x 11 inches (23 x 28cm). Private Collection.

The illumination cutting across the bottom half of the pastel brings out the light colors of the foreground. The dark greens of summer frame the truck with the red cab and the white house. The shape and color of the light-blue sky literally cuts into the composition, adding depth and atmosphere to the space. The size of the red truck proportionally gives volume to the size of the house. I painted this pastel on location in New York's Adirondack Mountains; I didn't do any fine-tuning in my studio afterward. This retained the freshness of the lighting effect, the colors, and the sense of space.

Radiating "Inner Glow" and Creating Paintings with a Life of Their Own

While I was an art student, my paintings didn't have an inner glow. I was working in a lower key then, and when the late-afternoon light faded in the studio, my works looked like dark, heavy rocks sitting on the easel. I was determined to achieve this exciting quality in my paintings. Today, I work in a much higher key with lighter colors and through various skills that I've developed, my paintings seem to possess this inner glow. Before when I worked lower in key, I tried to achieve light through modeling form, and as valid an approach as that is, it is no longer my main interest.

In my oil paintings, I now use plenty of subtle glazing and transparent passages. I start with transparent color washes that have more of a glow to them than opaque colors. Then I paint with semi-opaque colors that I weave in and out of the transparent color washes. At a certain point, an unexplained inner glow develops. This glow remains after I resolve and finish the paintings. When viewed in a low light, these paintings seem to have an inner life of their own because the colors and illumination in them radiate.

Blue Door in Sunlight

Oil on Masonite panel. 36 x 48 inches (91 x 122cm).
Collection of Dick and Donna Carlen.

I made this large oil painting on a white gessoed Masonite panel. In order for me to achieve a radiating inner glow, the ground I painted on couldn't be toned; it had to be white. First, I applied light, transparent color washes, oil paints diluted with pure gum spirits of turpentine. Because these transparent colors were either scrubbed on or applied like washes, they provided a sense of the finished work's radiance. This happens when I work transparently in the beginning stages of a painting. Then as I developed and resolved the painting, many areas received semi-opaque and opaque color applications. As I did this, I always remained aware of the already transparent colors. For contrast, I plastered other areas with thick palette knife work and kept still others loose and transparent. When the entire painting was resolved, nothing in the overpainting negated the inner glow that I'd achieved in the initial laying in of transparent color.

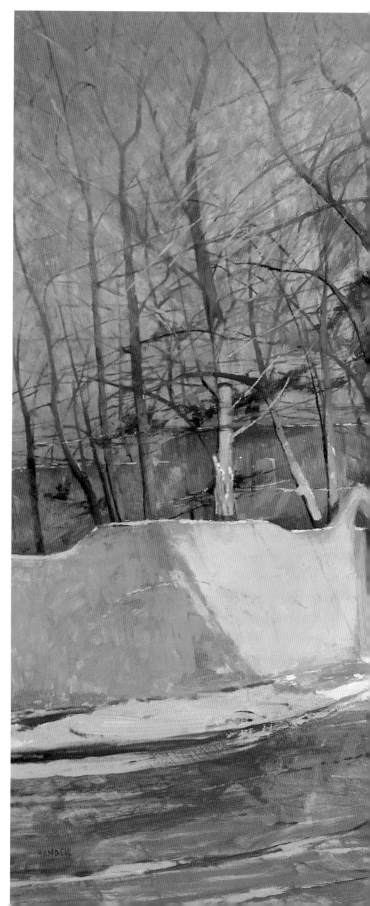

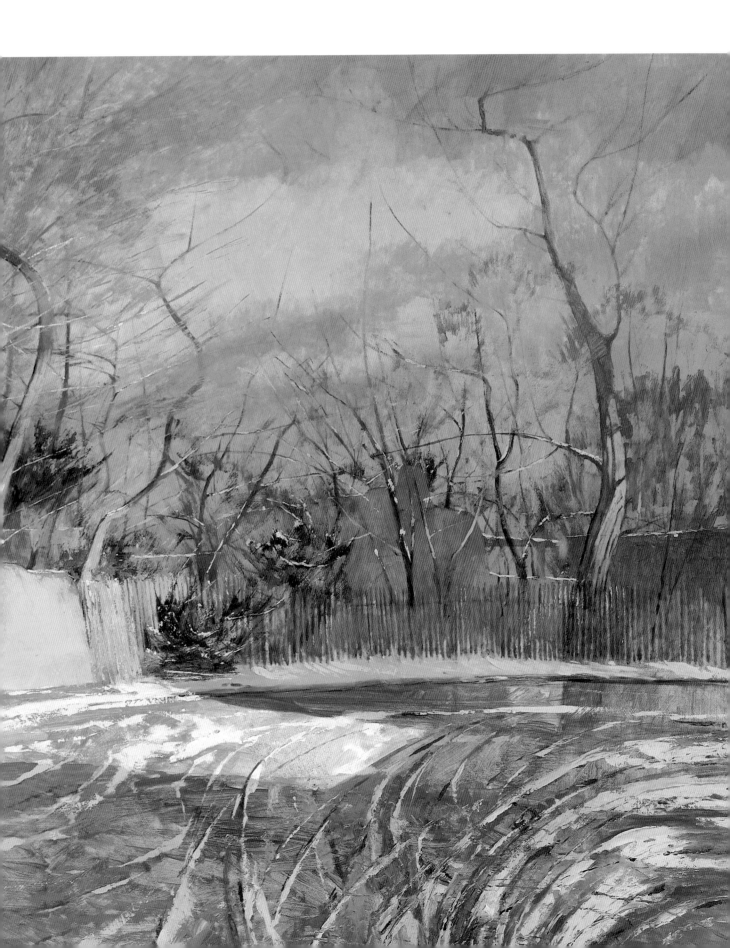

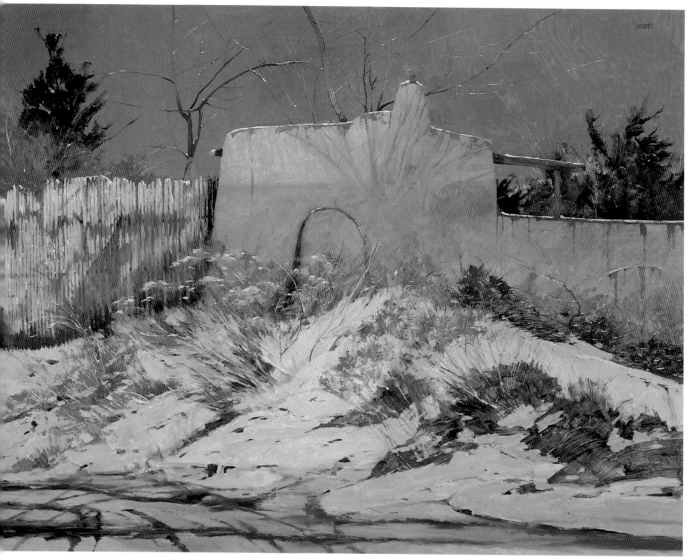

Camino Escondido

Oil on Masonite panel. 36 x 48 inches (91 x 122cm).
Collection of Harry and Renata Berry.

I made this large oil painting in my studio. To achieve the
glowing illumination in this painting, I had to start on a
white ground. I began by using transparent oil-color washes
that dry quickly and produce intense radiating colors. Later,
when I worked opaquely with oils on top of these transparent
color washes, I related the values of the opaque colors to the
transparent color washes. This kept the colors high in value. I
then applied opaque and semi-opaque applications of oil color
over the dried transparent color washes. This made these
areas denser but not darker in value. The sky, for example, is
rich in color with subtle variations from left to right. The sun-
light on the adobe is very close in value to the cast shadows
right next to it. Details of melted snow enhance both the
realistic effect and the glow of the light.

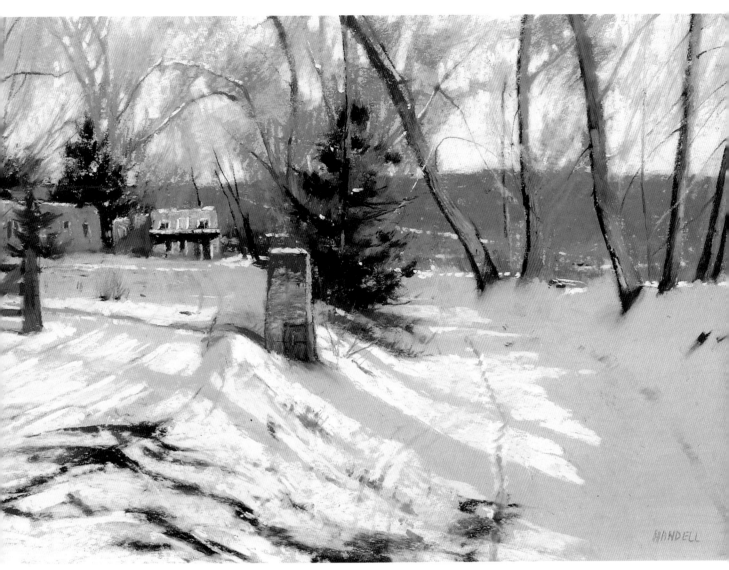

Tesuque Winter
Pastel on sanded board. 12 x 17 inches (30 x 43cm).
Collection of Deborah and Barry Pariser.

Tesuque is a beautiful, rural area close to Santa Fe, New Mexico. It is rich in subject matter, and I often visit there to paint, draw, and photograph. I shot the photograph I made this pastel from on a bright, cold winter morning. I wanted to capture that scene's brilliance in this painting. I find at times that when I paint a snow scene in pastel, raising the values of the bluish-gray cast shadows on the snow produces wonderful results in terms of the sense of light in the entire work. The painting seems to possess an inner glow. When I paint these cast shadows dark, the viewer's eye seems to trip over them. Obviously, this impedes the sense of flow present in the higher-value interpretation. Keeping the rest of the painting in harmony with this interpretation is essential.

Index